PROFESSIONAL WEB VIDEO

PROFESSIONAL WEB VIDEO

PLAN, PRODUCE, DISTRIBUTE, PROMOTE, AND MONETIZE QUALITY VIDEO

RICHARD HARRINGTON
and MARK WEISER
with RHED PIXEL

AMSTERDAM • BOSTON • HEIDELBERG • LONDON • NEW YORK • OXFORD
PARIS • SAN DIEGO • SAN FRANCISCO • SINGAPORE • SYDNEY • TOKYO
Focal Press is an imprint of Elsevier

Photography: Richard Harrington, Emmanuel Etim, Liang Cai, Ian Pullens, Pam Vinal, James Ball, Lisa Robinson, and Mark Weiser
Technical Reviewers: Phillip Hodgetts, Jason Van Orden, Kristopher Smith, and Lee Gibbons
Contributors: Jason Van Orden, Paul Vogelzang, Hayden Black, Ray Ortega, and Emmanuel Etim

Focal Press is an imprint of Elsevier
30 Corporate Drive, Suite 400, Burlington, MA 01803, USA
The Boulevard, Langford Lane, Kidlington, Oxford, OX5 1GB, UK

Notices

Knowledge and best practice in this field are constantly changing. As new research and experience broaden our understanding, changes in research methods, professional practices, or medical treatment may become necessary.

Practitioners and researchers must always rely on their own experience and knowledge in evaluating and using any information, methods, compounds, or experiments described herein. In using such information or methods they should be mindful of their own safety and the safety of others, including parties for whom they have a professional responsibility.

To the fullest extent of the law, neither the Publisher nor the authors, contributors, or editors, assume any liability for any injury and/or damage to persons or property as a matter of products liability, negligence or otherwise, or from any use or operation of any methods, products, instructions, or ideas contained in the material herein.

Library of Congress Cataloging-in-Publication Data
Harrington, Richard, 1972-
 Professional web video : plan, produce, distribute, promote, and monetize quality video / Richard Harrington and Mark Weiser.
 p. cm.
 ISBN 978-0-240-81509-1
 1. Video recording. 2. Video recordings–Production and direction. 3. Webcasting. I. Weiser, Mark. II. Title.
TR851.H37 2010
778.59–dc22
 2010038553

British Library Cataloguing-in-Publication Data
A catalogue record for this book is available from the British Library.

ISBN: 978-0-240-81509-1

For information on all Focal Press publications
visit our website at www.elsevierdirect.com

10 11 12 13 14 5 4 3 2 1

Printed in Canada

Working together to grow
libraries in developing countries

www.elsevier.com | www.bookaid.org | www.sabre.org

ELSEVIER BOOK AID International Sabre Foundation

Dedications

To my wife Meghan, whose love and patience makes all things possible.
To my children Michael and Colleen, who give my life meaning.
To my parents, for teaching me to work hard and treat others fairly.

—Richard Harrington

To Casey, for all her love and support.
To Brooke and Brian, for bringing a smile to my face every day.

—Mark Weiser

CONTENTS

Companion website: www.HyperSyndicate.com

Acknowledgments

The authors would like to thank the following individuals and organizations for their generous contributions to this book and our web video knowledge.

Gary Adcock

Jim Ball

Steve Bayes

Hayden Black

Richard Burns

Robbie Carman

Creative Cow

Bob Donlon

Emmanuel Etim

Mannie Frances

Michelle Galina

Eric Garulay

Barbara Gavin

Alexandra Gebhart

Lee Gibbons

Matt Gottshalk

Jeff Greenberg

Ron Hansen

Serena Herr

Phillip Hodgetts

Scott Kelby

Steve Kilisky

Todd Kopriva

Ben Kozuch

David Lawrence

Logan Leabo

Ron Lindebloom

Dennis McGonnagle

Stephen Menick

Dominic Milano

Patricia Montesion

David Moser

National Foundation for Credit Counseling

Ray Ortega

Mark Petracca

Greg Philpott

Chris Phrommayon

Dave Potasznik

Gary-Paul Prince

Carlin Reagan

The Staff of RHED Pixel

Scott Sheppard

Doug Smith

Kristopher Smith

Sound Mind & Body Gym

Douglas Spotted Eagle

Paul Temme

Jason Van Orden

Paul Vogelzang

Terry White

Tim Wilson

INTRODUCTION

Who This Book Is For

This book is written for those who need to create professional-quality web video or podcasts. We set out to write a book that would offer expert-level advice on all aspects of web video. We realize most of you reading this will have diverse backgrounds, so we will attempt to deliver information at two levels.

The body of the book presents you with the most essential information, richly illustrated, with straightforward advice. Interspersed throughout the book you'll find several tips and sidebars. This information serves two purposes. It either offers advanced information to let you go deeper on a topic or points out additional resources if you lack experience with a topic.

Whether you are a video enthusiast, a multimedia developer, or a communications professional, this guide is written to help you. We wanted to create a book that addressed the diverse requirements of web video. We also wanted to straighten out several misperceptions and bad practices that we have encountered. If you like your books to be based on real-world experience, this is the book for you.

What You'll Learn

We have structured this book to follow the path of professionally produced web video. We *highly* recommend that you read this book's chapters in order. We will build on the information from one chapter to the next. Here's the journey we'll take together.

The Evolution of Web Video

Chapter 1: Making Great Web Video—Learn how to determine your genre and technical approach. You'll also get a sense on the size of the web video audience and business opportunities.

The Production of Web Video

Chapter 2: Essential Preproduction—This chapter covers important decisions about determining your production needs as well as budgeting your show. Learn practical advice for mapping your production and working with talent.

Chapter 3: Audio Is Half Your Program—Learn how to record great sound for your web video. We also explore options for using music in web productions.

Chapter 4: Great Video Needs Great Lighting—Learn how to achieve professional lighting with an emphasis on value and portability. We also provide setups for different styles of video programs.

Chapter 5: Videography for the Web—Learn the key features you'll need in a video camera. We pay close attention to the evolution of tapeless acquisition and HD video. We also offer a specific packing list to help you bring the most important gear to your web video shoot.

The Postproduction of Web Video

Chapter 6: Telling Your Story with Visuals—This chapter points out useful ways to add visuals to your story. Learn how to work with photos and stock footage as well as practical tips for motion graphics.

Chapter 7: Editing Considerations—Putting all of your pieces together takes skill and experience. We share several lessons learned from having produced thousands of web videos.

Chapter 8: Encoding Video for the Web—Learn how to create compatible digital files that will work for a podcast, in a web browser, or on portable media players. Achieve smaller file sizes and better image clarity with our practical advice on video compression.

The Delivery of Web Video

Chapter 9: Understanding Flash Video—We take an in-depth look at one of the most popular methods for delivering video. Learn about your options when working with the Flash platform.

Chapter 10: Podcasting and RSS Essentials—Learn how to deliver a podcast with an RSS feed to list its contents. Search engines and podcast directories require this information in order to list your show. Learn what goes into the podcast feed and easy ways to create a compatible podcast.

Chapter 11: Hosting Web Video—This chapter explores several options for hosting your web video files. Learn your options for delivering your files and ways to minimize expensive hosting charges.

The Business of Web Video

Chapter 12: Promoting Your Video—We visit with numerous web video producers and share their secrets for successfully attracting (and keeping) an audience.

Chapter 13: Monetizing Your Video—Creating professional web video requires time and effort. In this chapter we explore options for recouping your investment.

The Icons Used in This Book

Gear Up—Recommendations for gear that makes the job easier or adds quality to the final production.

Further Reading—Recommended books or resources that let you explore a topic in greater depth.

Web Link—External websites that offer additional resources or information.

Noteworthy—Learn important "gotchas" or pitfalls that can put your production at risk.

Technical Tip—How-tos or important advice on how to get the job done.

Our Approach

Our advice is practical. We don't teach you how to cheat. We don't treat you like you are "dummies." Our productions vary; we've done work for Fortune 50 companies as well as small nonprofit associations. We have been in front of the camera as well as behind it. We teach you how to produce web videos that look professional while being keenly aware that web videos are a price-sensitive commodity.

We will offer you multiple approaches that address both high-end and budget-conscious workflows. We are fully cross-platform and use Macs and PCs in our daily lives. We also use tools and gear from a variety of manufacturers. We'll offer our opinions but feel that they are well formed. We'll also offer options and differing points of view, as we know that you'll want choices.

Our Qualifications

At the time of this publication, our company, RHED Pixel (www.RHEDPixel.com), will have produced close to 5,000 web videos. We've developed web video for companies like Microsoft, Apple, Adobe, and Google. We've also worked with everyone from educators to professional speakers to fundraisers. We've produced web videos on a variety of topics, software training, emerging technology, digital photography, health, parenting, and science.

We have spent five years refining this book. Rather than rush this book out the door, we have refined our workflows and opinions. The material in this book has been thoroughly tested. We have learned from years of video production and from working on so many web videos. We live video and new media production every workday, and the advice you'll find in this book is how we get the job done. We'd like to think you'll find the book useful. We believe in karma. We take the hard lessons we've learned and offer them back to the industry as a whole.

We hope you enjoy and we invite you to become part of the conversation by joining us at www.HyperSyndicate.com.

MAKING GREAT WEB VIDEO

We know why you picked this book up. You want (or have been asked) to make great web video. You want your video to connect with an audience and be seen. You want to entertain or inform. You want to raise awareness for a cause or recruit customers to your business. Your goals are diverse and complex, but they are attainable.

Our recipe for quality video includes four stages and an optional goal:

- **Plan.** A lack of planning leads to an abundance of failure. Whether you're spending real dollars or just time and effort, there is no excuse to skip planning. While "dumb luck" exists, successful planning is more likely to bring results.
- **Produce.** We'll tackle how to achieve high-quality results using both professional and consumer equipment. We're sure to reference tools at various price points (including free and do-it-yourself options). But we've never met a successful carpenter who hasn't reinvested in some good tools along the way.
- **Distribute.** There are many ways to publish video to the web. We'll explore how to successfully prepare your files for the net.

We'll also address important options like podcasting, hyper-syndication, video sharing, and mobile video.

- **Promote.** If you don't make some noise, you won't be heard. We'll discuss formalized and guerilla promotion strategies. We've also got some great advice from some top web video producers who share their secrets.
- **Monetize.** The monetization strategies we offer are practical ways to earn money from your program. We'll examine different models from sponsorship to selling products and services. This chapter is optional, but we'll share practical advice to turn your efforts into dollars.

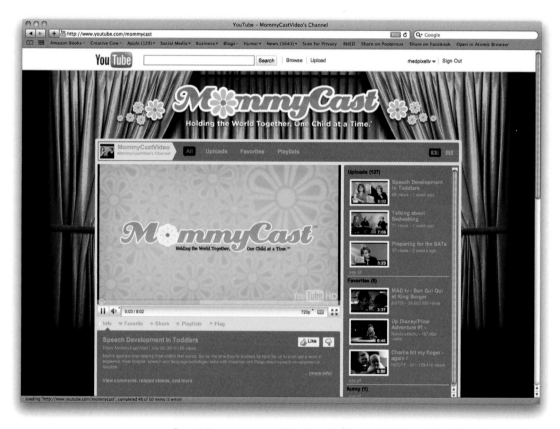

One of the programs we'll explore in this book is MommyCast (www.MommyCast .com). The show reaches millions of viewers and is distributed as a podcast, on YouTube, on Facebook, and even TiVo.

This book is written for those who need to create professional-level web video. We realize that the word *professional* has different meanings to different people, so let us be clear. You have a financial stake in the outcome. This may be an investment in your time, your company's brand, actual dollars from a client,

or a complex web of needs and expectations. You don't just want results—you need them.

Whether you are a video pro, a multimedia developer, or a communications professional, this guide is written to help you. We wanted to create a book that addressed the diverse requirements of web video. We also wanted to straighten out several misperceptions and bad practices that we have encountered. If you like your books to be based on real-world experience, this is the book for you.

The Opportunity of Web Video

There's a lot going on with web video in recent years. Technology has continued to improve at a rapid pace. This has enabled both the growth of new audiences and new opportunities as well as the ability to deliver a better-looking product to these audiences.

Many of the industry's largest television networks and video producers have also embraced web video as an opportunity to create additional revenue streams for their content. This new market is rapidly expanding, and it's one that most believe encapsulates the best opportunity to bring video to consumers.

In this section, we're going to explore some recent research about the state of web video and broadband Internet. Where possible, we're limiting our sources to only the most credible of government and nonprofit research groups to present a fair and balanced overview of the state of web video.

The Growth of Broadband Internet

While web video and podcasting do not require broadband access, they certainly thrive with high-speed connections. The Pew Research Center found that nine in ten consumers of online video have broadband at home. In fact, 76% of those with

A Dose of Reality

We have spent four years developing the content of this book. We've also been publishing video to the web since 1996. These ideas are time tested and put in practice every day. Rather than rush this book out the door, we have refined our workflows and opinions. We live video and new media production every workday; the advice you'll find in this book is how we get the job done.

The Pew Internet & American Life Project

Our principal source is of information is the Pew Internet Project, which is an initiative of the Pew Research Center, a nonprofit, nonpartisan "fact tank." This group provides information on the issues, attitudes, and trends shaping America and the world. The project studies the social impact of the Internet and shares its findings at www. pewinternet.org.

broadband access watch video at home. Those that want video want it fast. But just how many people have broadband Internet?

The exact numbers vary greatly over the world. Let's first take a look at the United States, and then we'll broaden our view globally. The U.S. Federal Communications Commission reported in 2010 that 78% of adults in the United States are Internet users and 65% of adults have home broadband access. The Pew Research Center had similar findings for 2010 and estimated that 63% of American adults now have high-speed connections into their homes.

Here's a look at the state of global connections:

Top 10 Countries by Number of Internet Users

Rank	Country	Internet Users	Population Percentage
1	China	420,000,000	31.80%
2	United States	234,372,000	76.30%
3	Japan	95,979,000	75.50%
4	India	81,000,000	7.00%
5	Brazil	72,027,700	36.20%
6	Germany	61,973,100	75.30%
7	United Kingdom	46,683,900	76.40%
8	Russia	45,250,000	32.30%
9	France	43,100,134	69.30%
10	South Korea	37,475,800	77.30%

From www.internetworldstats.com/stats.htm.

Top 10 Countries by Percentage of Internet Users

Rank	Country	Internet Users	Population Percentage
1	Iceland	285,700	93.20%
2	Norway	4,235,800	90.90%
3	Greenland	52,000	90.30%
4	Sweden	8,085,500	89.20%
5	Netherlands	14,304,600	85.60%
6	Denmark	4,629,600	84.20%
7	Finland	4,382,700	83.50%
8	New Zealand	3,500,000	83.10%
9	Australia	17,033,826	80.10%
10	Luxembourg	387,000	78.70%

From www.internetworldstats.com/stats.htm.

World Internet Users and Population Stats

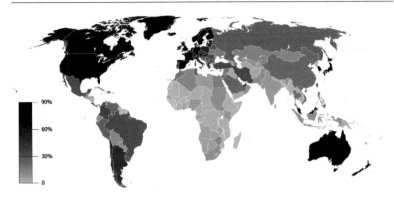

This is a file from the Wikimedia Commons.

The Growth of Internet Video

The growth of broadband video has had an impact on the viewing habits of its users. The Pew Internet & American Life Project found that in the year 2010, 69% of online adults have used the Internet to watch or download video. This total represents 52% of all adults in the United States.

Improvements in wireless connection are only boosting these numbers. Pew finds that "Fully 71% of those with wireless connectivity watch videos on video sharing sites compared with just 38% of those who do not access the Internet wirelessly."

This is also spilling into mobile phones and portable media players with both Internet connections and mobile publishing

Devices like the Apple iPhone are helping broaden the reach of web video.

The Fast Pace of Broadband Adoption

 Broadband Internet access has hit the 50% adoption milestone faster than most other consumer technologies. It has taken about 10 years for broadband to reach 50% of adults in their homes. For example, it took 18 years for color TV to reach 50% of Americans, 18 years for the personal computer, 15 years for the cell phone, 14 years for the videocassette recorder, and 10.5 years for the compact disc player.

The State of Online Video

 For full details on these statistics, be sure to read the Pew Research Center's report – The State of Online Video. It's available at www .pewinternet.org/ Reports/2010/State-of-Online-Video for free.

It's a Competitive World

 One in seven adult Internet users (14%) have uploaded a video to the Internet. This means you have a lot more competition that you used to. There's no room for sloppy planning or poor production—you'll just get swept under the wave of "user-generated excrement."

capabilities. Approximately 14% of cell phone users have watched video on their phone. Most interesting is the fact that cell phone users are more likely to record video on their cell phones than watch it; 19% of cell phone users say they've recorded video with their phone.

In an earlier (2007) report, the Pew Research Center found that "half of online video viewers (57%) share links to the video they find with others, and three in four (75%) say they receive links to watch video that others have sent to them." These trends bode well for web video producers. If you produce high-quality video that is on target, your audience will share it with others. This type of growth is often referred to as viral, and it works well online. Success can come much quicker than through other media outlets, and at a lower cost because traditional advertising often has little to do with viral growth.

The Involvement of Big Business

Web video is a part of traditional media's plan to stay relevant. Television networks in particular realize they need to move their video content to the web, enabling both space shifting and time shifting. The challenge here is that many of these traditional

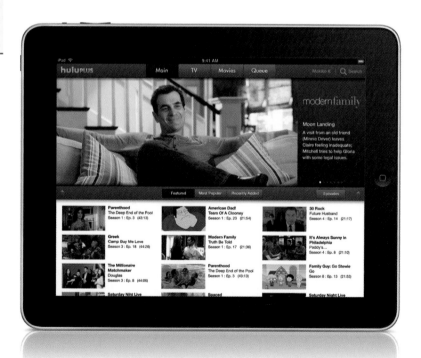

Image courtesy Hulu

content generators hold onto their old ways of thinking. While these studios would benefit from podcasting and online video, many want greater control over their digital files through the use of digital rights management (DRM) technology.

Motorola found that 45% of European broadband users watch at least some television online. The percentage was as high as 59% in Spain and France (it currently stands at 32% in the United States). The Pew Research group has found that 7% of all Internet users in 2010 have paid to watch or download a video. That number was only 4% in 2007, so that's steady growth where dollars are concerned.

The biggest change though has been the use of video-sharing sites like YouTube, Facebook, and Vimeo. These sites gather video together and make it easy to search content and share with others. The percentage of adult Internet users who watch video on these sites has grown from 33% in December 2006 to 61% in 2010.

All sorts of business models are being tested, from subscription content, to sponsorship, to selling related content. What has been a constant struggle is the goal to embrace nonintrusive advertising or monetization strategies that are highly targeted to the viewer. What will continue to be a struggle will be meeting the demands of consumers while generating revenue for the content creators.

Web Video Development

Now that you understand the size of the audience, as well as some of their habits, you can start to develop (or refine) your web video ideas. It all starts with a concept, the essential nugget of an idea that is your approach. You then need to determine the best genre or style of production that will connect with your audience. Once you've refined the idea, you'll need to examine your technical approach. We find that a guiding principle is how can we do as much as possible with as little as possible.

Once you know what you want to do and how you're going to do it, you'll need to communicate with others. Writing a treatment allows you to share your ideas with others. The same goes for a video or series description, which will become a critical creative and marketing tool.

When it comes time to kick off a web video project, you'll want to gather all the key players into a creative development session. This may be a face-to-face meeting or an online forum.

Many feel that the Apple iPad is changing the landscape for mobile and personal video consumption. Services like Hulu and Netflix are serving up premium subscription content to viewers.

Everyone should come together to brainstorm the most effective approach for the project. Just make sure you set an agenda and clearly invite folks.

Developing a Concept

A key step in your show's preproduction is creative development. The show's concept needs to be developed, beaten up, chewed up, and then spit out. Chances are your original ideas and assumptions will be a lot stronger after you put them through a creative wringer. Here are a few things we've learned in developing new shows:

Directories like Apple iTunes let you analyze your competition and see how they stack up against each other with ranking charts.

- **Don't try to reinvent what already exists.** You need to closely examine what's already in the web video universe. Don't waste your time developing a concept that is identical to a hit show. After all, it's a rare day when the clone surpasses the original. With that said, don't give up on your idea, refine it.
- **Figure out what you can do differently.** If your competition offers long shows, offer shorter shows to appeal to those on the go. If your competition comes out monthly, come out weekly. If the competition takes a serious approach, look at humor. In other words, don't change the subject, but do change the delivery. In broadcasting, it's called counter-programming and the concept holds true here as well.

- **Decide whom you want to attract.** Web video and podcasting are niche media. Going after a smaller, targeted group is what it's all about. You need to think long and hard about whom you want to reach. By refining your target audience, you stand a much better chance of appealing to them and capturing them as viewers and subscribers. That's not to say you want black-haired, blue-eyed, left-handed, 27-year-old chemical engineers. But a video that goes after engineers of all types would probably fail just as badly. What's important here is that you identify a specific group with specific interests, then develop content that fits their needs.
- **Make sure your visuals matter.** Could your web video be delivered as an audio-only podcast? If so, don't create a video just to make a video. Producing web video is more expensive than audio podcasting. Make sure you're leveraging the strengths of the medium to justify the cost (and download time).

The Five Ws

Although it may seem a little cliché, another way to refine your show's concept is to ask the standard who, what, where, when, and why questions:

- **Who?** Who is going to watch the show? Who is going to host the show?
- **What?** What topics will the show cover? What genre or format will it use?
- **Where?** Where will the show be recorded? A studio? On location?
- **When?** When will the show come out? Daily? Weekly? Monthly?
- **Why?** Why would a viewer subscribe to the show? Why would that viewer come back for another episode?

Developing a Genre

When you go into a major bookstore, you'll find that books are typically sorted by genre. All books of a particular category (such as mystery, history, or technology) are grouped together for sale. This practice makes it easier for consumers to find what they want. The same holds true for online video.

The Pew Research Center found substantial growth from 2007 to 2010 in all online video. These three genres saw the biggest growth:

- **Comedy or humorous videos,** which have risen in viewership from 31% to 50% of adult Internet users.
- **Educational videos,** which have risen in viewership from 22% to 38% of adult Internet users.
- **Political videos,** which have risen in viewership from 15% to 30% of adult Internet users.

Here's the breakdown by genre:

Does Age Matter?

For a great breakdown of viewing habits by age demographics, see http://tinyurl.com/ pewagereport. This will help you target a specific group more efficiently.

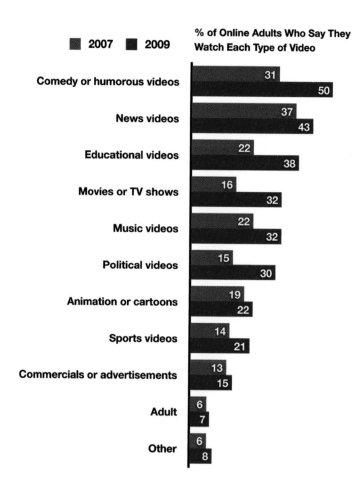

% of Online Adults Who Say They Watch Each Type of Video

■ 2007 ■ 2009

Genre	2007	2009
Comedy or humorous videos	31	50
News videos	37	43
Educational videos	22	38
Movies or TV shows	16	32
Music videos	22	32
Political videos	15	30
Animation or cartoons	19	22
Sports videos	14	21
Commercials or advertisements	13	15
Adult	6	7
Other	6	8

Source: www.pewinternet .org/Reports/2010/State- of-Online-Video/Part-1/ What-Kinds-of-Video-Are- Online-Adults-Watching .aspx?r=1.

Determining a Technical Approach

Once you've refined your topic, genre, and target, you need to make some initial decisions about how you're going to produce your show. Different styles of production can greatly impact the cost of your project. Be sure you identify how the web video will be produced. Using a studio can drive costs down as it adds an element of control to the production process. On the other hand, a screencast style of production for technical training often just features the voice of the talent and a capture of what they were doing on their computer.

Be sure to pick the best format to capture the visuals in your show that your budget can afford. Think about the big picture here, the major decisions that will shape how you will execute your show.

The same studio space, but two very different shows. *MommyCast* records new episodes every few weeks, whereas *Understanding Adobe Photoshop* records a year's worth of episodes in a few days time. Both shows are recorded at 720p at 24 frames per second.

- **Production frequency.** How often are you going to record new episodes? We personally favor shooting multiple videos at a time. Many of the web video series we work on only record a few times a year (some even go for a solid week and record a year's worth in a single period). This type of production is more cost efficient, but it makes it harder to be timely and react to outside events, viewer feedback, and sponsor's requests. You'll need to balance your production schedule with the needs of the content and your budget.
- **Acquisition size.** There's been a rush for high-definition (HD) video for the web. This is because many consumers are viewing web video on televisions and large computer monitors. Of course, the practice of mobile video on smart phones and portable media players is booming too.
- **Delivery methods.** You need to consider your primary and secondary delivery methods. A show that relies on downloads (such as a podcast or digital purchase) will be expected to have a higher image quality and data rate. On the other hand, you may be streaming the video off free video sharing sites,

Which HD Is the Right HD?

 We typically acquire shows in 720p HD (a frame size of 1280 × 720) at 24 frames per second (the same as film). We find this to be a great balance of image quality and cost. The progressive frames can also be cleanly scaled to smaller sizes for portable players.

The LCD Test

We believe in the least common denominator test. That is to say that the video must look good at a connection speed and on a playback device that we consider to be the low-end of our target. Currently, this threshold is video streaming over the YouTube player to an iPhone (using the slower Edge connection). We'll post test shots and graphics throughout the development process to check how the video looks and sounds. If it looks good there, it'll look even better everywhere else.

Multiple Treatments

Experienced producers often force themselves to write multiple treatments for the same project. This creative refinement process often forces the best ideas to the top. Plus, it gives you extra options when a client or boss doesn't like your first idea.

which will compress the picture heavily. The delivery method will impact the shooting style, sets, graphics, and even pace of editing that you'll choose.

* **Audience capabilities.** You need to make some assumptions about the members of your audience. Will they view your show on portable media players, laptops, or set-top boxes? Do they want faster download or streaming times, or are they willing to wait for a high-definition episode to download? You need to give careful thought to how your show will be consumed if you want to avoid alienating prospective viewers.

Writing a Treatment

The treatment is considered a standard part of the development cycle for most film and television productions. The truth is that all kinds of video producers can benefit from creating a treatment. The goal is to write a single document that defines the video's concept and summarizes the creating approach to be taken. The best part of making a treatment is that is formalizes the creative process for the producer. The major benefit here is that the document can then be shared with others as you work with other creative professionals, get approval from a client, or even seek funding or approval.

We recommend the following approach to developing a treatment:

1. **Define the goals and set parameters.** What core message are you trying to convey? Who do you want to watch the video? What desired outcome would you like to create (volunteering, purchases, political change, or a good laugh)? What's your budget, and how long will the video run?
2. **Identify the concept.** You'll want to be able to quickly summarize the theme and objective for the video. Describe to others the core message and frame its delivery method.
3. **Choose an approach.** Now's the time to lay out the specifics. This is generally a narrative summary of the journey the audience is going to take. In a way, it might resemble a book report you wrote in school—a clear summary that reveals all of the important details that will be presented to the viewer. Describe specifics that will elicit response by the audience including music choice, shooting style, and editing approach. Describe the emotions you will solicit along the journey and how the audience will feel at the journey's end.

Essential Questions to Ask at the Beginning of a Project

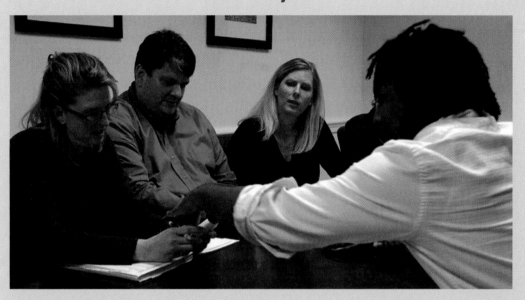

Through the years, we've learned a lot of lessons the hard way. Although every project is unique, it often seems that the problems remain the same. Here are a few questions we always encourage asking at the start of any video project:

- **Who is our customer?** Projects often have many parties involved. Be sure that you know whom you're responsible to keep happy.
- **What is the purpose?** You need to know what the video is trying to accomplish.
- **How will we measure success?** Determine which factors will be used to judge the success of the project.
- **What do we want to say?** Identify the goal of the piece and the message that the audience should walk away with.
- **What resources do we have?** Decide who will be assigned to the project. Establish if any assets or resources are available to the project that should be utilized. Make sure no assumptions are being made about what you have to work with.
- **What is the budget?** Never discuss approach without having an idea of your financial constraints. Creative types often get swept up into big ideas without knowing what the project can support.
- **What are the deadlines?** Equally as important as budget is schedule. You need to understand any major milestones so you can schedule work and adjust your approach to match the available time.
- **Are there any customer requirements?** Never make assumptions. It's always a good idea to ask the clients if they have any specific needs or requirements for the end product. You'll often be surprised how important details can go unspoken until the very end of the project.

Writing a Video or Show Description

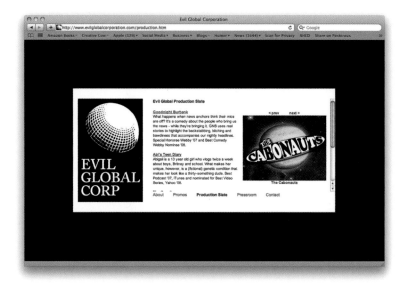

Hayden Black runs Evil Global Corporation (www .evilglobalcorporation.com), which produces some of the most original web series. The corporate site offers detailed and humorous descriptions of shows in development.

Let's take another page from the rulebook of television and film. Create a compelling description for your video or show. If you were a television show, this would be the write-up for the entertainment press. If it were a movie, you've just written the label for the back of the DVD.

The goal here is to capture the spirit of the web series or individual video. You'll need to convey to others in a short time frame what the project is all about. Many call this an "elevator speech," as it should be able to be presented (and understood) in less than 60 seconds. When done correctly, this document can also be used for early promotional efforts during the development of the video.

Budgeting Guidelines

If you're looking for a pot of gold, you're chasing the wrong leprechaun. Web video budgets are not the same as feature films

Shot Ratio Matters

Between DV tape and FireWire hard drives, the concept of shot ratio seems to have gotten lost. With web video, your shot ratio matters. Shot ratio is how much footage is acquired versus what's used in the finished cut. For example, if you shot 60 minutes of material and used 20 minutes, that would be a 3:1 shot ratio. If your shot ratio creeps above 4:1, you need to closely examine your shooting and production style. The only exception is multicamera-style productions. In this case, just count how much footage was used from the most utilized camera to produce the finished piece.

or commercial spots. With web video and podcasting, the key to making money is efficiency. Figuring out how to do more with less is the guiding principle. In this section, we explore practices that affect the bottom line.

Don't Make Assumptions

With web video, you need your shoots to run smoothly and efficiently. You will not be able to get the most out of your shoots if you've based your preproduction on bad information. You really want to know the goal of the shoot, the objectives of the shoot, how many episodes you are trying to accomplish, and that the client, the talent, and the director have the same expectations. We have found that we can record more than 25 episodes in a day if we plan properly and the talent is prepared. The bottom line here is efficiency. Be efficient, have a plan, and execute the plan with the minimum number of resources, and you'll do all right.

Estimating Time

There is a formula that many project managers use that comes from working with the federal government. It's a conservative formula that helps estimate the time it will take for a task in a project:

$$((1 * O) + (4 * M) + (1 * P)) \div 6$$

That's one times an optimistic work estimate, plus four times a most likely estimate, plus one times a pessimistic estimate, then divided by 6.

Here's how it works. Go to a member of your project team who's going to work on the task (such as the editor) and say, "So, how long would this take?" Note, this is not the most likely number. This is the optimistic number, because if you ask any creative person how long something is going to take, it's an exaggerated number based on the person's ego and personal self-worth. This time estimate is always off (this is not a slam on creative types, it is just true).

Then you ask, "Well, if it were anybody else doing the work, how long would it take?" This is the most likely number.

Next you ask, "If things went wrong that we really didn't count on—computer problems, bad communication—what's a bad-case scenario?"

Then you do the math: one times the optimistic work estimate, plus four times the most likely estimate, plus one times the pessimistic, divided by 6. This gives you a more accurate time estimate for the work at hand. You can increase the accuracy by surveying other subject-matter experts (such as all the editors in your office).

This is how the government does averaging, but you have to do it at the major task level. By getting the subject-matter experts involved, you are more likely to get accurate numbers about the work to be performed.

Keep It Short

Here's a simple idea: Keep your web videos short. It is better to have ten 4-minute episodes than one 40-minute episode. We try to keep our web videos to less than 10 minutes (in fact, they are less than 5 minutes long in almost all cases).

Web videos tend to be consumed during things like work breaks, downtime, and airplane flights. Others will use them during commutes on the morning train or the subway. Think of web video and podcasts as portable, on-demand learning or entertainment.

Remember that your audience is often watching web video on portable media players with small screens. Be sure to keep the total run time low to avoid viewer fatigue.

In the training videos we produce, we try to limit topics to one per episode. And if a single topic takes more than 10 minutes to explain, then we'll split the video into two or three parts. This way, the viewer can download part 1 and start watching it while waiting for the rest to download or be released. There's nothing wrong with multiple parts. That's the whole concept of serializing a web video into an actual series that builds up a subscription and viewership base.

Keep It Simple

Most web videos are unlikely to have huge budgets. It's a good idea to design your video using the principles of Electronic News Gathering (also known as Electronic Field Production, or EFP). The guiding principles here are speed and agility in acquiring the footage as well as swiftness in editing. The primary concern is getting the material to the audience in a timely fashion. News-style production is known for its efficiency, yet it retains production values that are perfectly acceptable to most television viewers. You should strongly consider adopting this approach when planning your shoots.

Giving Credit

We try to put our production company end slate whenever possible on web videos we produce (you see these graphics at the end of TV shows and the start of movies). If we can't get an end slate, we insist on getting a name credit in the show's credits. This should be a prominent credit like "Production services by." Whenever possible, get your name, your production company name, or your organization's name in the end credits.

Selecting and Prepping Talent

The good news is that web video is fairly democratic in nature. Web video audiences seem to prefer "regular" people as opposed to Barbie and Ken dolls, which often plague the traditional broadcasts. If you browse the top podcasts in each category on iTunes or look at well-performing series on YouTube, you'll find a large assortment of "nonprofessional" talent and hosts.

Don't Share Line-Item Budgets

 Although using a line-item budget is essential to creating an accurate budget, we try hard not to share these outside the company. We do not give clients line-item budgets because it often leads to unnecessary quibbling. Instead, we "roll" the budgets up. Identifying the major work packages to be performed and the total cost per category (such as preproduction, production, and postproduction). For example, we say, "The production budget is $2,500 and it includes a camera operator with camera, audio engineer with three microphones, and director for an 8-hour day."

Selecting good talent for a web video is perhaps the most important thing you can do. It involves finding someone who can connect with the target audience and deliver a message while keeping the audience entertained or interested. When it comes time to find your host or actors, you may have to look in several places.

Casting Talent

If you can afford it, then you can hire professional actors for your production. The benefit here is that people are paid to be professional. This means you stand a better chance that your actors will show up on time and know their lines (Note we said better chance—not a guarantee.).

You can use a casting agency in your area to help recruit talent. Agencies often keep several headshots of actors on hand. They can also set up auditions and rehearsals for you and take on some of the management tasks associated with recruiting and selecting talent. Of course, these services do typically cost money.

If you need a do-it-yourself approach, we recommend targeting places with high quantities of actors. This can include school and community theater programs as well as local professional groups.

The fees you pay will vary greatly. Some actors will belong to the Screen Actors Guild union, which sets minimum standards for payment. Other actors are not affiliated with a union and will set their price based on the work to be performed and how broadly the video is distributed.

Recruiting Talent

Most web video producers will find their talent through recruitment. They may call in favors or make an announcement through the sponsoring organization for people to appear in supporting roles. Others will also post ads to locations such as Craigslist to raise awareness. Chances are, if you're going this route you have little or no pay to offer.

Here are a few guidelines to ensure best results:

- **Be clear on the compensation.** Don't be vague about what you will or won't pay. No one likes their time wasted with vague promises of compensation. If all you're offering is a meal and experience, say so.
- **Offer something of value in return.** If you don't have cash to offer, give something back to your talent. It might be services traded (your time for theirs). If you're working with up-and-coming actors, be sure to offer copies of the final production. You may also be able to take a few additional photos or headshots while on set.
- **Be clear on expectations and time commitment.** Make sure people know *what* they are committing to. Be clear on just how long you expect to need them. Do your best to avoid slipping of schedule, and remember that time really is money.

Working with Clients

One of our core competencies is producing videos for others. We've been trusted with top corporate brands and major non-profit associations. In these cases, we often find ourselves working with the leadership of these corporations. There's no better way to lose a client than to make an executive vice president look bad on camera.

With that in mind, here are four simple steps you can take to improve your chances for success:

- **Schedule a conference call.** Try to have a short call before the shoot. Review the objectives and schedule. Be seen as being proactive and concerned. Encourage the client to bring a few changes of clothes to the shoot.

- **Assure your clients that you are there to make them look good.** We try to take clients aside before shooting and discuss the role of the director—how we might ask them a repeated question or to do another take. We're not doing this to be critical but to ensure they come off at their best. This is also a good time to address makeup and wardrobe concerns.
- **Establish open communication.** Make sure that the clients know they are part of the creative process and that they should raise their concerns and express any needs or desires about the production.
- **Remind the crew to be professional.** Clients are not your friends. They don't want to hear your jokes or the witty rapport between crewmembers. Be professional, courteous, and focused. You'll succeed if you remember to act more like a hotel's concierge and less like its bartender.

Preparing Talent

Oftentimes, web video talent has little or no on-camera experience, which is okay if you properly prepare them. Make sure your talent is well rehearsed. Utilize the setup time before the shoot to do an onset rehearsal. A lot of producers make the mistake of having the talent come only a few minutes before the call time. While the crew is setting up, we often ask the talent to show up; then we just go have breakfast, we talk through things, and let them get all their fears and anxieties out in the open.

Before the shoot, be sure to share the treatment, script, or other relevant materials. Make sure that those you cast are part of the creative process. Share your treatment or script so all can prepare. This will ensure a smoother shoot and give all involved a sense of belonging.

A Little Makeup?

We always try to get our talent (especially if they're clients) to allow for a makeup artist. These professionals are charged with making your subjects look their best. If that's too much to spend, we still offer makeup and apply it to help smooth out wrinkles and blemishes for the HD cameras. Of course, some refuse that too. Digital Anarchy makes a very cool plug-in for Final Cut Pro and After Effects called Beauty Box, which is essentially virtual makeup. It can be applied after the fact to smooth out the skin (without making the eyes or mouth look weird).

On-Camera Considerations

We share the following list with all clients and on-camera interview subjects to help them prepare. You may need to adapt this list to your specific needs or style of production.

- Please bring at least one alternate set of clothing.
- Herringbone, stripes, or small patterns do not look good on camera.
- Keep your jewelry simple.
- Please do not wear bright white. Cream, eggshell, or a light gray is preferred.
- We will offer you stage makeup when you arrive. This is to help you look and feel your best. You can choose not to wear it, but all the top network folks do (even the guys).
- Please avoid enumeration or the phrase "Like I said before." It is likely that we may only use an excerpt of your quote (and counting just confuses the audience).
- Don't be afraid to stop and start over. If you feel uncomfortable or would like a moment to gather your thoughts, please take your time.
- Relax. We're here to help you. We want you to look and sound your best.

PRO*file*: Evil Global Corp.

One of the most successful and creative forces in web video is Hayden Black and his Evil Global Corp (www .evilglobalcorporation.com). The Los Angeles-based independent production company creates original new media as well as promotions for television and film.

Since 2006, Black and his team have launched shows with strong followings. Their first show was Goodnight Burbank and two spinoff programs—Goodnight Burbank: Breaking News and Goodnight Burbank: Hollywood Report. The show describes itself as "a little *'The Office'*, a little *'The Daily Show'* and a lot of originality—that's Goodnight Burbank, a fictional 11 O'Clock newscast delivered straight from Hollywood's backyard."

Black shares his creative process. He says it takes a lot of thought and development to come up with crazy ideas that actually work.

"I do a lot of walking and spend a couple hours a day just thinking. If I laugh, I know I'm on to a good thing," said Black. "The trick is not to rush it. Let it stew and marinate. If it's a good idea it will get better and better. If it isn't, you move on to the next one."

Goodnight Burbank has become quite the success with millions of views both online and on mobile platforms. *USA Today* stated that it is "Funny…Well done. It's a lot better than 99% of the stuff on TV." In fact, the show is even in talks for re-airing its content on television.

It's this quality that lets Black work with top actors in the industry. His latest series, The Cabonauts, is described as "a sci-fi musical comedy starring all your sci-fi favorites in brand new roles—and singing and dancing as well. Think *Hitchhiker's Guide* meets *Glee*, and you're halfway there." The show features actors who've appeared in *Star Trek, Dollhouse, Buffy the Vampire Slayer,* and *Buck Rogers in the 25th Century*.

Black emphasized the need to approach web video with the same drive for quality as other outlets. When asked for the ingredients for a successful web video, he responded:

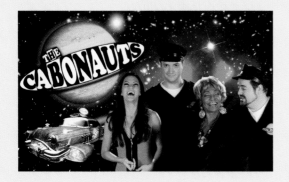

"First, great writing. This includes having an original idea and a unique voice with which to write with. Second is great actors, and third a great crew. Pretty much the same ingredients for a successful TV series or movie. Nothing's really changed!"

Black emphasized the need to really focus on original ideas if you want to succeed as a web video producer.

"Don't go with a parody. Find something new to say. And have fun," said Black. "Initially, it's going to be the most work you'll ever do for the least financial reward—but to see your vision come to life is the kind of fulfillment you rarely get to achieve."

Those creative ideas have taken Black to many different genres. His show, Abi's Teen Diary followed the life of a

fictitious (and unusual) teenager. He also launched The Occulterers, a comedy horror series about a group of dysfunctional ghost hunters.

"I have ideas. Sometimes I remember to write them down. Sometimes I develop them further. When writing a script, I often begin by over-thinking the whole thing and making them far more complex than I need to," said Black "I wrote the Occulterers in a few days, which was the most liberating thing I've ever done; just spewed stuff onto the page and then shot it a few days later."

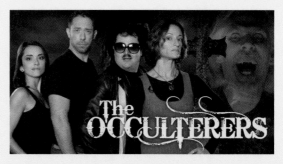

Learning when to greenlight an idea is a challenge. Black shared how he knows a show is ready to produce.

"Any writer will tell you their stuff is never ready and it's true; you can rewrite something endlessly. The trick is that at some point you have to divorce yourself from the rewriting process and say 'we're ready to go'," said Black. "A deadline can help with that! We knew we wanted to launch Goodnight Burbank 2.0 in September (of 2010) so we had to go into production in July."

Just as important as when to launch a project is knowing when to kill it or set it aside for awhile. Black makes sure his shows run their natural course and go out strong (as opposed to a whimpering death like many network programs).

"If it's not firing properly. If it's missing a bunch of things and they're not coming. You don't have to pull the plug completely—just put it aside and start working on something else. You can always go back to it when you have that 'eureka' moment," said Black.

The true measure of a successful career is to learn from every idea and each production (whether a hit or a flop). Black says that while he learns from his mistakes, he doesn't dwell on them. Making creative web video takes innovation and risk.

"Would I change anything I've done in regards to web video? Sure! But I use those lessons on new projects and don't waste time bemoaning what I've f*cked up on. Well, not much time."

ESSENTIAL PREPRODUCTION

There's one thing we've learned in our years of making video—without a plan, you're likely to fail. Despite this hard reality, many people often do everything they can to avoid preproduction. Most creative types would rather get their hands on a video camera or a nonlinear edit system than sit down and do paperwork, budgeting, or risk analysis.

We're right there with you. We enjoy the act of creation as well. But proper preproduction brings an increased likelihood of financial and professional success—two things that you will need if you'd like to survive in the world of video production. In this chapter, we'll focus on practical advice and techniques that are easy to implement.

We know you want to rush into the act of creation. Think of this as the courtship stage. You're going to find your good idea, make a great plan, and then achieve success.

Determining Production Needs

The greatest challenge in creating a good web video is the planning it takes to get the show out of the "big idea" stage and into production. Web videos and podcast series can be amorphous; you'll face several challenges as you try to pin down what a show is about and how to pull it off.

Matters are made worse by the relatively level playing field. After all, producing a hit show is within the reach of a first-time podcaster or web video producer. Combine this anticipation with the mandate to succeed that clients often demand, and you've got a giant hairball.

The Work Breakdown Structure

Our advice is simple: divide and conquer. No, we're not talking about barbarian hordes or cellular reproduction. Rather we mean good old project management. The easiest way to determine how to produce your show is to divide it into smaller parts. We often find that a web video series is easier to plan for when we first take the time to identify all of the elements that are going into it.

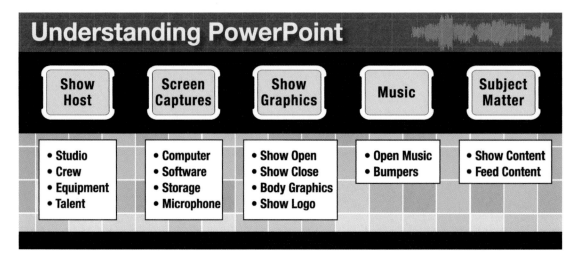

For example, let's take a look at a potential new video series we are developing to teach Microsoft PowerPoint. In this case, there are five general things an audience member will experience. These include the following:

- A show host who keeps the viewer interested and gives the show its personality
- The screen captures that show the software application being used
- Show graphics that provide brand identity
- Music that helps create mood and pacing

- Compelling subject matter that must be developed through scripting or outlining

As you can see in the figure, each element needed can be further refined into a more detailed list of ingredients or tangible items. By continuing to identify and specify, you can eventually develop an accurate list of requirements and items that will allow you to develop a budget and schedule.

This process of dividing a project into smaller pieces is called a work breakdown structure (WBS). A WBS analysis works well for both budgeting and project planning.

Let's revisit the food analogy. What you would do if you had to cook a 10-course meal? How much would it cost? How would you plan for it? The first step would be to identify what the 10 courses were. Next you would identify the ingredients for the 10 courses. This would give you a much better idea of what that 10-course meal would cost and how long it would take to prepare. The work breakdown structure is relatively simple to use and implement. We strongly recommend making it part of your budgeting process.

Determining Proper Crew Size

For most web videos we've produced, our budgets allowed for crews as large as five. The flip side is that we've had web videos where we've done it all with a crew of one (and if it were possible, the client would have requested a robotic camera). Our web video crews usually include two or three media professionals (we try to have one more crewperson than we do cameras on set).

A member of a three-person crew focuses on his or her respective tasks. Each camera has an operator, and a dedicated audio engineer tries to control the audio from three microphones in a very noisy room for a webcast.

The Risks of a One-Man Band

If you try to run with a "one-man-band" approach, you'll likely miss critical action. Be sure to staff appropriately for your shoots.

Thanks to shrinking budgets, we are asked to send out one-person crews all the time. Believe us, we've tried it (after all, you can't say you don't like Brussels sprouts if you've never eaten them). What we've found out is that it's a terrible idea to shoot alone. So many things can go wrong that if you're by yourself it is impossible to get the job done.

Consider the issues a single-person crew would face:

- Who will watch the gear if you have to unload and then park?
- If you do have to fly somewhere for a shoot, excess baggage charges are often more than a second ticket.
- During the course of a shoot, how will you handle basic biological needs like food and restroom breaks? Walk away and leave your gear unattended and it will likely not be in the same condition when you come back.
- If you blow a circuit breaker or have talent go missing, the second crewperson can resolve the issue.
- With a one-person crew, if that person gets sick or injured, the shoot is over.

So even if it just means hiring a warm body that's not going to steal from you, do so. We'll contact local grip houses, universities, or in a pinch use Craigslist. Spend the $125 and get somebody to be a babysitter of your gear and a gopher for the many needs that arise on set.

Our standard approach is this: We try to use a three-person crew. We send two people from our office and hire one person locally. The local person will usually show up with things like lights and grip gear (which are affordable to rent locally). Our crew shows up with audio and camera equipment, which we know works and we're familiar with.

Depending on the style of video projects you normally work on, this size crew may strike you as normal or woefully under-staffed. What it really comes down to is having the right people and equipment in the field. Multitalented crews are essential; you will need individuals that are comfortable shooting, lighting, and recording audio.

Instead of saving money by cutting crew, try to look at other costs. Can you save money on travel expenses? We often look for liberal baggage policies and flexibility for schedule changes. By cutting costs on travel, we can usually preserve crew size (and hence quality and sanity). We also consider the extra time that will likely be spent editing and fixing problem footage. Cut things too close, and you will bleed.

Performing a Site Survey

Video professionals know the worst situation is to go into a shoot blind. If at all possible, you want to go and look at the location you'll be shooting in before the shoot. Ideally this will be soon enough that you have time to refine and adjust your plans based on what you've seen. By visiting the locations you plan to use during your project before the day of shooting, you can dodge potential problems.

As you visit your potential shoot locations, try to view them with both a technical and a creative eye. Think about problems that may arise and gear you'll need. You'll also want to look for great shooting angles and attractive locations that will improve the quality of your video.

We bring a few key pieces of gear on our site surveys:

- **Digital camera.** Bring along a still or small video camera. You'll want to document important information about the location. You also may choose to capture shots that let you experiment with camera angles and potential shooting locations.
- **Digital audio recorder.** We'll bring an audio recorder on set to capture the sound of the location. This helps analyze potential sound problems. It can also be used to record discussions on the survey or to take notes. We find that our smart phone's voice recorder works fine for both tasks.
- **An Internet-connected device.** Questions are going to come up while shooting. You may also need to look up a contact or check project details.
- **Compass and SunPath calculator.** When shooting video, you're going to deal with the sun. A compass will help you keep your bearings and know if the sun is going to ruin your shot or help it. A SunPath calculator application can be loaded on your phone and allow you to look up where (and when) the sun will be for your shooting location.
- **Circuit tester.** A simple circuit tester from any hardware store is a key item as you plan your lighting. You'll want to know if outlets actually work whether or not they are grounded.

Don't Skip the Site Survey

The site survey is a big step toward forming a shooting plan. You need to be prepared to answer questions from all your crewmembers. It's a big waste of time and money to just keep people standing around. Remember, just doing a web search won't cut it. You can't rely on secondhand reports to truly tell you what you can expect.

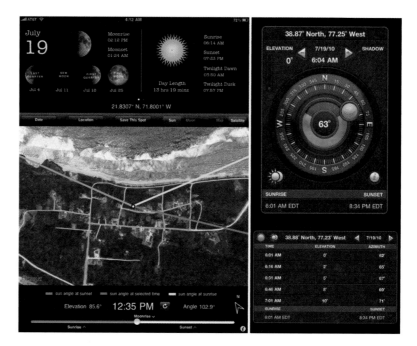

We find LightTrac for iPad *(left)* to be incredibly useful for understanding where the sun will be throughout an outdoor shoot. If you're an iPhone or iPod Touch user, then look at Focalware *(right)* for a smaller but still useful toolset.

Site Survey Checklist

When you visit your shooting location, try to accomplish these tasks before you call it a day.

Indoor

- ☑ Find the main power box or circuit breaker.
- ☑ Locate the building engineer.
- ☑ Examine fuses and identify maximum load for circuits.
- ☑ Check if wall sockets are grounded.
- ☑ Check wall outlets with circuit testers.
- ☑ Determine cable runs and the number of extension cords needed.

Outdoor

- ☑ Determine the sun path for given shoot day.
- ☑ Identify sunrise, twilight, dusk, and sunset.

Sound

- ☑ Listen for extraneous sounds that may be present on shoot day.
- ☑ Record room tone for analysis.
- ☑ Determine if you have control over the HVAC system.
- ☑ Evaluate control via scheduling time of day.

Logistics

- ☑ Determine where you park production vehicles.
- ☑ Determine where gear will be staged.
- ☑ Identify bathrooms.
- ☑ Identify food or craft services options.
- ☑ Determine if any additional permissions are needed.
- ☑ Determine the schedule for access to the location.

Creative

- ☑ Perform basic blocking of camera positions.
- ☑ Create a basic lighting plan.
- ☑ Identify the additional props needed.
- ☑ Document basic shooting order and schedule.

Picking an Acquisition Format

Choosing the right acquisition format involves balancing several factors. You need to examine the equipment you already own and measure against the benefits of new formats. This is an issue we explore more deeply when we look at cameras in Chapter 5.

We have encountered a lot of production companies and clients who are confused about high-definition (HD) video and the web. There are several pros and cons to using HD for web production, and we encourage you to consider both when you make a decision. We say make sure that you have a compelling reason to shoot HD.

The Benefits of HD

First, you should have some other purpose for the acquired footage, such as it will be distributed via Apple TV, TiVo HD, or as HD content on YouTube. It might also be that you intend to use the video files with a traditional video project that is being shot in high definition.

Ask yourself, does the content need to be preserved for an HD future? In other words, is the subject matter timeless or significant enough that there is value in spending the extra money to ensure that the footage can be used in an HD workflow for future projects or delivery? HD acquisition is considered "future proof," whereas standard definition cameras shoot legacy formats.

There is an increased demand for HD content. Many websites spotlight HD content (as it's rarer than lower-quality, user-generated content). There is also increased demand as many consumers are bringing HD web video into their living rooms with TiVo HD, Apple TV, Microsoft XBOX, and Sony PlayStation devices.

This professional P2 camera from Panasonic can shoot several flavors of HD at progressive frame rates (which work best for web productions).

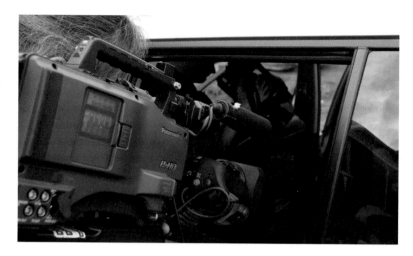

You'll also find that HD cameras tend to be much more flexible. These cameras often shoot direct to hard drive or have removable memory, which makes the files easier to load and edit. The HD spec also supports progressive frame rates (such as 24p). These frames avoid the traditional interlaced signal of older video cameras, which makes for a cleaner image on computer monitors, portable media players, and cell phones.

The Drawbacks of HD

Choosing a high-definition workflow can involve potential cost increases. You may need to invest in additional editing equipment. HD video needs more storage and more processing power for your computer. Do you have an HD monitor so you can see your video at its native size?

You'll also find an increase in render times for video editing and motion graphics. When you choose to encode video for the web, you'll likely need to make several different sizes for multiple delivery devices. The HD video will take longer to encode here as well.

Also, don't forget about distribution. Are your consumers really willing to wait up to eight times longer for the files to download? Are you prepared to pay more to host those files?

Make the Call

We can't tell you which method is right for your program. We can say that we're choosing to shoot in HD about 65% of the time (and this number has been steadily increasing). Standard definition acquisition is most common for our live streaming or live-switched events. In this case, the extra resolution is often overkill.

Don't be discouraged; just be sure that you can afford to give people what they want and that they are willing to wait for that larger size. Some producers take the "easy" way out and offer multiple sizes. Many video-sharing sites will even do this for you. For example, if you upload HD video to YouTube or Vimeo, those sites will encode additional sizes for delivery to smaller screens or through slower connections.

Mapping the Production

Although it may seem counterintuitive, spending money on crew and the right equipment can save you money in the long run. We're not talking about a craft services table with lobster bisque and imported beer; rather we mean having the right gear and a multitalented crew.

The mantra of "fix it in post" should rarely be heard on a web video set. We have found that relying on the "fix it later" philosophy can consume up to three or four times the cost of taking the time to make adjustments during field production.

The guiding principle here is that you never want to miss an opportunity to capture content because you didn't have the right gear or crew. This may sound contradictory to the electronic

news gathering (ENG) comments made earlier, but it's not. What we are emphasizing is the need to balance the size of your crew and equipment so they are fully utilized without being pushed to the point of breaking.

Planning for Multiple Shows

For MommyCast, the hosts prepare multiple interviews for a single day. This works best for their schedules and helps control costs.

It's a very good idea to determine your rollout plan early on. Remember, podcasts and many web videos are serialized, which means that there is some sort of plan for when they come out. Will you release new episodes daily, weekly, monthly, bimonthly, biweekly, on an emergency basis as needed, when inspiration hits? Whatever the decision, it's important that you determine what the schedule is going to be and that the client agrees.

The frequency of release is one of the greatest impacts on financial cost. Another way to contain costs is to shoot multiple episodes at a time. It takes a lot of effort to get all of the gear, crew, and talent in one location. Try to record a few episodes at a time so you can save time and money.

Maximizing the Day

We typically build our production days around a 10-hour schedule. This allows about 7 hours of time for shooting, and the other 3 hours are used for setup, breaks, and teardown. The important thing here is to pace yourself. Make sure you know what you want to accomplish each hour you're on set so you can measure progress or take corrective action.

A clapboard can help keep your shots organized during a busy shoot day. It's also a great way to synchronize multiple camera angles with an audio cue.

Although we try to maximize the day, we don't try to kill the crew. There's a difference:

- **Make sure you have enough help to load gear in and out so you get off to a good start.** For that matter, be sure to use a rolling cart to cut down on wear and tear on your body and speed up moving times between locations.
- **Be sure to allow time for meal breaks.** Keeping people from eating will only make them cranky and less productive. Try to bring some snacks and drinks on the set to keep people comfortable and from wandering off.
- **Keep the schedule reasonable.** We try to not to let the client schedule the first interview for 8 a.m. We've often had to convey to the client, "If you schedule this for 8 a.m., it means we have to leave our houses at 4:30 a.m. in order to have everything set up on time."
- **We routinely have to remind clients that an eight-hour day does not mean eight hours of interviews.** We also have to point out that it is a contiguous eight hours. You can't schedule a crew

Lessons Learned

A big part of budgeting is time estimation—how long will this take me to do this? One of the best sources of information is to look at time records from earlier projects. Learn from your mistakes by looking at your past budgets and time logs.

to start at 9 a.m., then give them a five-hour break in the middle of the day, and want them tape something that goes until 10 at night.

- **Be sure to work with your clients and gently educate them.** Sometimes we've had to say, "Yes, we can do this. But we're going to have two crews and we're going to have a changeover period here and the second crew will step onto the set and continue into the night." Be smart: Respect your clients and your crew if you want the best results.

Maximizing Locations

Every time you move equipment, you will lose at least 30 minutes (if not much more). It takes time to cool the lights down (move them hot and the bulbs will break). You also need to gather up everything, load it onto a cart, get to the next location, and set it all up again.

We try to design our lighting setups before we shoot to speed up production time. OmniGraffle is used here to create a diagram for the set.

You want to minimize crew movement unless it is essential. We have four techniques for maximizing shoot time when locations are involved:

- **Look for locations that can easily provide multiple shooting opportunities.** When selecting a practical location, we try for one where small changes in the camera placement or framing result in a new look.
- **If we are creating a set, we often just change the color of the backdrop, which can quickly result in a new look.**
- **If we have to move, then we try to bring one extra crewperson and a few lights.** This person can go to the next location and start to set up lights (usually the slowest part of moving).
- **Shooting green screen is also an option.** We'll often shoot multiple interviews on the same green screen. We'll then go out and shoot multiple video background plates that we can

key behind the subject. Be sure you frame these shots with the camera at the same height. You'll also want these plates to be slightly out of focus to create the appropriate depth of field.

Multicamera Coverage

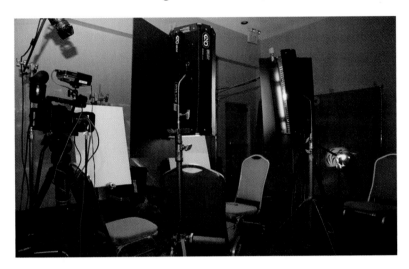

It is becoming increasingly common to shoot web videos with two or three cameras. This is possible because the cost of quality video cameras has plummeted in recent years. The reason for multicamera shooting is largely to make postproduction tasks like editing significantly easier.

Many nonlinear editing systems, including those by Adobe, Apple, Avid, and Sony, offer multicamera editing. By shooting a web video from multiple angles in real time, you have options during the edit. This works especially well for subjects like concerts, theatrical performances, hosted interviews, and how-to demonstrations. We'll explore this style of productions in more detail throughout the book.

Tapeless Acquisition

We have found that shooting direct-to-disk can be a big timesaver. This can be as simple as adding a special hard drive unit to your FireWire-based camera or switching to new formats like Sony's XDCAM or Panasonic's P2. Shooting tapeless can save time on the postproduction side. It also allows for instant playback of a take when in the field. We often use it as a way to quickly drop a shot into a nonlinear editing application so we can check audio levels or try a color grading or compositing task.

Units such as this FireStore allow for a DV camera to record to both tape and hard drive at the same time. These save a lot of time for the postproduction stages of the project.

Essential Planning Documents

Documents (like this call sheet) smooth out potential bumps in the road for your web video productions.

We know that you're itching to start shooting, so we'll keep our comments brief. Successful web videos rarely just happen. You've logged a lot of hours developing, refining, and planning a production. Wouldn't it be a real shame if everything fell apart as soon as you rolled cameras?

We offer some final preproduction advice. Here are three documents you need to use for successful web video projects. You can download templates for each from the book's website at www.hypersyndicate.com. The documents will save you time and money—two things we can all use more of.

Send the Crew PDF Files

We've learned the hard way that your crew or client might not have the same software. Instead of sending native Microsoft Office or Apple iWork files, send PDF files. This makes it easier for others to open the documents and can avoid any formatting errors caused by missing fonts.

Shot List

We highly recommend making a shot list ahead of time, as it can serve as a checklist during the shoot. You'll want to give some thought ahead of time and plan out coverage for your web video. What supporting footage (called b-roll) do you need to tell your story? Do you need multiple angles to properly document your technical demonstration?

We generally fill this information into a spreadsheet. Using a program like Microsoft Excel or Apple Numbers makes it easy to sort and sift information based on the contents of the list. Both programs help keep your shot list consistent and improve the speed at which you can build it.

Call Sheet

The call sheet serves as both a master schedule and a contact list for all the cast and crew for a video production. This single document has the most important logistical information

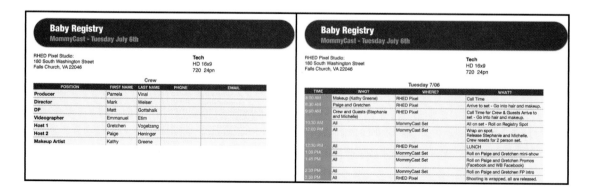

included, such as flight or travel information, addresses for each location, and multiple ways to contact key crew.

The call sheet also offers a detailed schedule for the shoot. It's important to have a detailed schedule on set so you can coordinate the arrival of clients and talent. It also can assist in keeping a project on budget because it lets the crew know how much time is allotted for each shot or scene.

Release Form

The final piece of essential paperwork is the talent release form. It is considered a good idea to obtain a release from each person who appears on camera. The form is your way of proving that the person appeared willingly and does not require additional compensation. There is no such thing as a standard release form, because legal requirements can vary from state to state or country by country.

We try to avoid the all-encompassing forms that ask talent to release all future rights to their performance. Rather we favor a clear release form that states how the video will be used and in what context. We also point out that the talent will not have a say in how their image is used and that they will receive no additional compensation for their involvement. We recommend you look at the provided sample form and customize it to your needs. If you have access to a lawyer, it's a good idea to get your release forms looked at. Once you have your forms locked in, be sure to print out enough and load them onto a clipboard for your shoot.

Shooting at Large Events

 If you are taping at a large event (such as a concert), you'll want to explore inserting a general release into the event registration or ticket purchase process. This way you don't need to worry about capturing releases from all the people who appear on camera. However, you should still get the more detailed release signed for on-camera interviews.

We also recommend posting signs at the door. Use language like this to alert people that you are taping. "By entering this facility, you grant [production company name] the right to film, videotape, or photograph you at this location for any reason without payment or consideration."

PRO*file*: Culture Catch

Culture Catch is a smart culture community that was launched in July 2005. Based in New York City, the company was founded by Richard Burns and Dusty Wright. While Culture Catch (*www.CultureCatch.com*) is a well-known web video series, the company also produces various live events that let their members interact. There are over 1 million people that visit the CC Website, attend its live events around the world, download its audio and video content, and engage with the community.

Culture Catch currently shoots two video episodes per week. The show has conducted interviews with cultural notables like David Lynch, Wynton Marsalis, Laura Dern, Richard Branson, Duncan Sheik, Henry Rollins, Bob Costas, Les Paul, Russell Simmons, Donovan, Gore Vidal, Kevin Bacon, and many more, all of which are available on the site, or on iTunes.

Wright and Burns were drawn to podcasting after multiple attempts to launch similar shows via traditional broadcasting avenues.

"We got tired of all the gatekeepers in conventional media telling us that our show ideas were too smart, or too long, or expensive, or not the right fit," said Wright. "Podcasting is so liberating on so many levels. It's refreshing to meet so many

different folks creating niche programming and really burning with the passion to produce it."

Burns added that web video lets him focus more on the creative aspects of filmmaking that he enjoys so much.

"As a filmmaker, when a project ended so did your employment. I was spending 90% of my time looking for

work or money to create films and 10% creating films, which seemed very stupid," said Burns. "Now I spend 75% of my time creating and 25% on the business of podcasting. Much better ratio for an artist."

Podcasting and web video have become a full-time job for both Wright and Burns. Their show, website, and events attract enough interest and sponsorship that they can focus on Culture Catch.

"This is my fulltime gig and I love it," said Wright. "It has allowed me to streamline my productions, too. I think about our shoots like a field reporter. I carry just the bare essentials unless we're really looking for some serious production value and then we might bring in a third cameraperson. But normally we look at each interview situation and determine how we want to shoot it before we hit record."

Culture Catch regularly shoots with two cameras. This gives Burns more flexibility when he edits the podcasts. Both Wright and Burns fill multiple technical and creative roles during shoots.

"A low budget production like a podcast requires the podcaster to wear all hats (or at least many)," said Burns. "In my case, that's audio, video, grip, director, editor, production manager, craft services, director of photography, make-up, etc. Thus, prepare and accept that you'll make some really stupid mistakes."

Wright emphasized the need to assume the worst and constantly check for problems.

"I once interviewed Daniel Lanois and didn't check my audio levels before I started the interview," said Wright. "I had a bad cable. I couldn't use any of it. I wasted one of

© 2007 Susan J Weiand

the greatest interviews I've ever conducted. He talked about producing U2 and Dylan and Emmylou Harris. It makes me sick to think that I didn't take the extra few minutes to check things out."

Burns agreed with Wright's warning.

"Always check audio and picture before recording. What you see and hear on the camera monitor isn't always what you are recording," said Burns.

Both Wright and Burns emphasized that being passionate is the key to succeeding at webcasting.

"Dare to be different. Dare to push the creative envelope," said Wright. "Don't let others tell you that you're wasting your time. If you feel your niche content can reach 60,000 other like-minded individuals, then go for it. If you're looking to reach the masses, it's possible you might. Grab your camera and mic and go… you'll know soon enough if it's working or not. And if it's not, tweak it until it is."

"The industry needs more personal voices and experts," said Burns. "Make your show very personal and niche. Big networks can't do that kind of programming. They are about broadcasting to a wide variety of people. Podcasting is about reaching a specific audience, owning the audience and developing a business model that services that audience."

Gear List

- Two Sony 950 3-CCD Mini DV cameras
- Two Sony EL 77B lavaliere microphones
- Four EV mics (1 RE635, 1 RE50ND, 2 RE16s)
- Two Shure (Beta 58s) mics
- Three Element Labs LED lights (brilliant lights, don't get hot, don't burn out, can use a remote to program color correction, etc.)

3

AUDIO IS HALF YOUR PROGRAM

You may be wondering why we start our discussion of web video by talking about audio. That's easy. If you have good audio, people can still listen to your video (even if the video quality isn't great). On the other hand, even if you have great visuals, people will stop watching if they can't understand what's being said.

Video professionals often say that audio is more than half your picture, and that is true on many levels. If you dispute this statement, try this: the next time you are watching TV, turn down the audio and see how much of your favorite program you understand. Then turn the audio up and close your eyes. You will most likely understand much more when you can hear what is happening versus when you can only see what is happening.

Great productions need great sound. Two mics are used to capture audio in this scene, a boom mic overhead and a lapel microphone on the interviewee.

The Limitations of Web Audio

The problem with audio on the web is that it suffers from a long chain-reaction effect. Web video producers often cut corners, such as using low-quality microphones or not hiring a dedicated audio person. Then video editors, many who don't know how to use filters to improve their audio, edit the material.

Of course, things get worse, because the video has to be smashed down for web delivery. It's common practice to throw away 99% of the file size in order to stream video over the web. Audio, of course, suffers. Making things worse is that people are using low-quality speakers or even built-in speakers for playback on their computers. Although those using portable media players may have decent headphones, they're often watching in noise-polluted environments like public transportation, airplanes, or crowded rooms.

Seems like a recipe for failure doesn't it? The solution is to start with the cleanest, highest-quality audio signal you can get. Great audio will compress well and sound significantly better under challenging situations.

Capturing Good Audio

Recording high-quality audio is essential for web video. When shooting video, people have a tendency to spend the entire effort focusing on the images and leave little time or resources dedicated to ensuring that good audio is recorded.

This is a mistake that many come to regret once they start the editing process. Despite how good your video looks, in the end if your audio is bad, the whole production will come off as amateurish and fail to retain the viewers you worked so hard to attract.

Essential Equipment

Odds are that the camera you are using to record your web video has a built-in microphone. Although using the onboard camera mic works well when you are shooting run-and-gun style

in the field, the audio quality of what you are recording is most likely poor. This is largely due to the quality of the microphone and the distance of the microphone from the audio source.

When recording web videos, you should use one or more professional-quality microphones. One thing you will need to understand about professional mics is that different types of microphones have different pickup patterns or directionality. That is, the area from which the microphone is designed to record varies depending on the type of microphone you use.

Microphones that have an "omnidirectional" pattern pick up sound from all directions, and those that are "unidirectional" pick up sound from a specific direction. Unidirectional microphones are subcategorized based on their specific pickup pattern: cardioid (narrow), supercardioid (very narrow), and hypercardioid (extremely narrow).

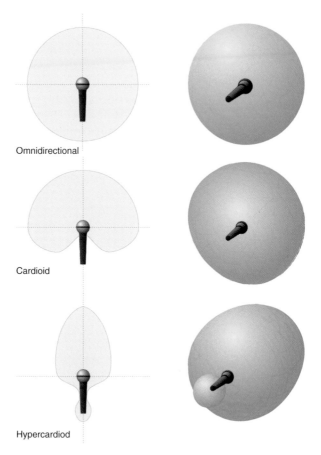

Omnidirectional

Cardioid

Hypercardiod

Lavalier

Keep a lavalier microphone within a few inches of a person's mouth for the best sound. A lavalier microphone (or lav) is the small microphone you often see attached to the lapel, tie, or blouse of news anchors. These small microphones are ideal for recording audio from a single individual during an interview or a presentation. The pickup pattern of a lav is generally omnidirectional, but because it is placed so close to the speaker's mouth, nominal background noise will generally be unnoticed once the levels are set on the recording device.

If you are using a lav mic and the interviewee is to be seated or is stationary during the taping, then running a cable (or hard wire) from the lav to the mixer or camera doesn't present a problem. However, if you are taping a presenter who is moving around, you will want to attach your lav to a wireless transmitter. This will convert the audio signal into radio waves on a specific frequency that are then collected by a receiver attached either to the mixer or directly to the camera.

When attaching a lav mic, you will want to keep a few things in mind:

- Place the mic about 12 inches below the person's mouth, and try to keep the mic as close to the center of the person's body as possible.
- If you are going to try to hide the microphone inside of the person's clothing, you will need to do it so that the mic does not rub against the person's body or clothes. This is tricky and usually requires some practice and the use of some strategically placed gaffer tape. Be sure to listen closely when monitoring the audio to ensure you are not recording rubbing sounds.
- Even if you are not concerned about hiding the mic, you should be sure to run the cable inside of the person's jacket or shirt so there is no unsightly cord running down the talent's chest when you switch to wide shot.

Shotgun

Shotgun microphones are typically attached to either a camera or a boom/fish pole. A shotgun mic is ideal when a talent is moving while talking. The pickup pattern of a shotgun mic is unidirectional and ranges from cardioid to hypercardioid, depending on the specific model of the microphone.

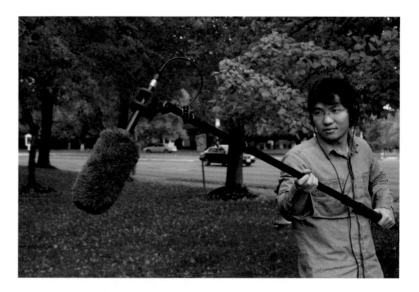

Although a shotgun mic can be used for recording stationary interviews, it is most useful when carried by a boom operator who positions the microphone as close to the talent as possible while keeping it just outside the camera's frame.

While this sounds simple, it requires a person with good coordination who can focus on the action and withstand the physical challenges of holding an extended pole above the talent for long periods of time. Often shotguns are used instead of or in conjunction with a lav mic during stationary interviews. Ideally you would use a stand with a boom holder in these situations.

Here are some other things to keep in mind when using a shotgun mic:

- Although a shotgun mic is great for recording sound from a particular person, it can pick up unwanted sound. When other noise is present, remember that anything inside of the pickup pattern of the mic will also be recorded.
- When using a shotgun mic on a camera, the audio from whomever you are shooting will be recorded along with whatever noise there is behind the person you are shooting. On lower-quality cameras, the mic may also pick up the sound of the camera running (such as tape moving through the camera). This is why it is a good idea to have a boom operator who places the mic above the talent with the mic pointed at the ground. This way the talent's voice will be in the pickup pattern and that pattern then continues straight to the ground (where substantial background noise is less likely).
- Shotgun mics are very susceptible to wind noise. Be sure to attach a blimp or fuzzy to the mic when recording outdoors. These can be purchased from the same store that the microphone comes from.

Røde makes affordable shotgun microphones that can run on 9-volt batteries.

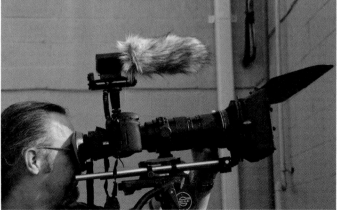

Wireless Microphones

A wireless microphone goes a long, long way toward a flexible production. This setup also makes it easier for a small or one-person crew where the camera operator is also running audio. It's much easier to work with moving talent than to have to chase after them with cables connecting you—less tripping and more recording.

Three wireless receivers are in use, one per actor. A boom microphone is also in use as a safety.
Photos courtesy of the National Foundation for Credit Counseling, www.DebtAdvice.org.

There is potential of radio interference when working with wireless microphones, so be sure to get a unit that offers the ability to use different frequencies. Most kits include a lavaliere microphone, an XLR adapter for other microphones, and a wireless receiver to plug into the camera.

You need to be aware of a recent development regarding the use of wireless RF microphones. As of June 12, 2010, the Federal Communications Commission (FCC) has made it illegal to use any equipment that operates in the 700 MHz band. This set of frequencies has been reassigned for use by emergency personnel only. Many wireless mics previously on the market operated in this frequency range and must be replaced. More information about this ruling can be found on the FCC website at www.fcc.gov/cgb/wirelessmicrophones.

Be certain to actively monitor your audio with headphones. Besides interference, there are a few common problems. One is that batteries can wear out, which can introduce dropouts and noise. The most common problem, though, is human error. With two off switches (one on the microphone and one on the receiver), it's easy to leave the microphone turned off. Remember, you plug into the camera and listen to what the camera is recording to know you are getting good audio.

Cables

The next step in successfully recording good audio is to hook your mics up to your mixer or recording device. To do so, you will need the proper cables. Just as a chain is only as strong as its weakest link, your audio recording system is only as good as its cables. Be sure to buy professional-grade cables with the proper connectors (this doesn't necessarily mean the most expensive ones in the fancy packaging).

Most audio cables come with one of four types of connectors: mini, phono, RCA, and XLR. The first three are considered unbalanced connections, whereas the XLR is a balanced connection. You will need a balanced connection if your cable run is going to exceed more than 20 feet.

Most lower-end camcorders will have unbalanced audio inputs, whereas more expensive cameras will be equipped with balanced audio connections. Be sure to check out the particular audio connections of the equipment you are using and make sure you have the proper cables and adaptors. We'll explore camera connections in the next chapter.

Professional XLR audio cables are essential.

Multichannel Mixers

If you are using multiple microphones on your shoot, you will want to use a field audio mixer to combine your audio sources into one or two channels, which is probably all that your camera is capable of recording (some newer HD cameras can record four channels of audio). A mixer will also boost your audio from mic level, which is a relatively weak audio signal, to line level, which is capable of traveling greater distances.

Most portable field mixers will allow you to combine between two and four audio sources. Many of these mixers have visible VU meters that will allow you to visually monitor the strength of the audio signal and if necessary increase or decrease the signal to optimum recording levels. If you are taping something like a panel discussion with more than four sources of audio, you will need a mixer capable of handling as many as 24 channels. These mixers are not portable (in that you can't carry them on your person), but they can easily be set up in a location such as a hotel ballroom. Although not required, the use of a mixer allows you a lot of control.

Field Interviews with a Stick Microphone

A lot of web videos use the "roving reporter" style of interview where the host holds a "stick" microphone and points it toward the interviewee. This style of web video is reminiscent of field reporting in broadcast news. So let's take a few pointers from our television friends:

- If your show has a graphic identity, carry it forward by placing your show logo on the microphone. Broadcasters often have microphone flags bearing the logo right on the mic. A quick web search will give you several choices. We usually get ours from www.markertek.com; simply print the logo out onto glossy adhesive, and carefully cut it out with a X-Acto knife and mount it. If you're doing a man-on-the-street video, strongly consider having one. That little piece of plastic has gotten us taken more seriously, more quickly, because people think, "Oh, this is going to be on television."

- Be careful with your microphone position. Common mistakes we see are interviewers shoving a microphone up someone's nose because they've never done an interview before. The proper distance is that from an extended thumb to an extended pinky finger on your hand (around 10 inches).

- Joking aside, it's like you are sharing an ice cream cone. You take a lick. The interviewee takes a lick. Repeat. You can learn how to hold a microphone by watching broadcast television news.

- Don't lose yourself in the moment. We often see inexperienced interviewers who remember to hold out the microphone for the first time but then continue to hold it by their own mouth for subsequent questions. It's important that the cameraperson (or audio person if you have one) is paying attention. Make sure someone on the crew is wearing good headphones and can clearly hear the sound that is being recorded.

In most cases, if you are shooting a web video you will also be recording your audio on the camera. Most camcorders and prosumer video cameras will allow you to record two channels of audio. Therefore, you can use the second channel as a safety. Some people choose to put the shotgun microphone here. Others recommend feeding the mixer's audio, but recording it at a slightly lower volume in case your subjects suddenly talk louder. This will let you avoid microphone clipping at a loud volume.

The final benefit of a mixer is consistency. You can feed audio with good levels and signal strength into a camera that lacks XLR audio connections. You can also loop the audio into multiple cameras if you have a multicamera shoot.

External Audio Recorder

This small audio recorder from Tascam can be discretely hidden near your subject for cleaner audio.

A great way to record audio in problem situations is to use an external audio recorder. Popular manufacturers include Zoom, Tascam, and M-Audio. These hard drive or removable media units can record audio at even higher-quality rates than top professional cameras.

Here's when we turn to them:

- As a backup recording device, when we know audio is going to be a challenge.
- On multicamera shoots of long performances (such as concerts or plays). This way you have a reference audio source for the entire production that stays at a consistent volume.
- When using cameras that lack professional audio inputs (such as HDSLR cameras from Canon or Nikon).

These units can run for a very long time. Some can even power microphones through phantom power. Although these units can run on battery, we recommend picking up an external power supply. Nothing ruins a recording like the battery running out and corrupting all your files.

Sync Sound Workflow

The folks at Singular Software offer some great tools that make it easy to sync video and audio (www.singularsoftware.com). Whether you're recording to an external audio recorder or have multiple cameras to sync, they have you covered. PluralEyes is a plug-in available for Final Cut Pro, Premiere Pro, and Vegas Pro. They also offer a standalone product for syncing video and audio clips called DualEyes.

What about Flip Cameras and Smart Phones?

Sure, we'll admit that it's convenient to have an HD camera in your pocket. Especially with a long-lasting battery and no need for tape. We own an iPhone and a Droid, and we regularly use them for cute video of the kids and cool little insert shots.

© Piotr Marcinski—Fotolia.com.

But we stop there.

Why? Because the audio from these cameras is beyond terrible. It's impossible to record good sound through a pinhole microphone that's 30 feet away from your subject. We've seen more than our share of videos made with these cameras, and the black mark on them is clear to hear.

If you have to use one of these cameras, consider either of these methods to get good sound:

- **Use a second video camera with real microphone inputs.** You can then use a handclap or other sound to synchronize the two sources.
- **Use a dedicated audio recorder.** There are many solid-state or card-based recorders that can be placed near (or even worn) by your subject. Just synchronize during editing.
- **Don't use the audio.** Just use these tiny cameras for extra footage that you cut into another production.

Headphones

Perhaps the single most important thing you can do while recording a web video is to be sure someone on the crew is wearing a good set of headphones. Using over-the-ear (earmuff) style headphones is very important (especially if you have to be your own sound person).

Over-the-ear headphones help isolate the audio you're monitoring.

You'll plug these headphones directly into the camera to monitor the audio being recorded. Be sure to listen if the audio gets too loud or too soft, as both will cause problems (over-modulation and hiss, to be specific).

We often favor noise-canceling headsets, as they make it easier to hear your sound. We know that some audio purists say they're a bad idea, but we find that the noise-canceling models are just cleaner. We've used models from Skullcandy, Bose, and Able Planet. They are all nice options that let you actually hear what you're recording.

Common Errors

Remember, it is much easier to add additional sounds to what you've recorded than it is to remove unwanted sound. So if the kid across the street starts to mow his lawn during the middle of your shoot, you may want to try greasing his palm with a twenty rather than going with the assumption that you can use a filter to remove this sound during postproduction. Besides making bad assumptions, here are a few more things to look out for.

Mic/Line Level

If you're plugging microphones into a professional camera, you are usually presented with a switch labeled "mic/line." If you are running your microphones through a mixer, you generally set it to line level. If the microphones are going directly to the camera, you set it to mic level. What is important here is testing. If your switches have been set incorrectly, you will likely get distorted audio that can be unusable. Be sure to check both ends of the cable (that is to say, the mixer and the camera).

© Pavel Losevsky—Fotolia.com.

Dead Batteries

Many microphones and mixers require power sources. A battery is the most likely power source. These might be AA, AAA, or watch battery style. Whichever your microphone or mixer uses, have extra (lots of extra) batteries. On nearly every shoot we've ever had, the field mixer burns through a battery. Also, the microphones seem to cut out at the least convenient time. If you are using wireless equipment, you'll go through batteries even faster. Investing in a spare package of batteries is much cheaper than delaying your shoot or missing a shot. We keep a compartment just for batteries and make sure it is refilled every time before leaving our shop for a shoot.

© milosluz—Fotolia.com.

Mic Placement

Microphones are great, but only if you use them correctly. Be sure you know the pickup patterns of your microphones, and then position them to capture the speaker. Another common mistake we see is forgetting how people may move on a set. For example, a person doing a technical demonstration may need to look over his or her right shoulder. If the mic is on the left shoulder, things are going to get pretty quiet. When placing microphones, always think about the likely movement of your subject and the pickup capabilities on the mic.

This mixture of audio, video, and power cables can cause signal interference and ruin your audio track.

© Pavel Losevsky—Fotolia.com.

Crossing Wires

Wise men were right to say, "Don't cross the streams." When microphone cables cross power cables, you can get a lot of electromagnetic hum. Audio cables can be shielded to help minimize this, but it's a good idea to run your audio cables so they do not cross or tangle with other equipment cables. In fact, be sure to tape things down, both for safety and to prevent cables from getting mixed throughout the production.

Other Audio to Acquire

While we've focused on recording great audio in the field or studio, there are still a few audio sources left to consider. Not every production will need more sound than you capture during your principal shoot. But many others may need a little enhancement.

Narration

Whether you're making a new report, documentary, or how-to video, the use of a narrator is common practice. Even videos that are primarily driven by sound bites may need a narration bridge to fill in gaps.

The script is often written in conjunction or after the edit occurs. This approach allows for editing efficiency and ensures great synchronicity between picture and sound.

Some producers favor using professional narrators. For simplicity's sake, these fall into two categories: union and nonunion. The American Federation of Television and Radio Artists or the Screen Actors Guild usually represent union talent. Going this route ensures a wide range of talent, but it typically involves licensing fees based on your video's distribution path. The good news though is that fees are generally clear and well documented.

Other producers favor nonunion talent. This option typically does not require additional fees and can be secured with a buyout agreement. Several websites are available that allow you to audition possible talent and even set up your recording time and negotiate fees.

If you decide to use your own voice (or that of a friend or coworker), that's an option too. Be sure to pick

up a USB desk microphone. We're big fans of the microphones from Blue Microphones (www.bluemic.com) and Shure (www. shure.com). Consider plugging the microphone to a laptop and searching for a quiet room that's free from air conditioning and environmental noise. If you have to record into a desktop computer, get a long cable and move the mic as far away from the computer as possible. Be sure to wear headphones in either case to ensure you're hearing what you are recording.

Our Standard Audio Kit for Web Video Productions

2	Headphones		1	Breakaway XLR mic cable
1	Sound Devices two-channel mixer		2	10-Feet XLR cable
1	7-foot boom pole		2	20-Feet XLR cable
1	Sennheiser shotgun microphone with cover		6	Spare batteries
1	Shock mount (connected to pole)		1	Box of audio adapters
1	Mathews grip head		2	Tram lavaliere microphone set
1	Boom pole mounts		1	Zoom H4N digital recorder
3	Sennheiser wireless mic gear			

A professional USB microphone, like the Blue Yeti, makes recording high-quality narration possible.

Sound Effects

The proper use of sound effects can really enhance your video. No, we don't mean cartoon effects like in a *Tom and Jerry* episode. Rather, we're referring to environmental noises that help engage the viewers in what they're seeing. Consider the sound of the ocean crashing, the hum of traffic rushing by, or the wind blowing through the trees.

The good news is that sound effects are fairly easy to come by. If you're using Final Cut Pro or iMovie on a Mac, then you have an extensive sound library to draw on (with Soundtrack Pro and GarageBand, respectively). Adobe Creative Suite users can turn to the bundled Soundbooth application, which can connect to Resource Central for a large sound library. Of course, there are extensive sound effects libraries online where you can purchase individual sounds. You can even grab a digital audio recorder and give your own hand a try at gathering sound effects.

Music for Web Video

© SSilver—Fotolia.com.

When it comes to music, there are a lot of misperceptions. Let us tackle the biggest one head on. Just because you bought a CD or purchased a music track as a download does not mean you can edit your video to it. There are hundreds of misperceptions about fair use, student use, limited use, and more. Even if you do qualify under the very limited rights of fair use, you'll need to be prepared to defend yourself in a court of law. Our simplest advice is don't do it, there are many easier options available.

Want More on Sound?

Several excellent books and DVDs focus on sound techniques for video. Here are two we recommend:
- *Producing Great Sound for Film and Video* by Jay Rose
- *Now Hear This! Superior Sound for Digital Video* by Douglas Spotted Eagle and VASST

Licensed Music

There are extensive music library services designed for video producers. These companies make original music in a variety of styles. Fees vary greatly, but two principal methods exist. If you create a lot of web video, you can subscribe to a library with an annual fee (often only a few thousand dollars per year). Additionally, many libraries allow you to license individual tracks for one-time use for a fixed fee.

If you have your heart set on using popular music, then you need to get a license. You can try contacting the artist and label directly (and don't take a lack of a response as permission. A great overview of the process is available at www.clearance.com/get_yourself.htm.

Royalty-Free Music

Several music libraries and musicians make their music available royalty-free. It's important to note that royalty-free does not mean free. It just means that once you've bought it, you don't have to pay any additional royalties.

There are a ton of options out there, just do a web search based on "royalty-free music." We often buy themed CDs for about $100 that give us unlimited clearance to use the tracks on any video production. You'll also find download services that typically charge $20 to $65 per song.

Podsafe and Creative Commons Music

Many musicians do welcome the exposure of their music being used in web videos. A search for the term "podsafe music" will generate several hits. These artists typically allow their music to be used free of charge (as long as proper credit is given). This is one of the best ways to find high-quality music and find fresh-sounding tunes that aren't overplayed. Even some well-known artists have released their music in limited-use cases. Be sure to read the rights or disclaimers and make sure you follow them.

Loop-Based Music

Another option for music is loop-based composing. Many editing tools are available (and even come bundled with video editing tools). Be sure to explore options like Apple GarageBand or Soundtrack Pro, Adobe Soundbooth, and Sony Acid.

Sound Effects

Our favorite site for purchasing individual sound effects is Sounddogs (www .sounddogs.com). This site offers a huge library and royalty-free licensing. It also has a massive library of stock music and audio loops.

Stealing Is Bad

We're not kidding when we say don't use copyrighted music. Criminal penalties for first-time offenders can be as high as five years in prison and $250,000 in fines.

More on Copyright

For more information on fair use and copyright, see these resources:
- www.copyright.gov
- fairuse.stanford.edu/ Copyright_and_Fair_ Use_Overview
- mediaeducationlab .com/2-user-rights- section-107-music-video

One of our favorite sources for audio loops is Advanced Media Group (www .amguk.co.uk). This service offers several loops in many genres. We like its pro line too, which includes musical building blocks from Norman Cook (Fatboy Slim) and Vince Clarke (Yaz, Erasure).

These programs work by letting you browse a large collection of musical loops (such as drum beats, guitar riffs, and more). They can then be assembled, looped, and modified. This is an easy way to create custom music that is free from copyright.

Original Music

If you want to be 100% unique (as well as free from copyright issues), then record original music. This might be the time to revisit your musical talent. If not, you can also utilize the talents of a local musician. There are also many musicians who advertise their composing services online. Costs vary greatly, but we've purchased original music for affordable rates.

4

GREAT VIDEO NEEDS GREAT LIGHTING

The key to great-looking web video is an understanding of light. While we're not going to send you back to high school physics, you do need to know some basics about light so you can control it. The truth is that cameras are nowhere near as sensitive as your eyes, so it takes extra effort.

If you take the time to learn how to light a scene, you can capture great-looking footage (even with less-than-professional cameras). It might mean choosing a location with good natural light, bouncing the available light where you need it, or creating your own environment using lighting instruments.

When it comes to web video, we realize you likely don't have the same luxuries as a TV commercial or feature film. There's probably not a lighting director or gaffer hanging around. You're going to need to know how to do it yourself if you want your productions to look professional.

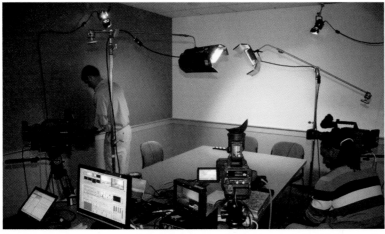

Only four lights were used to light this entire set. By getting the lights high toward the ceiling and shaping them with barn doors, a great deal of control was possible.

Lighting on a Deadline and Budget

When it comes to web video, you'll usually face constraints of both time and budget. Get too cheap with lighting, however, and the whole project will fall apart. If you shoot under poor lighting, your video will be grainy and possibly even out of focus.

Our solution is to work in more of an electronic news gathering (ENG) style of production while striving to achieve the results of a fully crewed production. In other words, how can we go in the field with a one or two-person crew and successfully get what we need? This style of production is foreign to many video production professionals, but it is essential for success when producing video for the web. This means packing the right equipment (without overpacking) and learning how to work with what you have on location.

Because the size of your crew will be constrained, you'll need a crew that's multitalented. This means that a crew of two or three (and sometimes one) needs to be able to do the audio, lighting, and videography. A crew really needs to be flexible to make web video production viable in terms of budget. With this in mind, let's explore some specific lighting scenarios.

Lighting Considerations: Indoors

This room had skylights, fluorescent, and incandescent light in the same room (at it was designated the room for press conferences). Talk about a challenge.

The good news is that you'll generally have greater control lighting an indoor shoot. This is because it's easier to control both the amount and quality of light on your set. When shooting outdoors, your primary light (the sun) keeps moving and even disappearing behind clouds or the horizon.

By building a basic lighting kit, you'll have the lights and accessories to control the look of your shots through creative lighting design. Entire books and courses have been devoted to the theory of light, but for our purposes let's take a look at the essential decision-making process. Once you get the basics, you'll see a quantum leap in the quality of your video.

What Is the Lighting Situation on Your Set?

The first thing you should do when you get on location is to take a look around. Does your room have mixed lighting, such as sunlight from windows combined with overhead fluorescent lighting? Or is the light coming from a single source? Your first consideration should be to assess what kind of light is present on your set. What can you do with what you have? Is there anything good about the existing light?

Can You Control the Color Temperature on Your Set?

Ideally, there is no natural light coming from windows or sky-lights. Additionally, you'll have the ability to control the existing lights in the room. If this is the case, then the room is easier to light with the lighting fixtures in your kit. However, if you are in a room with windows, or lights that can't be shut off, then you will need to be prepared to modify or adapt to these conditions. This often means using colored gels or changing the settings on your camera to ensure a proper white balance. Otherwise your camera will take on an unwanted colorcast that can ruin the video.

What Is the Color Temperature on Your Set?

Light essentially has a visible color, and this is particularly true on camera. Think of a bright blue, sunny day or the warm, orange glow of a candle. In a basic sense, light takes on the following colors:
- Sunlight = Blue light
- Standard lightbulbs (tungsten) = Orange light
- Fluorescents = Greenish light

Problems can arise when your camera isn't set up for the light you have. Even worse is when different colors of light start to mix together. The human eye is particular when it comes to color. Getting your video out of balance is bothersome to the audience and makes your production look amateurish.

Which Corrective Action Should You Take?

Once you know what kind of light is present, you'll know what type of light to add to fix the room. A common scenario you'll face is being in a room with lots of windows. The video lights you'll bring may be tungsten lights, so you'll need to take some corrective action:

Safety First

It's important that you're safety conscious with your equipment on a shoot. This means taking extra measures like using sandbags to secure lights as well as addressing power cables. We highly recommend using rubber mats or taping down all of your cables. Make sure the whole area is safe, because the last thing you want is someone tripping over your production gear and suing you. You can also pack a small set of safety cones (often available from sporting goods stores) to help mark out your equipment.

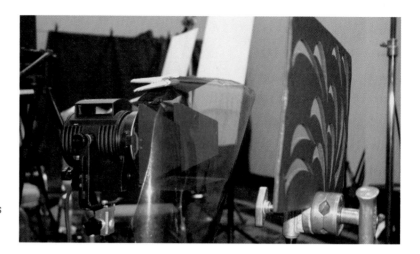

You may need to use colored gels on your lights to change their color temperature.

- **Change the windows.** One option is to cover all of the windows with a special gel called color temperature orange (CTO). This can be very effective, but it's time intensive and can get expensive.
- **Change the lights.** The other choice would be to place blue gel over your lights. Gelling the lights is usually the best decision when time and budget are tight. However, a full blue gel can substantially reduce the intensity of your lighting fixtures, so you'll need stronger lights.
- **Go a different route.** Because neither of these methods are great for time or budget, we recommend using specialized lights. Many newer fixtures use fully adjustable light-emitting diode (LED) lights. You can also find specialized fluorescent lights that can use both tungsten and daylight bulbs (more on both later in the chapter).

A receptacle tester cost less than $10 at a hardware store and offers a good way to test if an outlet has live power that is grounded.

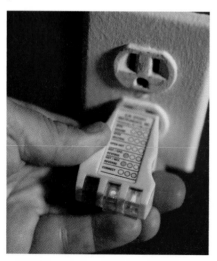

Do You Have Enough Power?

Without power you won't have lights. Seems like a simple concept, but we see people screw it up all the time. What happens if you blow a fuse? Can you access the circuit breaker? Are there enough outlets to power your lights? Do the outlets actually work? When lighting indoors, be mindful of the amount of power that your lights are drawing.

Let's keep it simple and look at a typical scenario for the United States. A standard current is 120 volts, and most single circuits are rated at 15 amps. If we remember basic physics watts = amps × volts, so 15 × 120 = 1,800. Therefore, a single circuit should be able to run at least 1,500 watts of lighting before the circuit breaker trips. Look at your lights and see how many

watts they are rated for (this information is usually on the light, plug, or bulb).

But your lights may not be the only things drawing power on the circuit—it's usually impossible to tell how many outlets there are on a single circuit. Therefore, it makes sense to run several heavy-duty extension cords (often called stingers) from multiple outlets in the hope that you are spreading your power load over multiple circuits. Many older buildings have different wiring set-ups, and you should always check to make sure you don't over-load a circuit, which could potentially be a fire hazard. Be sure you know where the electrical panel is so you can reset circuits as needed. After all, if a breaker is going to trip, it will usually wait until everything is set and you start to record your first shot.

Lighting Considerations: Outdoors

Whereas shooting indoors allows you a certain level of lighting control, the only certainty about shooting outdoors is that it will bring challenges. Besides the difficulty of inclement weather, you have an unpredictable lighting source (the sun). Among the challenges you will be presented with when shooting outdoors are the following:

- Your light source is constantly moving.
- The color temperature of sunlight shifts throughout the day—remember to white balance your camera often.
- The light can change from hard direct light that casts strong shadows to even flat light and back again—all in a matter of seconds.

To counteract these curveballs Mother Nature might throw at you, you can make use of specialty equipment.

Don't Use Auto White Balance

While you may be tempted to rely on an auto white balance feature on your camera, don't. The auto white balance can be overly sensitive to things like a passing cloud. Instead, just keep an eye on your monitor or viewfinder while shooting.

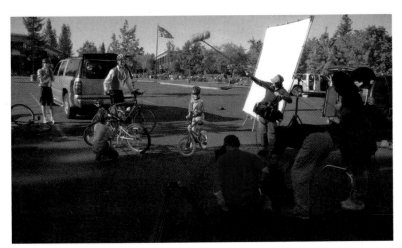

Shooting under the sun requires additional control. Large reflectors can be used bounce the sun onto your subjects.

Reflectors Are for Indoors Too

You can use reflectors for indoor shooting too. They can bounce both sunlight and electrical lights. They often work quite well for interviews, as you can bounce light onto the subject's face (as opposed to pointing a bright light in the person's eyes).

Reflectors

Here we use foam core board bought at a local hardware store as a makeshift reflector. This is our tool of choice when flying to a shoot location because it can easily be found locally.

An HMI light is an important addition to an outdoor shoot. They are expensive to buy, but can be affordably rented.

Unfortunately you can't change the position of the sun. But if you are dealing with direct sunlight you can use a reflector to redirect sunlight onto your subject or background. Reflectors are some of the cheapest pieces of equipment you can own and they are critical to outdoor shooting.

A reflector can be something as simple as a piece of white poster board. Many will make their own out of reflective material (such as Reflectix Insulation) and a piece of foam core. You'll also find reasonably priced reflectors made from fabric and a flexible frame (such as those made by Flexfill). You should invest in a few basic reflectors for your own lighting kit. Nothing works better for bouncing the sun.

HMI Lights

If you're shooting outdoors, one of the best tools you can use is HMI lighting. This type of lighting is unique in that it uses an arc lamp instead of an incandescent bulb (the letters stand for *hydrargyrum medium-arc iodide*). HMI lights are highly efficient and specialized fixtures. They can produce light with exactly the same color temperature as daylight (5,600° Kelvin).

HMI lights make daylight shooting very easy. Their color matches the sun, plus you don't need to use many of them to get results. A 200-watt HMI can produce light as intense as that of a 1,200-watt tungsten fixture (without needing nearly as much power).

There are two downsides to HMI lights for web video production:

- **Size.** HMI lights require an external ballast to work (which is essentially an external power converter). This ballast contributes to the bulk of transporting these somewhat fragile fixtures.
- **Cost.** A single 800-watt HMI fixture can cost in excess of $5,000, and replacement bulbs run around $250 each. We realize the thought of spending more on a light than on your camera can be shocking.

We typically rent HMI lights from local lighting houses, thus eliminating the need to transport them over long distances. The typical rental fee for a small HMI light is $65 to $200 per day. If shooting outdoors, we'll often add one HMI light to counterbalance for a disagreeable sun. On the positive side, you usually have an abundance of free light when shooting outdoors, so HMI lighting is really an "insurance policy" kind of choice.

Lighting Considerations: Multicamera

It is becoming increasingly common to shoot web video with multiple cameras (a technique we'll explore more in the next chapter). This is a common solution because it can both speed up the acquisition stage (by eliminating the need for multiple takes) and accelerate editing (by simplifying camera syncing issues).

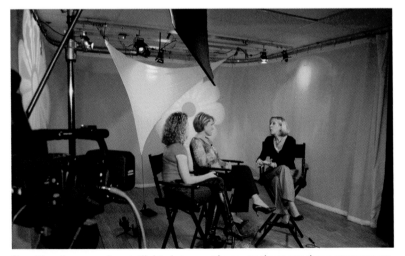

Consideration was given to light placement because there are three cameras on set. By hanging lights or keeping them high on stands, you have a wider angle for shooting.

Fixing It in Post?

Although we are big proponents of getting it right in the field, we are also realists. Sometimes corners will have to be cut in the field in order to accomplish the shot or stay on schedule. Knowing what can be done in an edit suite is helpful so the director or videographer can make judgment calls. It is often easy to tweak a slightly underexposed shot or increase the midtones to help separate the talent from the background.

Additionally, tools like Magic Bullet can be used to further enhance the look of the video during postproduction. Don't let your shoot deteriorate to utter crud, but be sure to know what you can and can't do with color correction. We try to light a podcast as right as possible, but if it means two lighting people and an extra $1,000 worth of lights, we'll sometimes make quality judgments. We recommend taking a test shot onto a laptop while in the field so you can fully understand the options you'll have with your footage.

Multicamera shoots likely happen indoors—if not, they happen outdoors. Because we've already touched on both, what's different you ask? It's important to design lighting setups that provide even lighting for all talent without having the lighting stands in the camera's field of view. Although this may sound easy, it gets much trickier to place lights when you have to accommodate multiple cameras. The most common approach is to hang the lights from a ceiling or a lighting grid. As this may not be available, you'll need to think closely when positioning your lights. Be sure to move the camera around and test your angles as you hang lights. Make sure there are no bad shadows or distracting stands or power cords in the shot.

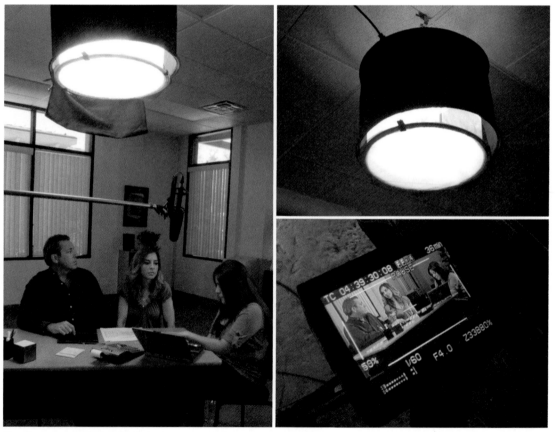

Hanging a large overhead light in the center of the set made it easy to fill in the scene and shoot from multiple angles with two cameras.

Lighting Considerations: Green or Blue Screen

The use of chroma (or color) keying software has gotten much easier in postproduction. The most common techniques involve shooting talent against a blue or green screen and then replacing that colored background with a new one. This process is a staple in filmmaking special effects and has made its way into web video as well.

To spice up the hosted segments, we shot on a blue screen. Custom graphics could then be inserted as well as a virtual set. Footage courtesy the National Foundation for Credit Counseling, www.DebtAdvice.org.

To succeed with chroma key, you want to pay close attention to shooting and lighting.

When shooting chroma key footage, be sure to turn off all the Auto settings on your camera. This means no auto-exposure, auto–white balance, or auto-focus. If any of these are left on, the footage you are trying to key will constantly be changing as your subject moves. These constant fluctuations will make it harder for you to get good results. While you're changing settings, switch your camera to a progressive frame rate (such as 24p), as you'll get much cleaner edges on your keyed shots.

You'll have many choices when selecting a backdrop. Although you can simply go and purchase fabric at a fabric store, many will invest in higher-quality backdrops from a video or photography retailer. The most popular backdrops use polyester fabric stretched by a metal frame, which offers an easy-to-light surface that avoids wrinkles and shadows. These backdrops can be easily folded and transported. Muslin backdrops are also used, but they may require more attention to lighting to avoid wrinkles and bad keys.

Avoid MPEG, DV, and HDV for Keying

 Many cameras shoot highly compressed video. This makes tasks like chroma keying much more difficult because of the lack of color information in the video. Consider using a higher-quality camera when shooting chroma key. If not, you'll have more work in the edit suite.

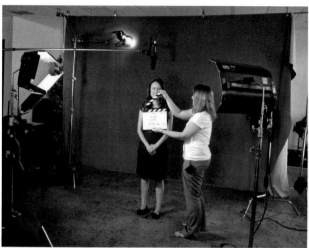

The location, a training classroom provided by the client. We shot on a blue screen (using Reflecmedia technology). The LED lights turn the background an even blue, which makes keying easy.

Here are a few practical tips for lighting and shooting a chroma key set:

- **Even lighting.** It is essential to minimize variation in colors for the backdrop. This means that you must evenly light the background to avoid hot spots. Diffused lighting (such as soft boxes or fluorescent lights) makes this easier.
- **Spill is bad.** Be sure your subject doesn't stand too close to the backdrop, otherwise you'll get shadows on the backdrop and color spill on the person.
- **Keep your distance.** Try to keep your camera as far away from the screen as possible. It's better to increase the distance, even if it means some blank edges are showing (you can always crop these out later).
- **Avoid fast movement.** A fast-moving subject creates motion blur. This is typically where keys become bad or obvious.
- **Use shallow depth of field.** If your camera supports it, lower your aperture. This will help make the background fall out of focus. This is an easy way to hide wrinkles, seams, and hot spots.

Invest in a Good Key

 If you plan to shoot a lot of chroma key, you may invest in a dedicated chroma keying system. We use a Reflecmedia Chroma Key system frequently. This approach relies on an LED disc attached to the camera lens that reflects light on a special fabric containing millions of glass beads that reflect the lower-powered light and create an even-colored surface. Systems like this cost more, but they are popular for their ease of use and portability. The system saves us a lot of time and money during the editing stages.

Lighting Considerations: Available Light

Sometimes, you'll have no control over lighting at all (such as at a concert or theater performance). In this case, you need to make do with what's there and properly set your cameras. You'll need to experiment with settings for color temperature as well as adjust the camera's iris.

Because this may take some trial and error, it's a good idea to do a site survey before the job (and bring your camera). Go and

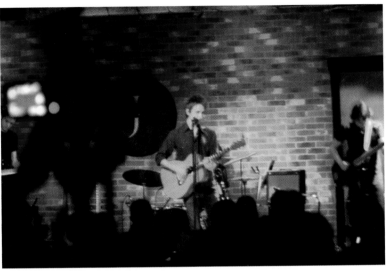

This concert by the Brindley Brothers was recorded at Jammin Java (www
.jamminjava.com) using available light.

look at the location and attempt to see what it will look like with
the lights turned on. You can then make better decisions about
how to handle the lighting, such as to go as is, or push to add
some lights to the budget.

Recommended Lighting Instruments

When we talk to many web video producers starting out,
they're hesitant to make an investment in lighting gear. We real-
ize that buying a gear like a superfast computer and high-end
camera seems like a good idea. You'll be able to use that high-end
computer to waste time fixing poorly lit shots. And that camera?
A great camera without proper lighting is like a jet plane with no
fuel. Here's the good news. Your lighting gear will last for years if
you take good care of it.

The type of lights you choose to use on your web videos will
vary greatly depending on the style of production and your bud-
get. When we build our lighting kits, we focus on performance,
value, and flexibility. We often find we are shooting in the field; as
such we need lights that are durable, perform well, and are easy
to transport. With this in mind, here are a few recommendations.

Tungsten Lighting Kit

One of the first investments video pros make is in a good tung-
sten light kit. The most popular manufacturers of these kits are
Arri, Mole Richardson, Lowell, and LTM (among others). You can

Tungsten lights are mainstays in professional video production.

Dimmers let you adjust the intensity of light without changing bulbs or fixtures.

Wear heavy-duty gloves when handling hot lights.

often find a great starter priced around $1,500, and it will include the following:

- Three or four lights
- Stands to hold the lights in place and adjust their height
- Barn doors to shape the light
- Scrims to diffuse the light
- A travel case to protect the gear while in transport

You can often find professional lighting dealers locally, or, of course, shop online. Although the brand names of the contents will vary, you generally want to get a kit that contains lights of different types and sizes.

A good kit will include an open face type light that can be fixed with a soft box or lantern to provide a broad light source. This is usually used as key (primary) light, especially when shooting interviews. This light will usually be rated for a 500- to 1,000-watt lamp.

The kit should also include several Fresnel lamps of varying intensity. Fresnel lamps contain a lens that allows you to control the spread of light from a spot to flood coverage. These versatile lights can be used to help fill in light on your subject, provide backlight for separation of foreground and background, and light elements of the background or set.

Other items in our Tungsten kit include the following:

- **Dimmers.** Dimmers control the intensity of the lights with a slider or dial. Be sure your dimmer is rated to handle the wattage of your fixture. Although the dimmer you pick up at your home improvement store may work fine with your 100-watt backlight, using it with a 750-watt Fresnel will create a fire hazard.
- **Gels.** These include a variety of color correction gels, theatrical gels in multiple colors for creating dramatic lighting environments, along with pieces for diffusion and neutral density. You can often find these at music stores that cater to disc jockeys or at lighting stores.
- **Leather work gloves.** Tungsten lamps tend to get rather hot; don't get burned. A pair of heavy, leather work gloves can save your hands.
- **Blackwrap.** This is essentially heavy-duty aluminum foil that is coated black. It is used to wrap lights and prevent unintended light spills.

Extra stands and a carrying case round out a good light kit.

- **Wooden clothespins and gaffer tape.** These are used to hold gels and other lighting accessories in place.
- **Extra stands.** You want enough stands to support each of your lights plus a few extras always come in handy to hold reflectors or monitors.

QP Cards Make for Easy Color Matching

One essential piece of lighting equipment emits no light at all. We adhere a QP card on our clapboard. These adhesive cards are a small strip with white, neutral gray, and black. They are generally sold as a three-pack for around $12.

You take one out at the start of your shoot and stick it on your clapboard. This way every take will have a color reference strip. Then in your editing software, you utilize a three-way color corrector with a white, gray, and black eyedropper. This makes it easy to calibrate your camera angles in post and ensure accurate color balance.

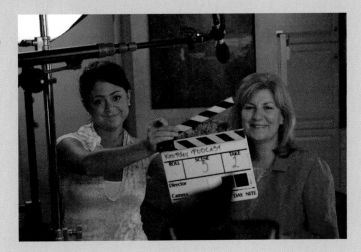

Fluorescent Fixtures

The use of portable fluorescent lighting fixtures has become popular among video professionals. Companies such as Lowell, Mole Richardson, Cool Lights, and Kino Flo make these fixtures. The reason for their popularity is that these lights offer several great features:

- They are a great source of even, soft light that is ideal for shooting interviews or lighting a chroma key backdrop.
- They run very cool, allowing them to be easily moved. They can run all day in a small room without turning it into an oven. This is important for keeping your talent and crew comfortable.

Bulbs can be easily changed in this Kino Flo light.

- Many of the lights are modular, meaning that you can change the number of bulbs used in the fixture. They can also be equipped with either daylight- or tungsten-balanced lamps. This is a great time-saver during setup because you don't have to gel the windows. The lights are essentially two set-ups in one fixture. We know that we walk into any shoot

environment, change bulbs, and turn the lights up or dim them down. It truly is a flexible lighting system.

- Many of the light control features such as ballasts, barn doors, and dimmers are built directly into some models.
- Many manufacturers offer kits that come with airline-ready shipping cases. They also meet the weight requirements of airlines, which make them easy to travel with. Speaking of travel, you can also find universal

This Kino Flo light is self-contained with light controls built right into the unit.

models that can be used anywhere in the world, switching from 90VAC to 265VAC.

A fluorescent light can be found starting around $300 for a single light kit and up to $3,000 for multiple light kits with stands. Although this is an investment, the lights have proven their value over time for our productions.

LED Lights

A new type of lighting technology has emerged in recent years, LED lighting. These fixtures use several light-emitting diodes (LEDs) as the source of light. Although LEDs have been around for years, it's only recently that they've become both cost effective and color accurate.

LED lights use a fraction of the power that traditional video lights pull. In fact, some of these lights can even run off AA batteries for an hour or more. These lights tend to be compact and lightweight (often not much bigger than a flashlight) yet put off a surprising amount of light. Other benefits include durability—unlike traditional lights, LEDs are very hard to break. They also run very cool, so your talent won't get too warm sitting under them.

We really like our Zylight fixtures. They adjust to any color temperature within 1° Kelvin. We also switch them to Gel Mode to produce colored hues with adjustable saturation (which comes in handy for colorizing backdrops).

When shopping for LED lights, you'll find a huge range in prices and features. Many smaller LED lights can be found at around $100 to $150. Other brands that include several additional features (such as built-in dimmers and color temperature controls) can range between $700 and $1,400 per light.

Building a kit with these lights, you'll have a lot of options when it comes to pricing. We've either bought or used lights from Bescor, Cool Lights, Litepanels, Reflecmedia, Switronix, and Zylight. We really like these lights for travel, as they're so lightweight (airline baggage fees add up quick). If you're going to travel much, LED lighting should be a part of your lighting kit.

China Ball Lanterns

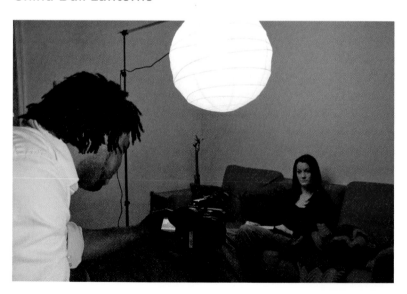

On the opposite end of the price scale are China Ball lanterns. These offer an easy and affordable way to illuminate a large area. The China Ball is a soft paper lantern that can attach to a standard light socket unit. The fixture can create soft natural light that produces pleasing skin tones.

Although prices vary, we often purchase ours from a website called Filmtools (www.filmtools.com). A kit needs the following items:

- **Paper lantern.** These range in size from 12 to 30 inches. The cost is usually $3 to $20, depending on the size.
- **Practical light socket assembly.** This is generally a medium socket with an on/off switch. The socket can handle up to 660 watts and terminates with a standard household connector. It costs approximately $6 per unit.
- **Lightbulbs.** Bulbs range between $5 and $20 for photo-quality bulbs. Be sure you do not exceed the recommended wattage of the fixture.

More on Lighting?

There are several excellent books and DVDs that focus on lighting techniques for video. Here are a few we recommend:

- *Lighting for Digital Video & Television* by John Jackman
- *Motion Picture and Video Lighting* by Blain Brown
- *Video Shooter: Storytelling with HD Cameras* by Barry Braverman
- *Light It Right* by Victor Milt and VASST
- *The Power of Lighting* by Bill Holshevnikoff

A China Ball lantern produces soft, even lighting that is very affordable.

These fixtures are very affordable and are also easy to travel with. Just be careful that you monitor their usage. Because the lanterns are made of paper (flammable), you should not leave them unsupervised on the set. To make them safer, consider adding a Lanternlock fixture (optional). This unit will fully expand the lantern and helps keep a hot bulb from setting the paper on fire. They run around $60 to $85 and can be added to increase the usefulness of a China Ball lantern.

Three-Point Lighting

Three-point lighting is the standard when it comes to lighting for film, video, or photography. This basic method, like the name implies, utilizes three light sources focused on the subject from different angles.

Key light. The key is your primary light source. Generally this is your most intense light, and it is placed between 15 and 45 degrees to the side of your subject. Using a broad soft source of light like that produced by a softbox or fluorescent fixture such as a Kino Flo is ideal when shooting interviews.

Fill light. The fill is your secondary light. It is placed opposite the key, and its primary function is to fill in the shadows cast by the key light. To what degree you utilize your fill light is a matter of creative judgment. Ideally you would use a smaller fixture as your fill light. But if your fill is the same size as your key, you can lessen its intensity by increasing the

distance between the fill and your subject, using a dimmer, placing additional diffusion in front of your fill, or bouncing your fill light off a reflector.

Backlight. The backlight is your third and typically least intense light source. Its purpose is to highlight the edges of your subject, thus separating the subject from the background, which creates a three-dimensional look. Placement of the backlight is usually behind and above your subject.

The final result. All three lights are combined for even and attractive lighting.

Once you understand the principles of three-point lighting, you are well on your way to understanding the art of lighting.

Two-Person Interview

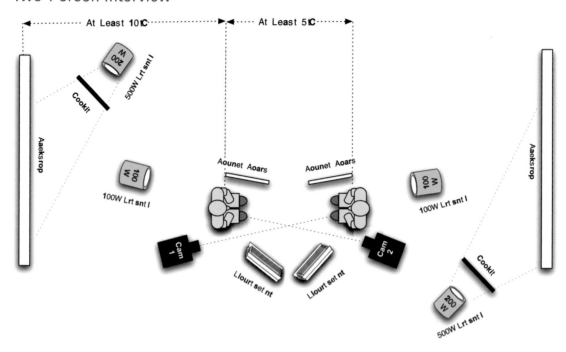

2	300-watt Fresnel w/ barn door	1	Leather gloves
2	100-watt Fresnel w/ 2 barn doors	6	C Stands with arms
8	Light stands	2	10-lb sandbag
1	Mathews grip head	2	Six-port power strips
2	Reflector holder	3	10-foot three-port extension cord
1	Gel and diffusion jelly roll	2	25-foot extension cord
4	300-watt dimmers	4	Backdrop support bar
4	Ground wire killers	8	Medium steel spring clamp
2	Tungsten/daylight reflector	2	Muslin backdrops
1	Spare lightbulb kit	2	Kino Flo 200—2-bank kit w/ stands and bulbs
1	Gaffers tape roll		
1	Blackwrap roll	2	White card stock (bounce card)

Technical Training Set

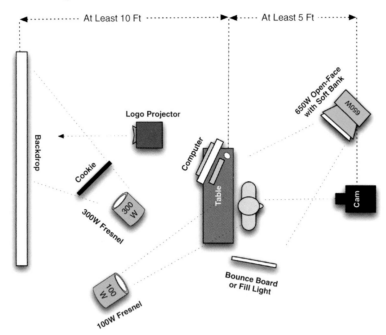

1	650-watt Fresnel	2	White card stock (bounce card)
1	Chimera soft box—small—speed ring	6	C stands with arms
1	300-watt Fresnel w/ barn door	2	10-lb sandbag
1	100-watt Fresnel w/ 2 barn doors	2	Six-port power strips
4	Lighting stands	3	10-foot three-port extension cord
1	Gel and diffusion jelly roll	2	25-foot extension cord
4	300-watt dimmers	1	Backdrop support bar
4	Ground wire killers	1	Overhead projector
1	Tungsten/daylight reflector	1	Client logo gobo
1	Lightbulb box	8	Medium steel spring clamp
1	Kino Flo 400-1 bank	2	Muslin backdrops

Multicamera Talk Show

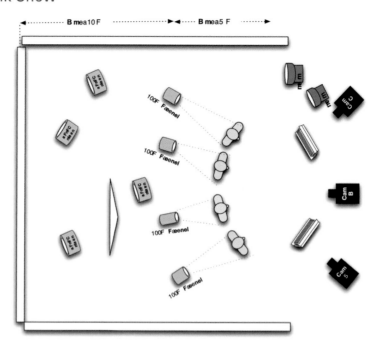

1	Studio space 36' × 14'	4	Zylights (LED lights) for colorizing background
2	Kino Flo Diva Lites (400 w)		These can be switched for 100-watt Fresnel lights with gels and dimmers.
4	Fresnel lights (100 watts to 200 watts) for backlight		
4	Light dimmers	4	Directors' chairs
2	Leko lights (750 watts or more) with logo.	1	White triangle silk
		1	White curtain

VIDEOGRAPHY FOR THE WEB

One of the quickest ways to destroy your video's credibility is through bad videography. If your camerawork distracts from the show's content, it can drive an audience away. Many producers of web video lack formal training in using a video camera or composing their shots for artistic impact. We will touch on guiding principles in this chapter to help those less familiar with the craft of videography. Even seasoned pros will find this information useful, because the computer or portable device screen has different rules than a television production.

Web video crews are often lean and multitalented.

Before we jump into specifics, let's offer an easy-to-remember concept called the KISS methodology. Keep It Simple, Stupid—do not overextend your skills and try to shoot everything with a handheld camera unless you really know how. If you (or your talent) aren't great at doing repeated takes from different angles, simplify and shoot with multiple cameras. The goal with web videography is attractive camerawork that can be acquired quickly and consistently.

Camera Considerations

Choosing the right camera for your production is all about balancing the requirements of the job, the equipment available to you, and your budget. In this chapter, we're not going to attempt to talk you into buying a lot of gear. Rather, we'll focus on different equipment options that have worked well for our productions and share our rationale for using the gear.

With that said, you may be in a situation where you don't have a lot of options. With that in mind, we'll also address affordable "add-ons" that significantly improve production quality or save time. You'll also learn about additional gear options for when you're ready to upgrade.

Let's start by taking a look at essential features that your camera should offer. Although you can always get by with less, we find that cameras need a certain level of base performance (after all it's kind of hard to make a car with two flat tires and a missing battery climb a mountain).

Things to Look For

When you look at cameras, there are lots of features to choose from. In truth, there are only a few features that really impact the quality of video that you'll record. Here are the essentials that we always consider.

Sensor

Cameras utilize charge-coupled devices (CCDs) or complementary metal oxide semiconductor (CMOS) sensors to capture their images. Each technology has its strengths and weaknesses,

Three CCDs will help capture a better image.

and neither is considered superior to the other. Although each uses a different technology, their purpose is the same—to convert the image seen by the lens into an electronic signal that can be recorded to tape, disk, or drive.

Many consumer-oriented cameras only come with a signal sensor, which results in a significantly poorer picture than cameras that contain three chips. In cameras with three chips, a prism is used to split the light entering the lens into red, green, and blue components, and then each component is directed to a single chip solely dedicated to a specific color. Additionally, you'll see that sensors are often identified by size. A $\frac{2}{3}$-inch chip is twice as large as a $\frac{1}{3}$-inch one and generally will give you better image quality.

Connectivity

Many cameras come with multiple connection types, including USB2, HDMI, and FireWire. The one that works the best with the most current editing applications is FireWire. All Macintosh computers and most PCs include a FireWire port. If they don't have one, or you need additional ones, adding an expansion card is a simple matter and generally costs less than $75.

When you look at the camera body, you'll generally see one of two types of FireWire connections. The full-size connector is called a 6-pin port. The primary advantage of the 6-pin port is that it is a sturdier connection type. However, many smaller cameras use the 4-pin connection type. Although this connector saves

Most cameras offer multiple connection types. Be sure to explore your options.

FireWire: A Technology with Many Names

If you are shopping for FireWire technology, you'll often see it referenced by two additional names. Sony frequently calls the technology i.Link, while others favor the generic IEEE 1394, which refers to the number given to it by the Institute of Electrical and Electronics Engineers. The technology is identical; what is at play here is a resistance to use the FireWire logo and name, which is closely associated with Apple, Inc., which co-developed the technology.

Adding to the confusion is that there is FireWire 400 and FireWire 800. The technology called FireWire 800 uses a 9-pin connection type and is much less common. It is generally used for higher speed hard drives and is not found on cameras.

space on smaller cameras, it is more prone to damage because it uses a smaller connector type. Be careful to avoid tension on your FireWire cables, especially if you are using a smaller, 4-port connection type.

Having a FireWire connection will let you load footage from your camera directly into your editing system. This works well for spot checks, chroma key tests, or sending the client a review clip. You generally do not want to rely on the camera for loading all of your tape, though, as the wear and tear can drastically shorten the life of tape-based cameras. A better option is to purchase an affordable feeder deck (even used is okay).

Other benefits of FireWire ports include the ability to harness direct to disk recorders and monitoring devices like Adobe's On Location software (which gives you the ability to calibrate your video camera for better results). Quite simply, you can't go wrong with a FireWire port, so make sure your camera has one.

XLR Audio Inputs

While we focused on audio in our last chapter, it's important to look at the bridge between your audio gear and your camera. One audio connection type that is standard in the professional world is XLR. Video cameras use the common 3-pin XLR cable type, which is also called a balanced audio connector. This works well for professional microphones because they can reduce noise. XLR cables are both twisted and shielded, which helps cut down on interference. The presence or lack of XLR inputs is one of the key features separating consumer from prosumer and professional cameras.

What Is XLR?

The name XLR connector refers to its original manufacturer, Canon. It was originally called the "Cannon X" series. Canon then released a version that could "click" into place with a latch, called the "Cannon XL." The final variation used a rubber compound to surround the contacts, which gave the abbreviation XLR.

High-Resolution Viewfinder

Don't overlook the viewfinder in the eyepiece. This is often just as important as the large flip-out viewfinder.

Many users find giant LCD full-color viewfinders to be attractive. The problem is that many of these viewfinders are very low resolution and often hide flaws in your video. Recently, higher-resolution color viewfinders are appearing on a broad range of cameras, while many professional video cameras still ship with a high-resolution viewfinder that shows a grayscale image.

Whether using a camera with a color or grayscale viewfinder, it is still a very good idea to use a high-resolution external reference monitor to check color and focus. If the reference monitor is not an option, then you can use the LCD as a last resort. But you will still want to learn to use the viewfinder to check important details.

The benefit of grayscale is that it is often easier to see things like exposure and focus when you remove the distraction of color. Additionally, many prosumer and professional cameras are adding focus assist features and even waveforms to their viewfinders. If your camera contains these features, be sure to read the documentation on how they work as this will help to ensure you capture the best image possible during your shoot.

Things to Avoid

Several camera manufacturers have been trying to integrate direct to web publishing features into their cameras. Other electronic manufacturers have started to put video cameras into cell phones and media players. Although these are features that are designed to help bring web video to more consumers, we find that they can truly get in the way of quality.

Keep Two Sets of Cables Handy

A mantra that we like to repeat often is this: 90% of all problems are cable problems. A bad cable can destroy your production. From pops in the interview to a flickering client monitor, a bad cable can do all sorts of damage.

Cables are cheap; reshoots are not. To avoid expensive problems, keep two sets of audio, video, and FireWire cables with your camera bag. And when a cable goes bad, toss it and replace it.

Direct to DVD/YouTube/WMV

Many cameras boast features that make your video ready for "instant" distribution. The problem is that the camera is heavily compressing the video. For best results, you want to capture video at the highest possible quality. You then edit the video together and make any improvements needed. The final step is compression with the intended target in mind. Most professionals in the digital photography world have addressed a similar issue by dumping JPEG acquisition in favor of the much more robust camera raw approach.

A simple rule of high-quality web productions is start high, finish low. You should avoid shooting heavily compressed files, because they do not offer you latitude when you are color correcting or compositing, plus they can take significantly longer to process on your computer. As broadband connection speeds continue to increase and server space becomes cheaper and cheaper, sites such as YouTube are changing their specifications to allow larger files to be hosted on their site. By capturing your video in a format that employs less compression, you will have the ability to scale your productions to meet changing delivery specifications.

Smart Phone and Flip Cameras

Several leading Smart phones and most of the Flip line of video cameras now offer high-definition (HD) recording capabilities at 720p. Although these types of cameras have seen vast improvements, they're still not well suited for web video use.

Why, you ask? Well, resolution is not everything when it comes to camera quality. We still recommend avoiding these types of cameras for anything beyond spontaneous shooting. The main reason for our opinion about these cameras is they lack any real manual image controls as well as professional audio and video connections.

They can produce nice images under ideal (outdoor daylight) lighting conditions, but as soon as you move indoors or the light fades, your image quality suffers. Again, cut corners on your camera, and you'll pay for it during the editing stage.

USB Video Conferencing Camera

Although it's easy to come by video cameras that are suited for instant messaging and videoconferencing, do not be tempted to use these. These cameras generally have poor focus controls as well as inferior lens quality. If you wanted your video to look like you shot it on a webcam in a basement, you wouldn't be reading this book.

Choosing an Acquisition Format

There are several competing tape and acquisition formats on the market. Many formats are tied to specific manufacturers, and you will hear competing claims of superiority as rival companies try to establish dominance. That's not to say that formats don't matter—they do in many cases. But let's start with the bigger question: Should you shoot standard- or high-definition video?

Standard-Definition Video

There are only a few compelling reasons left to shoot any type of video in standard definition (SD), the first being financial. SD video equipment is well established and readily available. As such, it still costs less to use an SD workflow. Cameras cost less, tape and storage media cost less, capture devices cost less, and so on. Because producing video for the web is generally a price-sensitive marketplace, standard definition is still a logical choice.

Plus, many of the shows on the market are delivered at 640 × 480 or 320 × 240. Both of these sizes can be easily generated by an SD video camera with minimal processing. It is important to note that SD just refers to a category and not a particular format. You will encounter several video formats that are all considered standard definition.

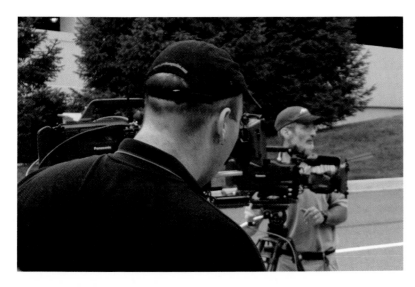

When using multiple cameras, try to match manufacturers and models.

DV/DVCPRO/DVCAM

The digital-video (DV) format launched in 1994 was originally intended for use by prosumers and consumers. Many pros embraced it, however, because of its ease of use and price competitiveness. The format is very space efficient—it only requires 12 GB of storage for an hour of footage. It is also easy to load, as these cameras and decks use the FireWire protocol. It also supports both 4:3 and 16:9 aspect ratios, thus extending videography options.

There have been some notable variants on the DV standard. Sony released the DVCAM format, which moves the tape 50% faster through the camera (resulting in fewer dropouts). Panasonic also developed the DVCPRO formats targeted at professional use. The tapes for DVCPRO are much thicker and sturdier, which works well for traditional tape-based editing.

The DV format works well for web video and is widely embraced because of its balance of cost and quality. The one area where DV footage is particularly problematic, though, is chroma keying. If you are looking to use blue or green screen technology with virtual sets, you should stay away from DV because it does not key well.

DVCPRO 50

The DVCPRO 50 format is an extension of DV technology and is available in many of Panasonic cameras. The DVCPRO 50 format uses dual encoders to double the bit rate of data being recorded. In tape-based cameras, this format uses the same tapes as the DVCPRO format but consumes tape twice as fast when recording. In addition to doubling the data being recorded, the format also uses a higher chroma subsampling, which produces better color fidelity and image quality. As such, DVCPRO 50 is much better suited for chroma keying. DVCPRO 50 also supports shooting both 4:3 and 16:9, which adds more flexibility to your productions.

Betacam SP/DigiBeta/Betacam SX

Although it is a venerable format with a rich history, Sony's Betacam option don't see much action in the web video space. Some established video production companies utilize their legacy beta gear (which is a high-quality format). The significantly higher cost of the equipment, though, can quickly balloon a podcast's budget. As such, you should be wary of working with footage acquired on Betacam. Additionally, the technology is often considered "dead" by media pros because it is waning in popularity as digital (and more affordable)

options become new standards. Sony has practically abandoned the format in that the company is not developing new products to sell and only carries one or two models of decks for each format.

XDCAM

A much more viable format for those web video producers who prefer to work with Sony gear is the XDCAM format. XDCAM is an optical, disc-based system introduced in 2003. It acquires directly to affordable discs that often sell for less than $30. Each disc can hold between 45 minutes and 2 hours of content, depending on the acquisition approach taken with the camera. Because of the affordable media recording options and the relative ease of loading footage, the XDCAM format has proven popular with some web producers.

High-Definition Video

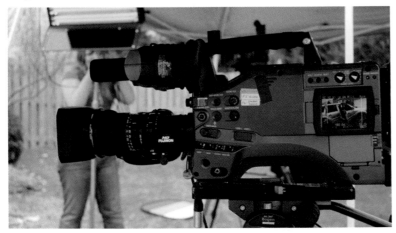

Although the production cost gap between standard-definition (SD) and high-definition (HD) video continues to close, it still exists. Working in HD still requires more robust hard drives, better monitors, more expensive cameras, and greater skill.

Acquiring video at high definition may seem contradictory when the goal is to deliver small, web-ready files at an affordable cost. With that said, many web video producers do just that. The decision to shoot HD video is really about future-proofing your footage.

Reasons to shoot for the web in HD include the following:
- The footage has residual value and will be used in future productions.

- The program is going to be distributed in multiple sizes and formats, including devices like Apple TV and TiVo HD digital video recorders.
- The project has additional distribution channels like broadcast or Blu-ray.
- You offer a premium subscription service with paid downloads for HD files.

High-end HD cameras offer multiple video and audio connections.

It is essential to stress that working in HD adds cost to a project. We find that HD projects tend to cost 20% to 30% more to complete than SD projects. This is due in part to the aforementioned costs associated with gear. Additionally, you will spend more time on tasks like rendering for graphics and effects as well as see longer compression times when finishing the project. We are not saying you should avoid HD—the many affordable cameras and options on the market are very desirable—just be aware of the additional costs involved. There are many HD formats on the market; let's explore some of the most common.

DVCPRO HD

The DVCPRO HD format is primarily used by Panasonic cameras. It has gained significant popularity because of its balance of cost and performance. DVCPRO HD is used for tape-based acquisition as well as tapeless acquisition. The tapes are interchangeable with the DVCPRO and DVCPRO 50 format, but DVCPRO HD uses four times more tape than DVCPRO.

The newer P2-based cameras were first introduced in 2004 and utilize a solid-state flash memory card. A P2 card can record either SD or HD footage. The P2 postproduction workflow takes a little time to master, but using P2 cards works well for many web producers because

you can plug them directly into a computer, transfer the files, and start editing. Although the cards are expensive, they can be reused nearly infinitely. This saves money on tape stock and eliminates the need for an expensive deck.

HDV/ProHD

The HDV format is a very popular format for entry-level HD. This inexpensive format compresses HD video using MPEG-2 compression (the same as DVDs) and then records it to tapes identical to the mini-DV format. This compression can create some workflow issues during postproduction and often requires extra steps. Nevertheless, because it is the least expensive way to move into HD production, many podcasters and video professionals have adopted it.

HDV was originally developed by JVC and Sony, which were later joined by Canon and Sharp. These companies manufacture several different models of cameras targeted at both consumers and prosumers. The format has also been extended by JVC and called ProHD. The main difference is that it can natively shoot 720p at 24 frames per second.

XDCAM HD

Sony's XDCAM format was discussed earlier in the chapter. Sony has extended it to offer an HD option. It is important to note that not all XDCAM cameras can shoot HD, so check your options when renting or buying a camera. Sony's XDCAM HD options offer different bit rates, so be sure to strike the right balance of file size and quality. You'll want to use the higher bit rates for more visually complex materials like fast-moving shots, outdoor scenic shots, and large crowds.

H.264/AVC

H.264 or AVC (Advanced Video Coding) is a video compression standard originally designed as a delivery format that some video cameras are now using as their recording format. It is also the default recording format for many very portable devices such as smart phones. You will often find that you must conform this format to a standard such as Apple Pro Res before you can work with your footage in an editing program such as Final Cut Pro. Some DSLR cameras also shoot video in this format. Currently, Adobe's Premiere Pro software can edit the files natively from some cameras.

AVCHD

This format was developed jointly by both Panasonic and Sony and now can be found in cameras made by Canon and JVC. It is based on H.264 compression standards and first appeared in many consumer cameras before finding its way into the pro-sumer market. It is used for both SD and HD recording. Recording media in these cameras has ranged from DVDs / Mini Discs to solid-state media such as SD and flash cards. Most video editing programs support AVCHD.

AVC-Intra

This is a format introduced by Panasonic that conforms to the H.264 standard and allows for high-quality HD production while harnessing advanced compression technology that yields dramatically smaller file sizes. Many of Panasonic's prosumer and professional camcorders now record in this format. All major video editing software now provides support for this format.

Digital SLR Cameras

The latest entry into the camera market that has created a lot of buzz is video-capable Digital SLR cameras. Manufacturers have enabled high-definition video recording on cameras that were traditionally only used for photos. The key advantages here are removable lenses, great depth of field control, and lowlight performance.

The Impact of Compression During Acquisition

Try to avoid heavy compression during the acquisition stage. Adding compression early on makes editing tasks much harder, as you'll need to transcode or render footage in order to edit it. Capture video at the highest quality you can afford, then compress after editing and color correction is complete.

We highly recommend that web video producers pay attention to these cameras. Currently, the market leader is Canon, but you'll find models capable of shooting video from most camera manufacturers. With large imaging chips and a wide array of lens choices, you can now achieve cinema-like footage with a relatively inexpensive tool.

If you want to learn more about these cameras, we recommend the following resources:

- *From Still to Motion: A Photographer's Guide to Creating Video with Your DSLR*
- Creative COW's DSLR Forum—forums.creativecow.net/dslr
- Facebook HDSLR page—www.facebook.com/DSLRVideo

Interviewer Tips

Becoming a good interviewer is an acquired skill that takes training and practice. For the less experienced, here are a few helpful pointers:

- Edit in the camera. Encourage short answers and come back to topics again. Better to focus on good, tight answers than trying to cobble together six takes to make your point.
- Avoid enumeration or the phrase "Like I said before." It is highly likely that you will use only part of the answer (such as step three, without steps one and two).
- Ask leading, open-ended questions, being sure to ask a single question only.
- Don't be afraid to stop and start over. Do not let an answer ramble on. Smiles and nods can let subjects know they have made their point and can stop talking.

Camera Support Options

Many budding videographers shoot their video without using a tripod. This is a terrible mistake, as few people should actually shoot their video handheld. Although handheld video can be used stylistically to great effect, it is rarely useful when it comes to video that is intended for the web. The slight (or not-so-slight) movement of the camera can result in pixelization or softening when the video is compressed for podcast.

Now some of you think you're better than this, so let's take a simple test. Stand up and extend your arm out directly in front of you with your palm raised (like you are a traffic cop stopping traffic). Now hold that position for 60 seconds without moving. Look at your hand. Is it twitching at all? Chances are, the answer is yes. It's not your fault—you're overworked, overcaffeinated, and suffer from a lack of rest (in other words, you are part of the modern workforce). Shooting smooth, handheld video is very difficult. Here are a few options for camera support that you can consider.

Tripod

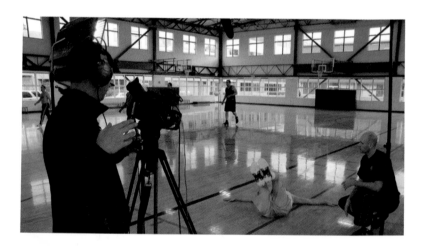

It should go without saying, but use a tripod. There are several price points out there on tripods, depending on how tall you want the tripod to rise. The head of the tripod is also critical, as you'll likely need it to smoothly pan and tilt for your productions. A top-of-the-line fluid head can cost thousands of dollars by itself. Luckily, with the advent of DV prosumer cameras, there has been an influx of tripods with decent fluid heads at reachable price points. Pros use tripods all the time; they are a given. Simply put, use the best tripod you can afford!

Monopod

A monopod is good if you need a stable shot in situations with great mobility. Think of it as being halfway between shooting handheld and using a tripod. A monopod uses a single leg to stabilize a camera. You won't be able to let go of the camera and walk away, but the camera will still be much less shaky. A monopod is also a great option to reduce body strain when a tripod is impractical.

© Fotolia

Steadicam

The name Steadicam is often applied to several models of camera stabilizers. In fact, Steadicam is a brand name for a type of unit originally developed by cinematographer Garret Brown in 1972. The units are meant to help capture smooth video when walking or jogging with a camera. The operator generally wears a special vest, which has a metal support arm that is stabilized by a spring and counterbalance system. Through the years, many variations have been

created. You can find out much more by visiting www.steadicam .com and looking at the different models. For videographers using consumer and prosumer cameras, the Steadicam Merlin offers a great number of features at an affordable price.

DLSR Rigs

One of the biggest challenges in shooting video using a DLSR camera is dealing with the form factor of the camera. For years, professional video cameras rested securely on shoulders. This allowed for some degree of stabilization when shooting. As cameras became smaller, the industrial designers gave thought to designing a camera that was meant to be held for extended periods of time.

DSLR cameras don't share the same form factor, as they are designed to be held directly to the eye and freeze movement. When shooting video though, the viewfinder is disabled and only the rear LCD works. The form factor is just not ergonomic, and it leads to lots of unwanted camera shaking.

To compensate, numerous manufacturers are bringing camera support bodies for DSLRs to the market. These rigs range from simple bodies designed to assist with the grip of the camera to full-blown rigs capable of integrating accessories like focus controls, lens filters, and additional audio gear. Two of the companies with advanced rigs are Zacuto and Redrock Micro.

Other Stabilizers

There are many other camera support options on the market for almost any budget point. Here are a few worth looking at that can help stabilize your camera and give you better-looking video when not using a tripod:

- **Frezzi Stable-Cam** (www.frezzi.com)
- **Fig Rig** (www.services.manfrotto.com/figrig)
- **Turtle X** (www.easyrig.com)
- **Glidecam** (www.glidecam.com)

Tapeless Acquisition Strategies

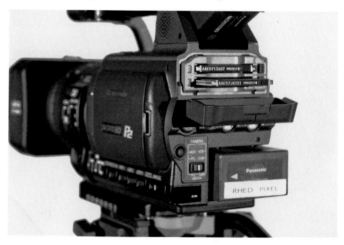

Earlier we discussed Panasonic's P2, Sony's XDCAM formats, and DSLR. Both offer acquisition of video material without using tape. These are not the only solutions; there are hard drive units that can work with almost any camera that offers a FireWire port. But why forego tape and shoot directly to a magnetic or solid-state media? There are several potential reasons.

Benefits of Tapeless Acquisition

There are many benefits of tapeless acquisition that can impact the web video producer. The biggest is the speed at which you can move from shooting to editing. Eliminating the need to log and capture tape can save you a significant amount of time. You can begin editing your material as fast as you can transfer the media to an editing system (which is often 10 to 15 times faster than loading a tape).

Other benefits include that the tapeless media can be used again and again. Although media like P2 may seem expensive at first, value is achieved over time because you do not need to keep buying tape stock. You can also play back your footage quickly and review your shots right in the field, deciding to drop bad takes before ever going into an edit session.

Tapeless media can also make it easier to share your footage with others. We often make multiple copies of media so that several individuals can begin editing at once. We also find it simple to turn interview clips into MP3 files if we need to get material transcribed quickly (the process of turning interviews into a text log). This can be helpful if the material needs input from project participants who'd rather look at a paper log or searchable text file.

Drawbacks of Tapeless Acquisition

When tapeless acquisition first became a reality, the biggest drawbacks were the cost of the media and the complexities associated with moving media management to the field. For example, the first Panasonic P2 cards only held 4 GB of data and cost close to $1,000. To record 30 minutes of 720p video, you had to plunk down a minimum of $2,000 in cards and then have the equipment and skill to do data transfer in the field if you wanted to shoot more than a half hour of media.

Luckily, Moore's law has held true in the world of tapeless acquisition, and that same $1,000 will now get you an E series P2 card with 64 GB of storage, which means you could get close to three hours of 720p footage on one card. Sony's SxS cards have seen similar gain, and several models of prosumer cameras now use a standard SD card as their recording media, which means even less expensive recording media is available to the web video producer.

At this point, the only real argument for not using a tapeless workflow is if you are restricted to using legacy tape-based cameras because of budgetary constraints or if your client has placed contractual restrictions on you that require tape-based deliverables of the field footage.

Don't Edit Directly from Tapeless Media

 Although you often can edit directly from a tapeless acquisition drive or disk, it's generally a good idea to transfer the media first to an editing hard drive. This will reduce wear and tear on the equipment and make it last longer.

So although the cost drawback of tapeless acquisition has become much less of an issue, we still find on many of our shoots the need for an additional person on set, often called the data assistant. This person fills a role similar to the person on film shoots who is in charge of reloading and handling the film needed by the cameras. Although this seems like an extra cost, this person does the same work as an editor used to do when loading footage from tape.

We cannot emphasize enough the need to have that individual on the set if you're working with disk or hard drive–based media. On our shoots, we generally make two backup copies of each card or disk. The first copy is loaded into the nonlinear editing system via an import command, which places the media on an editing hard drive. The second copy is a disk image, which we back up to a temporary hard drive. After the shoot, we transfer the footage to a RAID-protected hard drive array and eventually to Blu-ray discs if the client wants a set of "master tapes."

Which brings up the next point. Without tape, you may have no backup. Be sure your tapeless media is redundant. You'll need to make a mirrored copy of your drive to keep your media ready to use. You'll also need to explore cheaper archive solutions like a protected disc array, DLT drive, or Blu-ray DVDs to create affordable archives that can be stored for long-term backup.

Shooting for Portability

When you are shooting video for the web, you need to remember that the computer and mobile device screen behaves differently than a movie or television screen. Although web video can be delivered to television sets with relative ease, odds are this is the device with fewest amount of viewers for your video. So keep the following in mind.

The Screen Is Small

We tend to favor tighter shots; that is a conscious decision. Remember, video will likely be seen at a small size (some players are as small as 2 inches diagonally). Therefore, there are a few things you need to keep in mind when composing your shots. Tight shots work better than wide shots because much of the detail will be lost by the time your footage reaches the small screen.

Action Safe Is the New Title Safe

Traditionally, videographers have learned to frame their shots to protect both the action-safe and title-safe areas of the frame. In the world of TV broadcasting, monitors do not necessarily display the entire frame of video. For this reason, there are two cropped zones within the frame; both are equidistance on all sides from the edges of the full frame. The larger of the two zones is referred to as action safe, and the slightly smaller zone is called title safe.

The thinking is that when shooting or editing, if you keep the action inside the action-safe zone and any key information such as graphics and text inside the title-safe zone, then it will display properly on even the most restrictive of monitors. In the world of podcasting, you'll see the entire video clip. Because of this, we have basically done away with the concept of title safe and now just keep what we really want on viewers' screens inside of action safe. This allows a little bit of padding (like a margin) but maximizes the smaller screen.

Avoid Shaky Video

Because your source video is going to get highly compressed before it is delivered to the web, it is important that your shots be as steady as possible. Video compression saves space by repeating pixels that don't change from frame to frame. As such, your video will be much clearer if it is a stable shot. Remember, shaky video doesn't compress well and results in muddy-looking video.

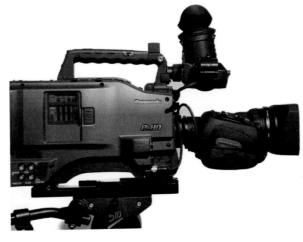

Recognize Lower Frame Rates

Web video and even podcasts can have reduced frame rates. Combine this with lower data rates and you want to avoid much camera motion. Lots of pans or zooms tend to break down during compression process. For this reason, we recommend favoring straight cuts rather than creating in-camera effects.

Evaluate Using 16 × 9

Shooting video in 16 × 9 aspect ratio has become quite popular. However, some web video is still delivered in the 4 × 3 aspect ratio. If you decide to shoot in the 16 × 9 format, you should protect your shots for center cut during postproduction. This concept is similar to the action-safe/title-safe concept described earlier, but in this case only a portion of the side of each frame will be trimmed during the edit or compression stages

Packing List for a Two-Camera HD Package

2	Panasonic HVX-200a camera	1	Panasonic BT-LH80WU 7.9" HD LCD field monitor
6	5400-mah batteries		
2	Battery charger with AC adaptor	1	Slate and dry-erase markers
2	Sharpie markers	2	25-foot BNC cable
6	16-GB P2 cards	1	Anti-shine powder with applicators
1	Video adaptors and barrels bag	1	Makeup kit
1	Leatherman multitool	2	Sachtler tripod with plate
1	Lens cloth		

Shooting Multicamera Productions

More and more web video producers have discovered that multicamera shooting can speed up production and dramatically cut down editing time. This is because synchronized angles truly make editing easier. But when it comes to multicamera editing, there is no "fix it in post." Screw up the technical details and you will have a difficult time putting the pieces together.

Camera Requirements

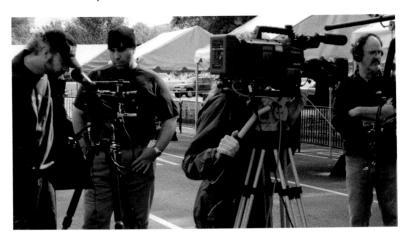

Choosing the right cameras is the most important detail for a multicamera shoot. This is both for aesthetic and technical matching purposes. The different camera angles need to smoothly cut together, or visual jarring can make your video hard to watch. Here are some details to look for when selecting cameras:

- **Matched codec/format.** Ideally, all your footage will have the same codec (compressor/decompressor). If you've mixed tape formats (like H.264 and AVCHD), you may need to convert the footage to match. You'll also want to be able to match frame rates so footage stays in sync.
- **Number of audio inputs.** Generally speaking, video cameras offer two to four inputs. Depending on your number of audio sources, more audio channels can really come in handy.
- **Tapeless acquisition.** By recording direct to disk or cards, it's easier to record for long periods without interruption. Make sure you have enough recording capacity to avoid having to stop for a "tape change." This will help you avoid continuity breaks in the footage.

Matching Cameras

The closer your camera settings match, the more likely the footage will match when you go to edit it. You want the footage to match as closely as possible. This requires you to make adjustments to both aesthetic and technical properties. Be sure to look at the camera menu settings and attempt to tweak them so the cameras seem similar in appearance on a calibrated monitor.

Even though these cameras aren't identical, they are by the same manufacturer. They also can be set to shoot the same codec and frame rate.

Be sure to match the following aesthetic settings:
- Color settings
- Gamma settings
- Shutter speed
- Black level

You'll need to check several technical properties for each camera. You need each angle in a multiclip to be technically identical for the multicamera editing technology to work. With this in mind, be sure to match the following properties across each camera:

- **Timecode.** Use the same method, drop frame or nondrop frame, for each camera angle.
- **Codec.** If the cameras support different codecs settings, try to match them.
- **Frame size.** Be sure your frame sizes match; you don't want mix cameras that are recording 720p with others that are at 1080i.
- **Frame rate.** Be sure to check that you have a precise match for frame rates. Keep in mind that there are lots of different frame rates these days with HD.

Color Calibration Tools

To get your angles to match up, make sure at the outset that the cameras have a good black and white balance on the same subject in the same lighting. This is often a piece of cake when you're in a professional studio with a chip chart, but what about when you're in the field? We have two favorite tools that are affordable and portable, and can help you calibrate cameras in the field and double-check color balance in post.

- **QPcard (www.qpcard.se).** A cheap and easy way to address color calibration between your angles is to use a calibration card when shooting. One of our personal favorites is the disposable QPcard. Priced at less than $5 per card, this is a great investment in accurate color. Simply use the adhesive strip to adhere one to your clapboard at the start of each day of shooting, and you'll have a great source for checking color balance in post.

 With a white, black, and neutral gray surface, it is easy to use the three-way color corrector when color correcting in Final Cut Pro. Using a new one each day may seem wasteful, but $5 spent per shoot is well worth hours saved on color correction. In most cases, it will only take three clicks per angle to calibrate across each camera.

- **Photovision One Shot (www.photovisionvideo.com).** This pop-up target is a great addition to a camera bag. This calibration device offers a black, white, and gray stripe to color calibrate. The other side is a white flexi-fill that can be used as a reflector to help bounce light on set. What's great about it is that it is reusable and can fold to a small size to fit into a camera bag. Various sizes are available, from 6-inch targets to wear around your neck to 34-inch targets for large multicamera events.

Once camera angles are synced, the editing process can go much more quickly.

Syncing Cameras

To edit between camera angles, you'll need to keep them in sync. This way as you cut from one angle to the next, you won't see a skip in the audio track. There are several ways to do this. The most professional method involves using timecode, whereas other approaches rely on audio or visual sync points.

Here's a quick rundown on how you can synchronize multiple angles:

- **Slave cameras together.** It's often possible to "jam" two or more cameras together. By taking the timecode from one camera and feeding it to the other, sync is possible.
- **Time of day timecode.** Some cameras let you set timecode to a clock. Be sure you've accurately set the clocks on all cameras to match.
- **Use a clapboard.** When picture and sound are recorded to two different systems, it makes it easy to synchronize, because there is a visual and audio cue point. The same holds true with multiple angles. Simply point all your cameras at the clapboard for the initial sync and to resync if any camera stops recording.

6

TELLING YOUR STORY WITH VISUALS

The whole point of creating web video is to use the power of images to educate, entertain, or motivate your audience. Without compelling visuals, you have just a bunch of talking heads.

Depending on your approach, you may need photos, videos, slides, screen captures, or motion graphics. In this chapter we'll explore the many options for footage that you can use to tell a story. A professional podcast or web video needs the "whole package" to complete the viewing experience.

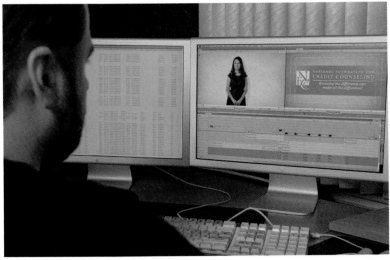

Web videos take more than just camera footage. The use graphics can quickly provide important information to the viewer.

We recognize that web videos often face a constrained budget. Learning how to make a lot from a little is a key skill for successful publishers. In this chapter we'll explore several options for improving the quality of your web video with effective visuals. We encourage you to implement as many of these ideas as your budget and narrative approach will support.

Working with B-roll

The term B-roll has held many meanings through the history of film and video. It originated in the days where two prints of a film would literally be spliced together to tell a story. During the days of linear video editing, it came to mean the footage playing in a second deck (or B) that was edited into the primary sources or interviews coming from the primary (or A) deck.

The term has been further modified and has come to be regarded as a broad category of footage that is used for a successful edit. As you remove unwanted parts of a performance or interview, you'll need to cover the edits (otherwise it is a jarring edit, called a jump cut). The technique of using a cutaway is a great way to hide unwanted camera movement as well. You can also use it to hide unwanted coughs, ums, and uhs by your subject.

Besides technical necessity, B-roll can significantly add to an audience's understanding and enjoyment. The visuals can help enhance or tell the story besides the on-camera interviews. By showing what is being discussed, your web video moves from being talk radio with visible heads toward the approach of television and film. There are several sources for B-roll, but you need to start thinking about it early on with your productions.

B-roll Acquisition During Production

Be sure to plan ahead. You'll likely have many great things that happen during your shoot. One approach is to capture visuals *while* you are shooting the principal coverage. This is usually accomplished by using a second camera that focuses on additional footage. For the example of a cooking show, this camera would generally stay close on the hands of the chef as they prepared food; it might also provide close-up details of the prepared food.

Other programs take a parallel approach to capture events that happen related to the video's subject. For example, you might be profiling a topic like car restoration. Although the interview with the subject matter expert can be compelling, adding visuals of the topics being discussed can really improve comprehension and viewer enjoyment.

In both cases, be sure you leave time in the schedule to go and acquire footage. We often bring an extra camera on location

so the producer can step away and capture some more footage. This all ties back to the advice of having a multitalented crew. You'll often be able to cut a person free from your set to gather visuals. What's important is that you generate a shot list before the shoot day. List your anticipated needs, and then quickly move to capture the material.

Stock Sources

There will be times when you won't have the time to shoot B-roll. Or maybe it's raining. Perhaps the event being discussed is historical, or on the other side of the world? The bottom line is that you'll often need to get creative in where you find your visuals.

Archive Materials

Several high-resolution clips from the Prelinger collection are available at www.archives.org.

There are several sources of publicly available footage that can be freely used in video projects. This material generally comes from government-funded archives (such as the United States National Archives). There may be small fees involved to get copies of footage, but the material can be often used with few or no restrictions. A great place to start your search is www.archives.gov/research/formats/film-sound-video.html. Another place you can browse is www.archive.org, where you'll find several different collections (just be sure to read the usage rights for the footage you want to use).

Trade and Business Groups

You can find professional groups on almost any topic or industry. These groups often have footage or photos that they will share (don't just take it from their website; contact their communications or media relations departments). Additionally, groups such as chambers of commerce and tourism boards often have great footage that they can make available to you. If you're tackling topics like health or education, there are numerous nonprofit groups that can offer you free footage to use (just contact their marketing or public relations departments).

Old Productions

If we are producing web video for a client, we'll often ask for copies of previous videos they've made. This can be a great source for video materials. Your own archive is also a great place to start if you have rights to the images. Be sure to follow the rabbit hole down; you may need to trace a project back to the original vendor to get the highest quality source materials.

Stock Footage

If you can't procure, acquire, or locate footage, you can often buy it. Stock footage costs can vary greatly; the two biggest factors in cost are uniqueness of footage and exclusivity of use. There are several vendors for stock footage. Here are a few that we turn to do the following:

- **Artbeats** (www.artbeats.com)
- **CNN ImageSource** (www.imagesource.cnn.com)
- **Digital Juice**—Video Traxx HD (www.digitaljuice.com)
- **iStockPhoto** (www.istockphoto.com/video.php)
- **Revostock** (www.revostock.com)
- **Shutterstock Footage** (www.footage.shutterstock.com)

By using stock photos and free government resources, a more visually compelling story can be told.

Working with Photos

Many web video producers overlook the power of still photography. In our experience, photos are a fantastic alternative to video. Photos are generally easier to find or acquire, and thus less expensive and more plentiful. We're big fans of taking our own pictures whenever possible. Cameras are a great way to bring on shoots, as many are capable of shooting both stills and video (thus a potential solution for the B-roll problem too).

The amount of royalty-free stock photography sites has boomed, with many offering affordable images or subscription plans. The Internet is filled with thousands of sources for stock photos; a simple web search will inundate you with hits.

There are also free sources for images, but you'll often need to do some research. Rather than sending you on a hunt- and-peck mission, let us offer three great resources:

- **Richard Harrington Blog.** Rich Harrington keeps a list of government websites with images available for free use. You can find the directory at www.richardharringtonblog.com/resources/free.
- **Creative Commons.** If you are looking for generous folks willing to share their photos, then check out Creative Commons (www.creativecommons.org). Just be sure to check the requirements for an image's use.
- **Wikimedia Commons.** The folks behind Wikipedia maintain a large catalog of supporting images (and footage). You'll often find the images in articles (be sure to look for the Wikimedia Commons logo and terms of use). You can also access the library directly by visiting commons.wikimedia.org.

Enhancing Images

We've never come across a direct-from-camera photo that couldn't be improved. Some of the most common adjustments to photos intended for podcast screens are boosting the saturation and adjusting the gamma or levels for the image. The number one software application for these tasks is Adobe Photoshop. If you need to prep images for use in video, be sure to check out the podcast and the book called *Photoshop for Video.* There's lots more information on preparing still images for use with digital video.

Google Image Search Is Not a Candy Store

 Just because an image is free to view on the Internet does not mean it can be used freely. We know many producers who turn to web search tools like Google Image Search to find photos for their videos. This is generally illegal and can get you into a lot of trouble. There are many affordable stock photo websites as well as photo communities where images are freely shared. Don't be lazy; it might get you sued.

Avoid JPEGs at All Costs

 Although not exactly malevolent, JPEGs should at least be considered evil. After all, the file type loses additional quality with each File >Save. The compression scheme used in JPEG files is also problematic when mixed with many common video formats. This can lead to jittery images and flashes. Remember that JPEGs are a web distribution format; the only reason some digital cameras use JPEGs is that they are targeting consumers or trying to reduce the cost of storage media. You should either shoot your images as Camera Raw files or batch convert your JPEG files to an uncompressed format like TIFF or PSD. Trust us when we say avoid JPEGs.

Resolution Requirements

For maximum image clarity, it's a good idea to properly size your images to match your editing screen size. Otherwise your editing software will have to scale the images. This leads to an increase in render times and a major drop in image sharpness. Although there are several ways of doing this, one of the easiest is to use Adobe Photoshop. A fast way to do this is using the Image Processor Script (File > Scripts > Image Processor). With it, you can target a folder of images and set a target output size.

Creating Moving Footage

One additional technique when working with stills is employing motion control to animate your photos. Some users call this the Ken Burns effect. By animating a photo, you can create zooms and pans to help guide the viewer's eyes through a photo. This technique has been popularized by many documentary filmmakers and is quite effective.

In our opinion, the best way to do this technique is with Adobe After Effects. It offers precise controls and advanced options to make simulated camera moves appear more natural. These techniques can be accomplished in most editing tools, however, through the use of keyframes or specialized plug-ins.

Want to Move Pictures?

 For a free web tutorial on Motion Control techniques with After Effects, visit Creative Cow's website at library.creativecow.net/articles/harrington_richard/doc_style.php.

Working with Screen Captures

If you are producing technical training video or need to show something like a website or a video game, then you'll need to use a screen capture tool. There are software programs that allow you to record what is happening on your computer's screen. The software can create a video file and store it on a hard drive so you can edit it with your nonlinear editing software. Let's start by looking at some of the popular tools.

Screen capture software is needed if you want to record a computer screen for creating how-to tutorials or demonstrations.

Software Choices

Although there are several choices out in the market, a few really stand out. The Macintosh platform has several more options than the PC world (go figure). Here are a few proven ones that do a great job:

- **iShowU (www.shinywhitebox.com).** This tool creates remarkable computer screens for Mac users. It is reasonably priced and does a great job of writing files to disk as it captures (which makes them ready to use in moments).
- **Snapz Pro (www.AmbrosiaSW.com).** This is another Mac-only tool for capturing both static and motion screens. This tool is very established, with many users. We prefer it for capturing stills, but find that it waits until you stop capturing to write to disk. This can hog RAM and can be quite slow.
- **Screenflow (www.telestream.net).** This tool is really an all-in-one suite. Although it captures the computer screen, it can also record a video camera and even build basic graphics for keyboard shortcuts. The tool is Mac-only, but it is a popular solution for screencasters.
- **Camtasia Studio (www.techsmith.com).** This is a cross-platform solution that writes very small files. It can then write out to virtually any video format.
- **Screenr.com (www.screenr.com).** This web-based application is a free option for recording the screen. Although you are limited to five minutes, you can post directly from the site to YouTube or Twitter. You can also save the file to your computer for additional editing. We find this cross-platform application works best with the Firefox web browser.

Capture Strategies

We have found that getting high-quality screenshots can be tricky. Fortunately, we've had lots of practice in working with these tools. There are several factors that contribute to success. Here's some hard-earned advice we've found over the past five years.

To use screen capture tools, you'll need a pretty powerful computer. Be sure to boost your system's RAM; screen capture software needs plenty of it. You'll also want at least a 128 MB graphics card. A dedicated-capture hard drive (preferably a high-speed RAID) connected via FireWire or SATA is also needed.

If you'd like to get the best results, capture at the size you need. For example, use the square pixel equivalent of 640 × 480 if you are editing a 4:3 podcast. It's important to note that you may need to use a higher resolution monitor setting, such as 800 × 600 or 1024 × 768. If this is the case, you can compress the files after capture and resize to a nonsquare pixel size like

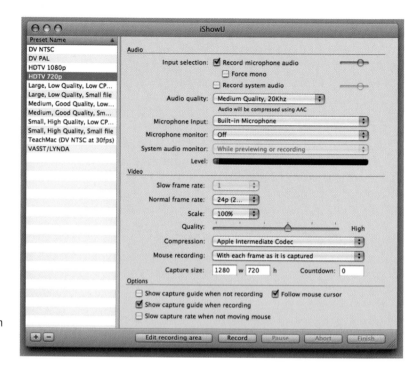

iShowU can capture full-screen video at standard frame rates including 24p.

720×480. If working in HD, then be sure to use a 16:9 aspect ration (such as 1280×720 or 1920×1090).

If you'd like to have more flexibility during the edit, you can instead capture the video larger than you need. Then simply bring the video into a resolution-independent nonlinear editor (such as Premiere Pro or Final Cut Pro). These types of nonlinear editing packages allow you to load images that are bigger than standard video sizes. Once you've edited the screen capture in your timeline, you can apply scale and position values to adjust what the viewer sees.

One area that can be problematic with screen capture is frame rate. Some software tools support capturing at video native frame rates. However, you really need a powerful computer to perform these styles of capture. If you can't get a consistent frame rate, we recommend running your captured files through a compression tool and converting to a consistent frame rate. Ideally your file will end up at 29.97 or 25 frames per second (fps) to match NTSC and PAL, respectively, or the newer 23.98 fps, which is used by most 24p cameras.

If you need to capture a computer screen, you'll need to avoid the DV or HDV codec. A codec is a video format's compressor/decompressor. For best results, you'll want to minimize the compression applied to the screen capture. Be sure to check which "uncompressed" formats your nonlinear edit system supports.

Final Cut Pro Quality Control

Be sure to open your sequence settings in Final Cut Pro (Sequence > Settings). If you're using screen-captured files, click the Video Processing tab and change the Motion Filtering Quality pop-up to Best.

Analog Screen Captures

Sometimes, capturing a computer screen using a software tool will be impossible. For example, you may need to record the screens of multiple presenters at a conference or you may have to capture a video source directly from a projector. Don't worry; this too is possible if you use an analog video capture device. The biggest drawback is that the files will likely be larger and a little less clear than the software capture tools.

To successfully capture a computer screen's analog signal, you'll need the following:

- A computer that is capable of mirroring its video output so you can see what you are doing on the computer's monitor and still drive an image on a plugged-in device such as a projector or a second monitor.

- A scan converter that lets you feed in the computer's image via a VGA or DVI connection and then converts the signal into analog video. These devices are readily available if you are looking for an S-video connection type. For maximum image quality, however, you should look for a scan converter that offers a component connection such as those from Comprehensive/Kramer.

- A video capture device that accepts analog inputs. Ideally this device will allow resolutions above DV compression. You may already have a device like a capture card or breakout box that allows you to capture directly into your computer. Slightly less desirable, you could record to a high-quality tape format and then capture.

- High-speed hard drives that can work with the uncompressed video. It's important to note that the files can be quite large and demanding if you are used to a DV or HDV workflow.

- Editing software that supports an uncompressed workflow. You will want to have very high quality sequence settings so the screens are as easy to see as possible.

Working with Speaker Support/Slides

Many presenters use slides to reinforce key points as they talk. Common software tools include Microsoft PowerPoint and Apple Keynote. These tools can be used to create text and informational graphics that can be quite effective. When used correctly, you can create informational graphics that match the quality of broadcast news. Although these programs can create effective visuals, you'll need to process the images a bit to make them ready for web video.

Design Slides Properly

Be sure to leave a slight pad around the border for all slides. These edges make it easier to read on a smaller screen by allowing a margin.

By default, most slides are not optimized for video. Text can be hard to read, or even get cut off. Don't worry. It's a pretty easy fix; just follow these guidelines:

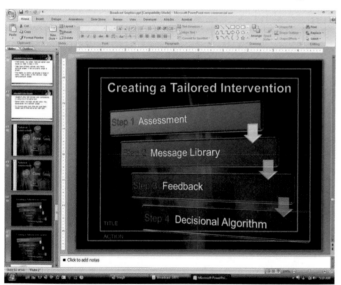

- **Don't go too close to the outermost edge.** Leave at least a 10% margin around the outside edge of the screen.
- **Simplify your message.** Try reducing the length of your bullet points and spreading your slides' content across multiple slides.
- **Increase the size of your type.** The web video is often played back on a small screen; use a larger and thicker font.
- **Increase contrast of the text to the background.** For best results, try using light text over a dark background.

Export Still Graphics

To use slides in a video-editing tool, you'll need to convert them to a standard graphic file format. It's important to note that you won't be able to edit the content of these exports. Be sure to proofread your slides before export and to keep a copy of the original around in case changes become necessary.

Microsoft PowerPoint

Microsoft PowerPoint makes it easy to save your slides as graphic files. PowerPoint supports seven different graphic formats, including the versatile TIFF and PNG formats.

1. To save your slideshow as a series of still graphics, open your presentation in Microsoft PowerPoint.

2. Click the Office button and choose Save As Other Formats. Near the bottom of the Save dialog box is a Save as type: drop-down menu. Pick the file format you need (such as TIFF).
3. Specify a location for the files on your hard drive and click Save.
4. PowerPoint then gives you three options: export Every Slide, Current Slide Only, or Cancel.

Apple Keynote

If you are using a Mac, you should strongly consider using Apple's Keynote application, which is part of iWork. This program is similar to PowerPoint (and can even open PowerPoint files). To export slides, simply choose File > Export. There are two key differences that make Keynote desirable for preparing slides for a podcast.

• Keynote anti-aliases the text on the slide. This process helps reduce flickering text and makes it look better on a video screen.
• Keynote can export slide animations (such as charts) in a QuickTime format. This adds a lot of life to your podcast.

Motion Graphics

Getting your web video graphics to look their best and work effectively often comes down to how they are designed. It is important that your graphics are easy to use and modify, as well as look great on their intended playback devices.

The advice we offer here is specific to web video graphics. However, if you are inexperienced with broadcast graphics, we strongly recommend additional reading and practice. See the advice in this chapter as being the essential information. Here are the key points we've learned when designing graphics for web video and podcasting.

Screen Size

Web video graphics often play back at a small size (such as a width only 320 pixels). Even though many web videos are produced and delivered in HD, the maximum screen resolution that most watch is only 640 pixels wide.

What quickly becomes apparent is that you should build your graphics to match your editing (and not delivery) standard. This means use the presets that match your shooting format. All motion and standard graphics applications offer templates or preset settings to simplify this process.

We recommend building your podcast graphics at standard video size, then edit with your video. You can always resize the entire episode after editing with compression software.

As such we usually build the graphics to match the acquisition format (such as 720×480 with nonsquare pixels for NTSC and 720×576 in nonsquare pixels for PAL). We assume that the show is probably going to get reformatted and could end up on a DVD or even be broadcast. Working at the size at which the video was acquired speeds up editing and rendering times.

Codec Issues

The video camera you use will often highly compress the footage as it shoots. For example, if you are shooting video using

The graphic on the left is an uncompressed original. The one on the right has standard DV compression applied. The differences are subtle, but they are most evident in the small text details and glowing areas.

mini-DV, DV Cam, or DVCPRO 25 formats, you are likely using the DV codec in your sequence. This codec is essentially throwing away three-fourths of your graphics information, "smooshing" your graphics to heck. It would be the equivalent of shooting a beautiful photo with your digital camera and then only being able to deliver it at a JPEG set to low quality.

There are two ways to work around these limitations:

- **Mixed formats.** Some nonlinear editing systems allow you to mix resolutions in the timeline. In this case, your footage can be heavily compressed, whereas graphics use a lower-compression format.

- **Switch settings.** If your sequence doesn't support real-time performance with mixed formats, then you should edit your video in the correct native editing (matching sequence settings to the primary camera acquisition format). Once your content is locked down, you can add your graphics. At the end of the production, switch your sequence settings to an uncompressed codec for finalizing. This way when you export your self-contained QuickTime movies to compress them for web delivery, they come out very clean.

Remember that the goal with video compression is simple: start high, and finish low. The better quality image you feed into the podcast compression software, the cleaner and smaller file you'll get out. The original file doesn't need to play back smoothly; it only needs maximum image quality.

The codecs used for web delivery are primarily designed for video sources (and not graphics). As such, there are a few things to consider when building motion graphics. If your compression software encounters really flat areas of color, it will often try to oversimplify the material and overcompress it. Many graphics will look terrible because they've been overly compressed. We get around this by putting a little texture or gradient into the graphics. Another way to improve quality is to use motion blur. Modern video codecs can support relatively fast motion.

Font Selection

Fonts are critical to a successful design. Be sure to invest in a font for your web video that is unique (and that didn't come preinstalled with Microsoft Office). You need to find a visual identity for your podcast, and good use of type is an easy way to do it. Yes, you're going to have your favorites—your classics—but you need to find a font that gets used for show titles that complements the logos, the set, and the colors in your graphics.

Kiss of Death

The digital video codec instantly throws away three-fourths of the work you've done and makes it look terrible. Be careful if you're working with DV footage; do not finish your sequences using the DV codec.

Motion Blur Can Be Good

Most motion graphic applications support the use of motion blur. This rendering option adds a gentle, directional blur to fast-moving objects. If you don't use motion blur, your graphics may actually compress poorly for the web because video codecs are designed to work with video most often. In the real world if you're shooting with a video camera, if something's moving fast, it has motion blur.

Find a Video's Personality

When we start a new video project, we try to get the client or those involved to describe the video with adjectives. We call it the adjective game. We ask for 10 to 20 words to describe how the video should feel. These words can be used to help you select your font choice (as well as everything else after that). The font choice is one of the biggest things that impacts overall style and truly sets the tone for your graphic identity.

Mixing Cases

We often recommend a mixed approach when choosing font case. If you have larger enough letters, you can use a mixture of upper and lowercase letters (which will be easier to read). This gives you better variation between individual letter shapes so the human eye can more quickly read it and cognitively process the information. If you have a very small space, then you might switch to a small caps style. This will switch all of the characters to uppercase but will leave the capital letters larger. This takes up less space, but you need to leave the graphic up longer because it takes more time to be read.

Take a look out there; there's a typeface that has your video's personality. Something that is unique and helps convey the character of your show. Here are a few of our favorite type foundries:
- **Chank** (www.Chank.com)
- **Dinctype** (www.girlswhowearglasses.com)
- **Blue Vinyl** (www.bvfonts.com)
- **Acid Fonts** (www.acidfonts.com)
- **Fontalicious** (www.fontalicious.com)

Text Placement

Remember that web videos are often viewed at a small size. Be sure to set your display window to a lower magnification to simulate viewing the video on a smaller screen. Be sure to make the text larger and easier to read.

The graphic on the left keeps all text within the Action Safe zone used by broadcasters (the innermost 90%). In traditional video, text and logo elements are kept within the title-safe area (the innermost 80%), as shown by the graphic on the right.

In broadcast graphics, designers usually use a safe title grid that identifies two zones: title safe, which is the innermost 80% of the graphic and where all text should fall, and action safe, which is the innermost 90% and where all essential design elements should fall. In broadcast, if these are ignored, text can become difficult (or even impossible) to read on a television.

For podcasting, you can treat the action-safe guides that most graphics programs offer as your title-safe zone. Go all the way out and just leave a 10% margin around the outside edge of the podcasting graphic so the text doesn't get hard to read by being too close to the edge of the computer screen or the edge of the portable media player. By keeping all text within these guides, you ensure that it is easy to read on the portable screen or computer. However, if your show is going to be used in both traditional and podcasting situations, you may need to create two master sequences for the different graphic standards.

Contrast

With web video graphics, contrast is key. Does the graphic still work when you remove color? If it does, this means that you have proper contrast and you are ensuring that your audience has an easier time comprehending the information.

You'll want to check your graphics in grayscale mode. If they're still easy to read, then they're easy to read. One way to do this is to add an adjustment layer in your graphics application with a hue/saturation effect. By pulling down the saturation, you can strip out the color.

Another way to accomplish this is to print them out in grayscale mode to a printer. These are both simple, but good tests. If the graphics hold up, then you've got a good balance of contrast and luminance. Proper contrast is essential, as it affects how easily the viewer can comprehend the information.

How does the graphic hold up when you remove color and just look at contrast? The middle of this animation looks a little low contrast, but where it really matters for the end sponsor logo, contrast is proper.

For this video, it was important to find the right balance for the background images. The client wanted to create an active virtual world, but also communicate several ideas.

Busyness of Background to Foreground

Power Windows

We often use a power window (or a vignette) around the edge of the screen. This can be an effective way to draw a viewer's eye to the center of the screen. We do that because people watching videos on mobile devices often have lots of things around to distract them. The more you draw their eyes to the middle of the screen, the more they're watching your content.

In recent years, the evolution of the stock animation market has led to a terrible problem. In the quest to stand out from their competition, several manufacturers of stock animation have made their backgrounds more and more elaborate. As such, we've gotten to the point where backgrounds are too busy and compete for attention with foreground elements such as text. A background is just that, a background. We find an easy solution is to blur and darken our backgrounds.

Type on Pattern

Related to both the contrast and busyness of the image is the type-on-pattern issue. What often happens in video is that text is placed over a busy or moving background. As such, white text can intersect with a bright area in the background and become difficult to read. This problem is easy to address.

First make sure that your font choice is relatively thick. A heavier font will hold up better on the video screen. Then add a contrasting edge such as a stroke or drop shadow. Light text should get a dark edge, whereas dark text should get a light edge. Take advantage of contrasting edges to make the text easier to read.

The use of a solid bar helps the text stand out to the podcast viewer (even when viewed at a small size). The use of uppercase letters was a stylistic choice, but it also helped readability and kept the text blocks more compact. Finally, a drop shadow was added to some elements (such as the logo) to address the moving background.

Additionally, try to keep lines of text shorter. This is because of how web videos are viewed. For example, on the small screen of an iPod, larger text in smaller blocks is easier to read. A viewer watching on a laptop may blow the video up to full screen. In this case, it's going to get pixilated. If the font is thicker and has contrast, it won't fall apart as badly. Fortunately, these guidelines work well for both viewing scenarios. In a confluence of circumstances, thicker, larger text generally holds up better through compression and at scaled playback sizes.

Testing Graphics

If you want to see how your graphics are going to look on the web, then you need to test them. We subscribe to the belief of pushing graphics to the point that they break, then backing off a "few feet" and you're good.

Most people subscribe to an overly conservative view of the web, which is, "Oh, we want to serve the least common denominator." They're concerned that a person standing on top of the Colorado Rockies with an Edge cell phone connection can view a high-definition video and have a pleasant experience.

Screw that. This is not your target audience or whom you're trying to please.

If your primary audience is people in office buildings, go to a couple of office buildings and look at the video. If you want to see what it looks like online, drop it to your private YouTube channel at low quality and take a look at it. Put it on a portable player and look at it.

We test our graphics throughout. As we are starting to build things we do test compressions along the way. Closely examine the effects of compression, then make decisions.

With animated sequences, the "read-aloud" rule still applies. Be sure your audience understands each element by giving it enough time to be easily read twice, out loud.

Read Times

Many motion graphic designers and editors seem to forget that graphics are actually meant to be read by an audience. The idea with read times is that you want to be able to read the graphic out loud, preferably twice before removing the graphic. This is an old broadcast standard for a good reason.

Unfortunately, most motion graphic designers are watching their motion graphics play back at less than real-time speed. Instead, they choose an arbitrary number like three seconds. Remember, you are adding graphics to enhance the viewer's understanding. Allowing the graphic to be read aloud twice ensures that the viewer has enough time to read the graphic while still absorbing the other information being presented simultaneously by the host or B-roll.

Creating a Graphic Identity

If you want your web video to stand out from the clutter, motion graphics are the way to succeed. By giving your show a polished graphical identity, you make it easier for your audience to connect with your program. Even more important, because video-sharing site viewers will typically outnumber viewer's on your website, a graphics package helps establish the author and sponsoring organizations.

A well-designed graphics package can help establish the topic of your show as well as reinforce its personality and style. The show's graphics essentially create its brand. This is essential to both attracting and maintaining your audience.

Flexibility

It is essential that your graphics be easy to modify. You'll often need to make tweaks to your content to freshen it for changes in current events. You may also find that a popular video may need follow-up content or updates based on viewer feedback.

Two very different shows, same principle in ease of production. By keeping show titles easy to modify, you will save significant time in producing custom graphics.

We employ two primary techniques to ensure flexibility:

Prerender. The first method involves prerendering elements and adding them to a template sequence. Essentially everything except the text or media placeholder (for a headshot or video) is rendered in advance. For example, in our weekly shows we only need to add the title and the host's name. This makes changes simple and results in a short render time (often done by the video editor). With easy-to-modify graphics, it is not a challenge when it comes time to pump out 40 graphics for a series.

Use edit points. The other technique involves creating edit points right within your graphics. In almost all of our podcast graphics, we find a way to creatively dip to black or dip to a color. This makes it easy to edit the show title or attach it to the body sequence. This has several ramifications, including ease of use and rebranding.

On several shows, we have had to go back to our library of previously edited shows and simply copy and paste the new graphics onto the front. These quick updates let us keep old shows looking fresh. We know that we will change the look of graphics packages from time to time in order to refresh our content. We don't want to have old graphics in our episodes because it sends an inconsistent message. The lesson learned is that you want to make it easy for graphics to be stitched on. Make sure your graphics are easy to take on and off of your show. Another lesson learned the hard way: save graphics-free masters of your podcasts so you can easily add new graphics.

Clean Appearance

Although clean is a subjective judgment, it is still essential. By clean, we mean crisp, easy-to-read, and easy-to-understand designs. You want clarity with your podcast graphics; if things feel too busy, they probably are too busy. If you think your design is a little hard to read, your audience will think it's very hard to read.

We are not advocating for vanilla design; just remember that podcasting is a low-resolution medium that is also heavily compressed. You have less latitude than you do with print (and even video), so it is essential you design with the medium in mind.

Start Simple

When building a graphics package, we usually tackle the background and the lower third first because those are some of the easiest graphics to put together. They'll also serve as the cornerstone for a lot of your other graphics by providing the fonts, color, and texture. We'd rather hash out internal and client design arguments over the graphics that don't take a long time to make and then move on to the more complex graphics. It's called winning an easy battle before you take on a big war. Don't start with the hardest part of the project first, start with one of the easiest parts and work out your battles over design.

This show's graphics were created on a tight budget and little time. Simplicity was the goal all around, and it resulted in a clean and popular appearance. This show was time limited, but it spiked as high as number two in the Technology category on iTunes.

There Should Be Bugs in Your Video

If you watch broadcast or cable television, you'll see that they frequently place a logo in the corner of video to establish network identity. For a web video we recommend that you insert one into your show every 90 seconds or so.

Logo bugs don't need to be giant or obnoxious (subtle is fine). We often create them at partial transparency to let the video show through. Graphics should go in either the lower-left or lower-right corner.

Match Style of Video

We see many videos that have a patchwork-quilt appearance. This is because many producers rely on stock graphics and then pick and choose from several different volumes or collections. Think of your video as being a unique individual; you want it to stand out from the crowd, but not because it is wearing two different colored socks, a fur hat, a leather cowboy jacket, and a Scottish kilt. Make sure your elements match or complement each other so the show remains consistent in its style.

The goal is simple: You want the personality of your graphics package to match the style of your show and its host. Make sure that you're figuring out a way to make your show different than the rest. Analyze your perceived competition and develop graphics with a unique appearance that matches your show.

We often see graphics that are "hot and sizzling" and the talent is barely a "warm fish." There is nothing wrong with having low-key or subdued talent, just make sure the graphics match the show's personality. If your show is warm and nurturing, then look to networks like the Oxygen or Food Network for graphic ideas and not MTV2.

For the Final Cut Help podcast series, the graphic identity was carried through the show's open and sequence graphics onto the set. In fact, the branding and design carried through to the commercial DVDs that are sold by the show's sponsor VASST.

Integrating into Set Design

You should also have a color palette that carries through from graphics to the set. You can take the key colors of your graphics package and repeat them on the video shoot. This looks good and adds a level of professionalism to the show's appearance. By tying the look of the visuals together, you can create a cohesive visual experience for the audience. Here are a few practical tips:

- **Background colors.** We often use various colored backdrops in our productions. Affordable backdrops made from muslin or other materials can be bought from photography and video

vendors. If using a practical set, try to place props with the show's colors in the background.

- **Project logos and artwork.** We'll often use show logos or design elements and project them on the walls of our set. If you're on a budget, you can use a simple slide or transparency

The daisy shape from the MommyCast logo is projected onto a curtain. Other colors from the show's palette make up the rest of the set.

Style in Action

At RHED Pixel, we've produced two regular shows on Adobe Photoshop. The first show, *Understanding Adobe Photoshop*, targets a mass appeal audience that is less experienced with the software. The second, *Photoshop for Video*, looks at the software for experienced video professionals and motion graphic artists. Same subject, same host—different audiences, different graphics.

As such, we rebranded our shows to make them feel different. *The Understanding Adobe Photoshop* show is packaged to feel consumer friendly. Because we were attracting a more basic audience, we wanted the opening to feel more like a McDonald's commercial.

For the other show, *Photoshop for Video*, we used a much more aggressive and gritty approach. There are several elements that are very technical, including old registration patterns and testing bars. The graphics would be fairly meaningless except to those in the know. This podcast goes after a niche audience, and the graphics reflect that.

projector. You can also create a custom gobo, which is a cut-out of the logo. These can be made of steel for monochromatic options or glass for full-color choices. A gobo will typically cost you between $150 and $500 depending on complexity and number of colors. You'll also need a light to hold the gobo; a standard Fresnel light can work or you can purchase special fixtures for around $200.

- **Prop pieces.** If you'd like to integrate your show logo, you can order small quantities of printed items. For example, you could use coffee mugs with a custom logo for a talk show or a custom printed mouse pad for a technical program.

- **Microphone flags.** A common branding in traditional broadcasting is the microphone flag. You can order preprinted flags or use a blank one that you adhere your logo to. Two sources for mic flags that we've used are www.mikeflags.com and www.markertek.com.

Creating Show Graphics

Several tools for creating graphics are available. Which tools you use will be a matter of availability and skill level. When it comes to motion graphics, you should see the software as being part of a bigger toolkit. As such, it is common to use several tools on a project. The three most common graphic tools are these:

- **Adobe Photoshop.** The one graphics tool that is almost universal is Adobe Photoshop. If you understand Photoshop, most other graphics tools will make sense. Photoshop integrates well with nearly every motion graphics and video-editing tool on the market. Before you invest time learning another tool, start with Photoshop. It's important to focus on graphics that look good when they're not moving; then these can be animated. You will learn to use technology for compositing and design. Plus, compared to other graphics software, Photoshop is easier to learn. This is due in large part to the vast number of books, websites, and even podcasts about the program. If Photoshop is outside of your reach, then pick up the very capable Photoshop Elements, which offers a pared-down feature set that is still quite capable.

- **Adobe After Effects.** After Effects is often called "Photoshop with a timeline." It has close integration with Photoshop, in that it can easily import layered Photoshop files, which can be animated. Adobe After Effects is a wonderful yet complex tool that will take an investment of time to learn. However, the investment pays off in that After Effects knowledge is a very marketable skill.

- **Apple Motion.** If your workflow is primarily Apple based, then you should strongly consider integrating Apple Motion into your toolset. Although Motion can work with keyframes much like After Effects does, it has additional, unique features like behavior-based animation and the ability to turn a project into a template, which is accessible through Final Cut Pro. If you already have Adobe-created artwork, it is easy to import. With Motion, you can bring in elements that you've created in Photoshop and After Effects as well as use Motion's toolset. The graphics can then be easily accessed in the Viewer window as a template project. This is particularly useful if your video editor needs to update graphics but lacks extensive graphics capabilities.

PRO*file*: The Rest of Everest

The Rest of Everest is a web video series conceived and created by documentary filmmaker Jon Miller of TreeLine Productions (www.treelineproductions.com). It is "the rest" of the footage from the groundbreaking expedition documentary "Everest: The Other Side" which engrossed thousands of viewers when it premiered on Dish Network Pay-Per-View in May of 2005.

The film documents the 2003 expedition to the Northeast Ridge route in Tibet, and coincides with the 50th-anniversary climbing season. The story revolves around 23-year old climber Ben Clark and the fulfillment of his dream to become one of the youngest climbers to ever summit Everest. Although the film has been very well received, there was just so much of the story left to be told.

"I had recently finished the edit on my own film about climbing Everest and thought it was such a shame that I had all of this material on tape that would never see the light of day," said Miller. "Surely there was a group of people who were interested in seeing hours and hours of Everest that no one ever shows?"

Miller returned from Everest with over 80 hours of tape from the 60-day expedition. The final cut of the film totaled just 84 minutes. That meant that only one minute of every hour filmed made it into the finished version. Miller was looking for a way to get his footage out there.

"In Fall of 2005 I watched my first video podcast, Four Eyed Monster. It was a show about the trials and tribulations about promoting an independently produced film," sad Miller. "The podcast really flipped a switch in my head. I thought the podcast was as engrossing as the film it was based on could ever be. I realized that podcasting was an entire ecosystem. A podcast could exist on its own for its own sake."

The show features nearly all of the footage from the trip. Additionally, the climber, Ben, and others offer audio commentary to the footage. This lets the viewer get all of the stories right from the people who experienced it first-hand. This new approach really connected with the audience.

"Podcasting has doubled my workload…and in a mostly unpaid way. But I love it and wouldn't change a thing," said Miller. "The show had introduced me to so many amazing people who simply found the show in iTunes or through Google. Every morning I get up and check my email first thing to see who has written me while I was asleep. Podcasting is international in nature too; I regularly get emails from Australia and Japan, Europe, and all over the USA. I make it a point to write back to every single person."

Miller's passion for his show and its audience has been a key to its success. Besides staying in the top-rated list for his podcast, he's received several honors for his show. The Rest of Everest was a finalist for the Best Video Podcast at the 2007 People's Choice Podcast Awards. The show was also designated by the iTunes directory as one of their exclusive "Best of 2006" podcasts.

"I was absolutely stats-obsessed when I began the show. I stayed that way for most of the first year. At some point that all changed and I began to slow down on my obsessive-compulsive behavior. I knew I was producing a quality show and people, viewers, had noticed it as well," said Miller. "I began to build relationships with several of the bigger fans. People started emailing me to say how the show had inspired them to travel or to climb the mountain outside of their town."

"It was these emails and friendships that I developed that made me realize that I was going to produce the show even if my viewership dropped down to just these people. It was for them. After I made that perspective change, the show has been a much more enjoyable endeavor. I still check stats, but I'm surprised to find that it can be up to a month between log-ins."

Miller encouraged other media professionals to give podcasting a try. He emphasized how enjoyable the entire process is.

"I've been a professional content producer for over 10 years now and I can say that podcasting is the most gratifying endeavor I've ever undertaken," said Miller. "There's just something magical about being able to shoot, edit, and publish all by yourself and in such an immediate, international way. It's changed my life for the better. I'm happy to be a part of the podcasting community."

Gear List

- Sony HVR-A1U & HVR-V1U cameras ("I'm a real fan of tape since my productions take me to remote areas.")
- Libec TH-M20
- AKG C414 microphone
- Mackie 1402-VLZ PRO mixer
- Ultrasone 550 headphones

7

EDITING CONSIDERATIONS

The advent of nonlinear editing software has dramatically changed the way video is made. In fact, the emergence of lower-cost (yet powerful) editing tools is directly responsible for the rise of web video. Without a means to create video for the masses, there would be no podcasting or YouTube.

But finding the right nonlinear editing tool is a tricky game. You will encounter several choices on the market as well as hotly contested platform and manufacturer wars. In this chapter, we share with you tools that meet the needs for various types of web video producers, as well as identify specific tasks you need to accomplish during the editing stage.

The Evolution of Nonlinear Editing

Nonlinear editing tools have been around for many years. The technology is defined by its ability to access any frame of video loaded onto the computer system, without needing to shuttle through tape. In using a nonlinear editor, it is possible to assemble video in a word-processing-like approach. This means that video can be built in segments, which can be easily reordered or modified at any point in time.

This is different than the traditional tape-based methods that involved meticulously assembling one shot after another by dubbing from one tape to another (with little to no ability for changes). It is now possible to both build a library of video assets and to experiment much more freely.

When you work with a nonlinear editing system, you must transfer material (such as video from the camera) to a computer hard drive. Some formats of videotape must be digitized, which is why some modern cameras offer tapeless acquisition of

What's the Big Deal?

The emergence of nonlinear editing allows for nondestructive editing. This means the original source tapes or files are not modified during editing. Rather, the editing software records the decisions made by the editor in an edit decision list (or EDL). These files can often be interchanged between editing tools (even from different manufacturers). Newer systems are using XML-based project files, which can transfer much more data between software tools.

Many nonlinear editing tools offer powerful color correction tools for calibrating and improving images. Software scopes like these used to be a hardware-only option and would add thousands of dollars in cost to an editing system.

material that can just be copied. Once the material is imported, it can be edited and arranged using a variety of software tools made by several companies. Many of these software tools have a rich history and have seen a long period of evolution (see the sidebar).

The emergence of DV technology and FireWire signaled a huge shift in the editing marketplace, leading to the release of high-quality tools targeted at significantly broader audiences. Tools like iMovie and Windows Movie Maker brought desktop editing to the homes and schools, while companies like Sony, Avid, Adobe, and Apple released multiple products for different segments of the professional and prosumer markets. Thanks to DV, video could really be edited on fairly standard computers. This revolution in FireWire filmmaking democratized the market. Without this revolution, there would be no web video movement.

A Short History of Nonlinear Editing

The first nonlinear editing system was the CMX 600, which was introduced in 1971 by CMX Systems. This system had a console with two black-and-white monitors as well as a light pen to control the system. The system helped establish the idea that the left monitor was where the editor made selections and previewed edits, whereas the right monitor showed the assembled program. Costing near $250,000 (and that price is *not* adjusted for inflation), the tool was very expensive and only six units were placed into use. But it was a start, and it led to more innovation.

Many others tried to develop nonlinear editing systems throughout the 1980s. These used computers that coordinated multiple laser discs or several tape recorders. One of the more successful units was the EditDroid system invented by Lucasfilm. Only 24 EditDroid systems were ever produced, and the company was eventually sold to Avid Technology in 1993.

Avid is often seen as the leading pioneer in nonlinear editing software and hardware. The company first showed its Avid/1 product in 1988 to a private audience at the National Association of Broadcasters Event. The product continued to evolve with new features. Originally, Avids were intended as an "offline" tool meant to serve as a creative editing solution; the actual edits would then be reassembled in a linear editing suite (called an online edit).

But as computers and storage technology improved, many industries started building programs on their Avids, then releasing them directly to broadcast. In 1993, a group of industry experts lead by a Digital Video R&D team at the Disney Channel found the key solution. Previously, computers had a limit of 50 GB of storage, but these engineers found a way to build a system that gave the Avid Media Composer access to over 7 terabytes of digital video data. The industry was reinvented again, with feature films now being edited nonlinearly.

These early days were interesting, with lots of innovation and technical challenges. The market saw competition from manufacturers like NewTek's Video Toaster and Media 100 editing systems. These both challenged Avid's dominance, mainly by attacking it on price. Other tools emerged such as Adobe Premiere, which offered both software only and a variety of third-party hardware options.

One late entry into the nonlinear editing space is Apple (which many see as a market leader). A group of engineers originally left Adobe to start a project called "Keygrip" for Macromedia. This project couldn't really get off the ground and was eventually purchased by Apple. It was seen as a way to compete with Adobe Premiere and a precautionary move since Avid had begun to move away from the Mac platform and push its Windows-based solutions. Final Cut Pro was unveiled in 1999—and originally was not taken seriously. Apple has continued to invest heavily in the product, however, making major strides in technology and value, leading the company to a dominant position in most market segments. A big part of Final Cut Pro's success was the advent of DV-based video formats, which use IEEE 1394 (or FireWire).

Nonlinear Editing Software

Lots of tools are used to edit video. Selecting the right one involves the balancing of several factors. If you are considering investing in a new NLE, be sure to evaluate these options. We have listed tools by top manufacturers, sorted alphabetically by manufacturer, then by cost. There are more tools on the market; these are just the most popular in the web video space.

Our Tools of Choice

We think it's important to be transparent here. Both authors have significant experience using nonlinear editing software. We both began using Avid editing systems. When we started RHED Pixel, we chose the Mac platform because of personal experience and our ability to maintain it. RHED Pixel was one of the first companies to adopt Final Cut Pro and use it for a variety of broadcast and nonbroadcast projects. We also use Adobe Premiere Pro (mainly for its excellent integration with Adobe After Effects and DSLR Video). We are open-minded and constantly look at new tools to compare their features and opportunities.

- **Adobe Systems** (www.adobe.com)
 - Adobe Premiere Elements (Microsoft Windows)
 - Adobe Premiere Pro (Microsoft Windows, Mac OS X)
- **Apple, Inc.** (www.apple.com)
 - iMovie (Mac OS X)
 - Final Cut Express (Mac OS X)
 - Final Cut Pro (Mac OS X)
- **Avid Technology** (www.avid.com)
 - Avid Liquid (Microsoft Windows)
 - Avid Xpress Pro (Microsoft Windows, Mac OS X)
 - Avid Media Composer (Microsoft Windows, Mac OS X)
- **Media 100** (www.media100.com)
 - Media 100 HDe (Mac OS X)
 - Media 100 SDe (Mac OS X)
- **Microsoft** (www.microsoft.com)
 - Windows Movie Maker (Microsoft Windows)
- **Sony** (www.sonycreativesoftware.com)
 - Vegas Movie Studio (Microsoft Windows)
 - Vegas (Microsoft Windows)

NLE Selection Criteria

Asking video pros to tell you which editing system they'd pick will often invoke passionate answers. Editors tend to have strong feelings about how they like to get their work done. When choosing for yourself, remember that there is no one-size-fits-all answer here. You'll need to balance out your needs and budget to choose the right tool. There are some selection criteria that you should be aware of. This advice is framed solely around use in web video, so keep this in mind when we make recommendations.

Cost

Nonlinear editing tools run the gamut in cost. For example, both iMovie and Windows Movie Maker are included with Apple and Microsoft's operating systems. So if you are looking for a tool at no additional cost, you likely have one. Both of these tools are effective, though many users eventually outgrow them as they develop their video editing skills.

At the next level, you'll find tools like Apple Final Cut Express for Mac and Adobe Premiere Elements or Sony Vegas Movie Studio. These tools start to increase the feature set for the editor and run between $79 and $299. These tools offer significantly more control over editing your video and fixing problems, but they do have a steeper learning curve.

But even the pro-level tools can be within reach of web video producers. Many choose to invest in options like Apple Final

Premiere Elements is a flexible tool that works well for Windows users.

Cut Studio or Adobe Creative Suite Production Premium. These bundles offer significant savings and combine multiple video tools into one package. These package deals are useful as they combine video editing, motion graphics, sound editing, encoding, and publishing tools into one bundle.

Be sure to fully explore the tools and their costs. It's also a good idea to visit a certified reseller or approach peers so you can try out the systems you are considering. You can also read video editorial reviews from magazines such as *Layers Magazine, Creative COW Magazine,* and *DV Magazine* where you can get independent opinions on editing software.

Ease of Use

Ease of use is subjective and depends on the individual user. We have heard from many that Apple, Adobe, and Sony lead the way with products that are powerful and easy to use. It is

Apple iMovie offers an easy-to-use interface and is designed for newcomers to nonlinear editing.

Looking for Training?

There are lots of companies on the market that produce training for video tools. Here are the ones that we personally use and believe in:

- **Creative COW**— www.creativecow.net
- **Future Media Concepts**— www.FMCtraining.com
- **Focal Press**— www.focalpress.com
- **Peachpit Press**— www.peachpit.com
- **Kelby Training**— www.kelbytraining.com
- **Ripple Training**— www.rippletraining.com

important to realize though that video editing is a complex task. Be prepared to pick up books, training DVDs, and even enroll in a class to learn video editing skills.

The biggest mistakes we see are from the people who choose to go it alone and teach themselves. Sure, you probably could have learned to drive a car with no outside help, but it would get really expensive with all those crashes and fender benders. Same holds true with video editing—if you are going to invest in expensive equipment, invest time and money in learning to get the most out of that gear.

Editing Formats

Different camera manufacturers have closer ties to certain NLEs, so be sure to investigate if your type of camera or video deck will work with a particular NLE. It's important that you fully explore this important connection before investing money in technology. A good place to start is to look at the manufacturers' web pages and see which equipment and video formats they list as supported.

Additionally, we prefer resolution independent NLEs. Tools such as Adobe Premiere Pro, Apple Final Cut Pro, and Sony Vegas allow you to bring in a variety of materials and mix them in one

timeline. This is particularly useful if you need to frequently work with photos or screen captures.

For example, our *Understanding Adobe Photoshop* series takes video shot on a high-definition video camera with nonsquare pixels and intercuts it with screen captures that are digitally acquired. The screen captures are generally larger (often much more) as we can then pan around and show close-ups of the software interface (we simply scale down to show the whole user interface). We prefer this flexibility, as it increases our working options.

Multicamera Editing Abilities

The ability to synchronize and edit multicamera video shoots is essential to web video. When executed properly, a multicamera shoot saves enormous time in the postproduction process. Once the angles are synchronized, it is easy to maintain continuity. Additionally, the material is easier to edit as you have multiple angles and can cut between them with a single keystroke. Multicamera options are available for most pro-level tools:

- Adobe Premiere Pro
- Apple Final Cut Pro
- Avid Xpress Pro and Media Composer
- Sony Vegas

Slated Takes

We have already discussed using a slate to sync and mark takes when in the field. Be sure the editor knows to look for these (and that whoever is loading the footage doesn't chop them off). This way, people not involved in the shooting process can have an easier time editing the web video.

Multicamera Assistance

If you're looking to edit multiple camera angles together, be sure to check out the different tools from Singular Software (www.singularsoftware.com). We find them to be a huge timesaver.

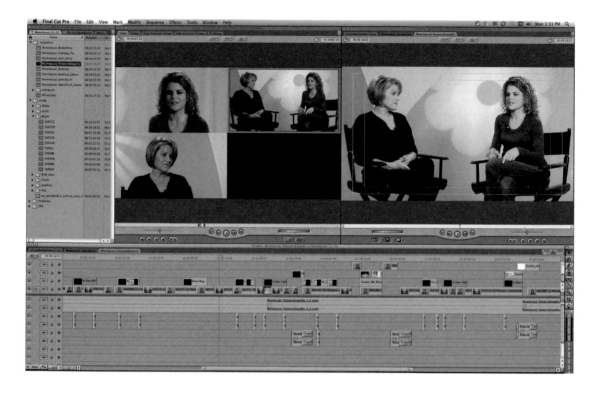

Export Abilities

Just as important as what you can put into an NLE is what you can get out. Most nonlinear editing tools fully support multiple web-ready export formats. Some build support right into the application via the Export or Share menu, while others offer more options through standalone compression tools.

It's important that you test the abilities of the NLE to make an MPEG-4, H.264, or Flash video file for use in web video. Although many editing tools do an adequate job, you may still consider some of the dedicated compression tools that we will discuss in Chapter 8.

Are Your Hard Drives Fast Enough?

Do you plan on editing multicamera edits? What about HD footage? Then you need to get some fast hard drives. Here are a few simple tips:

- Use the fastest scratch disk available on your system.
- Never use the system boot drive; it is too cluttered to perform.
- Look at RAID-style hard drives. These have multiple drives striped together for better performance. This is essential for uncompressed and HD formats.
- If your system supports them, take a look at adding serial ATA drives in and stripe them together for performance.

Adobe Premiere Pro offers a great variety of export options including Flash, DVD, Blu-ray, Windows Media, and MPEG-4.

Customer Support

As we've said many times, editing video is not easy. Therefore, you'll want to examine how much support is available for a product. Look at the company's website for an active user forum. Does the company offer certified training classes? How many books or DVDs are published on the tool? Can you find a local user's group in your area for sharing ideas and support? Different manufacturers have different levels of loyalty. Apple and Sony tend to have the biggest "zealots" followed by broad support for Adobe tools and a large established training system for Avid.

Technical Considerations During Editing

The editing stage is the place where all the pieces come together into the final story. In many ways, it all comes down to how the editor puts the pieces together. It is beyond the scope of this book to teach you how to edit. Rather, we'll identify the most common problem areas when it comes to editing video podcasts. These are the skills you must master (or find someone who has). Knowing what problems to watch for is the hardest thing. Here's what we've learned (often the hard way).

Determining Finishing Size

There is often debate as to how to set up your sequences for editing. Some suggest setting the sequences to match the finished web video size. Although this is a valid choice, we don't recommend this method. Working with nonstandard frame sizes

A Camera Is Not a Deck or Card Reader

We see many people plug their cameras in to load material into their video editing systems. This is a *very bad idea*, as it significantly stresses the equipment. Shuttling and rewinding tape can quickly wear out a camera, as can plugging and unplugging cables. You are much better off buying a tape deck or card reader to feed your material. This way you can have shooting and editing going simultaneously and your camera investment should last significantly longer.

usually results in significantly more editing and rendering. After all, it is easy enough to reformat the video when it is edited (more on this in the next chapter).

The best advice here is to set your video editing timeline to match your primary acquisition source of video. This means that if you shot DV NTSC, set your timeline to 720 × 480 nonsquare pixels. It is also a *very* good idea to stick with the sequence presets that ship with your editing software. Just be sure to match the right sequence settings to your footage. If you have to render everything in your timeline in order to play it, the sequence settings are wrong.

Determining Sequence Settings

It is important to set your NLE timeline up properly; otherwise the settings could lower the quality of your images. With a podcast or web video, determining the right sequence setting to use can be a bit tricky. This is because you'll often mix elements like video, archival material, photos, slides, and screen captures. The guiding factor is the format of your primary source material. You want your editing sequence to match your most dominant or important source.

Apple's Final Cut Pro offers flexible sequence settings. These allow you to create customized sequences to match nonstandard footage.

This generally means that you want to set your sequence to match your on-camera footage. The good news is that most NLE software tools make this easy. You should find sequence presets for common cameras or video formats. It is generally best to set your sequence up to match your camera footage so you get the most real-time performance from the computer and can edit without having to first render.

After the initial edit is complete, you need to evaluate your image quality. If your sequence contains heavily compressed footage mixed with higher-quality sources like screen captures or photos that use less compression, you'll want to "up-rez" your sequence. Duplicate your edited sequence, then modify its compression type (or codec) to match your highest quality material (such as Apple ProRes, Avid 1:1, or Cineform HD). You'll likely need to render much of the sequence, but this file will make a much better source for web compression.

Maintaining Optimal Color and Exposure

Many web video producers understand little about color correcting their video. This is because web video doesn't have the same rigorous issues of quality control as broadcast video. This

doesn't mean that you should ignore the stricter rules of broadcast television:

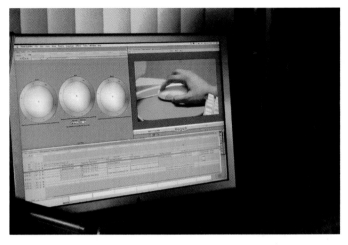

- Web video codecs work best when the source material has its colors and exposure set properly.
- You might also need to deliver your video for playback on a television.
- Following the best practices of video is literally good practice and will make all of the videos you do look more professional.

You want to make sure that you have adjusted exposure properly. Try to avoid blowing the image out. If it's a choice between too light or too dark, favor a little bit dark. Make sure you have sufficient contrasts because a lack of contrast will cause problems when you compress.

Most modern video editing tools include reasonably good tools for color correction. The problem is that most NLEs contain bad tools as well. In general, look for tools that offer three-way color correctors or curves-based color tools. On the other hand, avoid the use of brightness or contrast filters, as they are the two worst filters for fixing video images. Color correction is a tricky task, so be sure to invest in some training to learn which tools work best for your NLE.

Color Grading for Best Look

Color grading goes beyond mere color correction. It is the manipulation of color for artistic purposes. You'll often choose to manipulate the color in your podcast to help give it a visual identity. The manipulation of color is a powerful way to convey mood and style to your audience.

There are several third-party tools that are useful for manipulating color in your video. These plug-ins cost extra, but they offer powerful options that can simulate film as well as processing techniques used in cinema. Although you may not be able to do color grade on every show, download demos and try out some of the following tools:

- **Magic Bullet Suite** (www.redgiantsoftware.com)—Final Cut Pro, Premiere Pro
- **Nattress Film Effects** (wwww.nattress.com)—Final Cut Pro
- **Celluloid Film Looks** (www.vasst.com)—Sony Vegas
- **Tiffen Dfx Software** (www.tiffen.com)—Final Cut Pro, Premiere Pro, Avid

Using Color to Tell a Story

If you're looking for more on using color in your video productions, be sure to check out **The Visual Story** by Bruce Block or *If It's Purple, Someone's Gonna Die* by Patti Bellantoni.

Power Windows: Simple Vignettes

In the traditional color grading process, a vignette (or power window) is often added to the footage. Vignettes offer a simple way to draw a viewer's attention subtly to a person's face or some other object on screen. Most NLEs offer a vignette plug-in. You can also find a free vignette overlay file on the chapter's page at www.VidPodcaster.com.

Keep Getting Flash Frames?

Do you keep ending up with flash frames in your edits? The likely culprit is you! It is a bad idea to drag video to or around your timeline. It is an inaccurate way to edit and often results in "little" errors as a result of sloppy dragging. Instead you should use the precise trimming controls as well as set In and Out points for your initial edits.

Check for Flash Frames

Before we export a show and publish it online, we give it a thorough scouring. One of the things to check includes looking for flash frames. A flash frame is usually a one- or two-frame edit that is unintentional. It may be a few frames from a scene change or a small gap where no video is present.

It sounds meticulous, but step through your show and review each edit point. You can often find a keyboard command to cycle around your edit points, playing a few seconds before and after. Trust us, avoid flash frames—they are amateurish.

Consider Transitions Carefully

You will want to carefully consider the use of wipes and transitions in your podcasts. Oftentimes transitions will "break up" because of the limitations of web video. A transition (especially a dissolve) is much too complex to compress effectively. This is because so many of the pixels are changing at the same time and usually quite rapidly.

Most web compression relies on MPEG-4 or Flash technology, which is based on saving space by only updating pixels that change. When you use a wipe, it causes a spike in the data needed to show the image clearly. Because web videos generally have caps on their data rates, this results in the picture breaking up. Many producers eliminate wipes altogether and instead rely on the most basic dissolves and fade-to-color transitions (or even the most basic transition of all—the cut).

Avid editing systems offer several transition styles to choose from.

Dealing with Interlaced Material

There's a good chance that the video in your timeline is interlaced (even if it is shot at 24P). Most video formats involve some interlacing. This is a "leftover" technology from the earliest days of television. Video interlacing causes half of one frame to load, followed by the second half. This material is often identified as the upper or lower field (or even and odd). Essentially, every other frame of video is refreshed each 1/60th of a second for NTSC video and 1/50th of a second for PAL.

Although this is useful for video that is intended for television sets (it can produce smoother motion), it looks terrible on progressive type displays. An interlaced video file is jagged on a portable media player or computer display. Therefore, you need to determine when to remove interlacing:

- **Shoot progressive.** If you know that you're only delivering to the web, try to get rid of fields and shoot your video progressive.
- **De-interlace the timeline.** If your NLE allows, set your video editing timeline to progressive. You'll generally need to remove fields using a plug-in or effect. Most NLEs include a de-interlacer or flicker filter. A better option, though, is to purchase a re-interlacer and advanced de-interlacer plug-ins. Filters can take a while to render, so weigh carefully adding the filters to your edit. We generally recommend filtering during the edit if you want greater control or plan to export several versions of the file.
- **During compression.** Many compression tools offer the ability to de-interlace via a filter as part of the encode process. This option is valid but only works well if all the material in the timeline is from consistent sources. If you have mixed many sources in the timeline (such as footage from different cameras), it is often better to de-interlace your footage within the timeline itself via a filter.

Shot Selection

If you have a lot of experience editing video for other, more traditional, media, you'll need to retrain yourself a bit. Web video involves putting video out to devices that are not usually television

Dual Chain Errors

If you are using both FireWire hard drives and a camera or deck, you can have major technical problems. For most machines, the built-in FireWire ports all share the same system bus. This leads to major problems when you try to load video into the system and write it out to drives at the same time. The solution is to either capture to a second, high-speed internal drive or to hook up an additional FireWire card. This can often be added to an empty card slot in a tower or slipped into a cardbus slot on a laptop. These options will run you between $50 and $100 and will significantly cut down on technical issues like dropped frames and aborted capture errors.

The frame on the left shows how interlacing can affect image quality when viewed on a noninterlaced display (such as a computer or portable media player). The frame on the right was shot progressive with a Panasonic DVX-100B.

sets. This means you need to choose your shots with the playback medium in mind.

Your shot composition will tend to be tighter than you're probably used to. Instead of wide shots, you're more likely to use medium or medium close-up shots. This is because of the lower resolution and smaller size that most web video is published. The best thing for an experienced video creator to do is export and test the video early on. Get used to seeing your video on smaller screens and computer displays. Let this guide you as you select shots to use.

Audio Mix

Your web video may end up with several tracks of audio. Many editors will try to "troubleshoot" their audio mix. The editor intently listens to the show, as if intensity alone could move the edit from a "fine" cut to a "final" cut. Intense focus is a good thing, but make things a little easier by narrowing your focus.

We generally find that the only way to spot problems is to narrow our focus. Problems will stand out in your audio track when you listen to the elements separately. Use these tips:
- Turn off your audio monitors to listen to tracks (or pairs) individually. This way you can isolate problems with the audio tracks.
- If you've added audio edits to your music, do things transition smoothly, or are you trying to hide your music edits? Learn to use your NLE's trimming tools to finesse audio edits.
- Are there any loud breaths, gasps, or "guttural" sounds in your narration or sound bites? Throat clearings and coughs can be cleaned up easily.
- Because many viewers of your podcast or web video will listen with headphones, you should too. This way you get an idea of what the viewer will experience.

Audio Normalization

Pay attention to your audio levels. With the rise of portable media players and smart phones, many web video consumers have headphones jacked into their ears. If your audio mix keeps varying, with very loud areas being followed by areas that are very quiet, you will annoy your audience.

Audio is a much bigger issue when you've got the sound pumped directly into your ears. So a sudden blast because the talent got really loud will cause someone to take the ear buds out and turn your show off. Fortunately, many NLEs or bundled audio editors offer normalization gain. This process attempts to automatically smooth out your audio levels. It won't totally "flatten" the mix, but it will move it all closer to the middle. Your highest highs will drop to a specified target (in dBs) and your lows will be raised closer to the center. This is an important step and worth doing.

Run Time Strategies

We've rarely watched a web video that couldn't benefit from being shorter. Never forget your target run time. For most web video and podcasts, you are editing short-form entertainment or training. It is far better to keep it short and to the point. In our opinion, this is an easy way to meet the audience's needs and lower production costs.

You are financially better off if you can generate more episodes with less work. You'll do much better by thinking shorter and getting more individual episodes (making it easier for people to search for your content). This is actually what most audiences prefer—shorter videos, because they are consuming it as on-demand content.

Little Upcuts

 No matter how good of an audio editor you are, the more edits in your vocal tracks, the more likely you are to have small pops in your sound track. We usually add several four- or six-frame audio dissolves to all audio edits on a narration track. These short dissolves go a long way to smooth things out in your vocal track.

After adding the dissolves, be sure to listen to your mix. You want to make sure that when you add that dissolve, you're not picking up extra audio (random words and double breaths) from the media in the clip's handles.

Using Dynamic Noise Reduction?

 Many NLE's offer the ability to use a dynamic noise reduction filter. This technology works by sampling the ambient noise in a shot when people aren't talking. This can then be used to filter out the noise from the scene. Although this works great, here's an important piece of advice. Fix any sound problems like this first, before you start to edit. It is much easier to filter and fix the entire interview or on-camera take than it is to go back and do it 15 times because you made several edits. This will save you significant time and effort.

Keep an Eye on the Finish Line

Here's a suggested workflow to improve the quality of your podcasts. These steps should be completed in order and are based on a professional video workflow. The checklist can, of course, be amended with project-specific tasks, but here is a general list that you can adapt for your needs. Thanks to Robbie Carman for the suggestion.

1. Watch the show.
2. Note problems with video and audio using markers.
3. Color-correct the show.
4. Mix the show's audio track.
5. Check graphics for consistency (i.e., fonts, colors, position, and spelling).
6. Watch and get approval for the show.
7. Output the show and create compressed files.
8. Archive and back up the show.

Be sure you monitor your editing and agree-upon target length. For example, you may determine that you want all episodes to run between four to six minutes, but the show inched closer to seven or eight minutes. In this case, you should split it in half for two parts. If the show clocked in at twelve minutes, you could deliver two six-minute episodes or three four-minute shows. The important logic here is that you pick a target run time then manage your editing so the segments time out.

One trick is to add a marker in your timeline to make it easier to see your target run time. Remember, most shows benefit from editing out the "bad" parts. A shorter show helps you distill your content to only the best content. Trim the fat and get to the good stuff quicker.

Backup Progress

Save your work. There, we've said it. Having an organized approach to backing up your work is essential. We generally take a multifaceted approach to our backups. Here are a few strong suggestions for implementation in your projects:

- **Drive mirroring.** If the content we are using is irreplaceable (for example, screen captures or tapeless acquisition with no tape backup), then we mirror our drive. This involves getting an identical sized or larger drive and copying all of the content from the edit drive. We can recount a few times too many where this basic backup has saved the day. Once the project is done and archived, you can erase and reuse your mirrored drive.
- **Auto-save/Vault/Attic.** Most NLEs offer some level of control of the program's ability to autosave. This means that you can target a set number of automated project backups to be recorded on a different directory from the system drive or media drive. We often specify a removable drive like a USB "thumb" drive for backup.

- **Nightly backup.** We recommend giving every editor or graphics person involved in the project his or her own portable hard drive. Additionally, give the mandate that project files should be backed up every night before leaving work. This is a very good idea and puts ownership into the team's hands.

- **Use protected drives.** There are many affordable drive solutions on the market that automatically protect against data loss. We use drives from Drobo in our facility; they have a failsafe mechanism to account for drive failure (remember, *all* drives eventually fail).

- **Self-contained movies.** When you export your movie files for compression, we recommend "self-contained" QuickTime or AVI files. Many users choose "reference" movies, which are dependant on project media and render files. A self-contained file can be easily used in the future if DVD compilation or recompression needs arise. Hard drives have gotten much cheaper, and the extra effort is great insurance for the future.

- **Common Media Folder.** We're often asked about our backup strategies. What do we save, where do we store things on our drives? Here's one methodology that works for us. We create a Common Media Folder for each project. Inside we put folders for all sorts of common media types, such as a sequences folder, a capture folder to hold loaded video, a graphics folder, and an audio folder. Within these folders things are further broken down into source projects, renders, and so on. You will want to create a folder structure that works for you. By using the same structure for each project, it becomes easy to find project assets, as well as make changes. Plus, this folder can be easily backed up to a mirrored drive or archived at the end of a project.

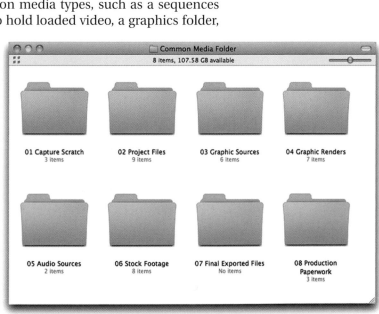

PRO*file*: LetsKnit2gether

LetsKnit2gether is a five to ten minute video podcast about knitting produced by CAT and Eric Susch. The episodes cover topics like knitting socks, blocking, felting, cables, knitting with ribbon, and lace knitting. LetsKnit2gether (www.LetsKnit2gether .com) focuses on intermediate to advanced techniques and take special care to show the actual knitting up close with simple and clear instructions. Let's Knit2gether is frequently featured in the iTunes Store Top 10 in the Hobbies category.

While many people focus on cameras, Eric Susch recommended keeping an eye on lighting and sound.

"Good audio is the single most important thing. If your viewers can't understand what people are saying, they won't care how pretty your pictures are. Good audio is also an unconscious sign of a professional production," said Eric Susch.

"Lighting is the second most important thing. We take a lot of care with the lighting for our demonstration shows. We shoot in our home and have several standard locations in different rooms so there is a bit of variety in the shows. I have very detailed lighting diagrams so that we can set up and break down quickly. We also shoot multiple shows at once so we can save time."

The show also takes "field trips" to knitting events like the Sheep and Wool festivals in New York and Maryland. There they try to capture the spirit of knitting culture. A recent field trip took the show to Shea stadium to watch a Mets baseball game with eight hundred knitters.

CAT Susch, who has been knitting for more than 20 years and develops all the demonstrations, hosts the show. Husband Eric handles all of the production and editing. Eric leveraged his experience producing shows for the Discovery Channel to create his web video series. The show is shot entirely in HD, with an emphasis on high production values and enjoyable content.

"We shoot everything in HD and finish to broadcast specifications. We use two different cameras for the two types of shows we do. For the demo shows we shoot with a JVC GY-HD110U," said Eric Susch. "For our 'field trips' we shoot with a Sony HC1 because it's small and non-threatening."

A focus on saving time and money is just one the lessons learned.

"Shorter is usually better (when in doubt, cut it out!). Podcasting is not time-based like TV, where every show has to be an exact length to fit in a time slot. Don't fall into bad TV habits by adding fluff to fill time because you lack content. Let your content decide how long your show will be. This is one of the advantages of podcasting over TV and your viewers will appreciate the fact that you are treating their time as valuable."

Eric Susch has embraced podcasting. He sees it as a valid alternative to traditional media outlets.

"A few years ago it was becoming clear that broadcast television was changing, and not for the better. Production budgets were getting smaller and smaller. The business is now about volume with every show getting more and more tabloid to get attention," said Eric Susch. "I started looking for a new outlet. When podcasting began I said to myself, 'How can we get into this and try it without spending any money on it?' Let's Knit2gether started basically as a test to see what this new

medium can do. CAT had all the knitting expertise (so the 'content' was free) and I had a lot of the equipment and production expertise. We could start a show and give this new medium the ultimate real world test. Our first year was extremely successful and our test has become something we want to continue and try to make money with."

Eric is now focusing his professional career on LetsKnit2gether and developing podcasting and new media programs for others. He is learning a lot as he goes, but offered practical advice for those starting out.

"Keep it simple… video podcasting can be whatever you want and that leads to many exciting possibilities. It's impossible to travel down all those roads at the same time and you can quickly become overwhelmed. Figure out what you want your show to be and stick with it," said Eric Susch. "Your success is not dependent on one or two episodes, it's based on the show as a whole. That leaves room for a misstep here and there. It's not a big disaster if you have a terrible show. Make any adjustments necessary and continue on."

Gear List

- JVC GY-HD110U camera
- Sony HC1 camera
- Sachtler System tripod
- Sony 17" HD LCD Monitor
- Arri Softbank 1 kit that has two 650 fresnels, one 300 fresnel, and a 1K open face with a chimera and an egg crate
- A 30" silver/white FlexFill
- Pro Prompter
- Schoeps CMC 5 microphone
- Electrovoice 635AB Wireless Microphone
- BeachTek DXA-2S XLR audio adapter

ENCODING VIDEO FOR THE WEB

While you work hard to have a great-looking video, delivering uncompressed video over the Internet is just impractical. Uncompressed video formats can top out at 1 GB per minute, and even DV compression still weighs in at 200 MB per minute. This would cost a fortune to deliver and even the most motivated audience members wouldn't be willing to invest the time in getting content.

Fortunately, video compression techniques and technology have dramatically improved. It is now possible to deliver video that looks great using data rates that measure 1 to 10 MB per minute. In fact, adaptive streaming technology has allowed video viewing on smart phones to grow enormously.

However, getting video to still look great despite the task of discarding 95% or more of the information takes skill, time, and technology. We can give you two of the three, you'll have to either learn patience or just keep buying a faster computer.

Image quality is essential as consumers start to watch web video on larger screens.

Server Side Encoding

For many web video and social media sharing sites, your video is going to be recompressed (no matter what you do). This is generally referred to as server side encoding, and it can really wreak havoc with the quality of your video. This is done in order to unify all of the video on a site and ensure that it plays back smoothly. Here are some things to keep in mind.

- **Be sure to look at upload limits.** You'll often have a cap on runtime and file size. Be sure your video falls beneath both or it will likely be rejected. For example, Facebook requires files to be less than 20 minutes and 100 MB, whereas YouTube allows 10-minute clips that must fall below 1 GB.

- **Check your options.** Most sites will accept several different upload formats. You are best compressing the video to an intermediate file that meets the upload requirements. Most sites accept H.264 video files, which offer a good balance of image quality to file size.

- **Test post.** Before you upload several clips, be sure to test post. Try out a compressed file and see how it looks. Find the right balance of image quality to file size in order to maximize the video's appearance online.

The Challenge of Encoding

The task of encoding video faces a triple constraint. To come up with the right encoding technique, you must balance file size, ease of development, and final quality. This is not unlike the old adage of good, fast, cheap—pick two. Unfortunately, you (and the world) want all three:

- Getting a small file size with good image quality is not easy to do.
- Likewise, you can usually generate high-quality podcast files quickly using default presets with the encoding tools, but the files will be unnecessarily large.
- Of course, you can make small files quickly by just throwing away information. But these fast encode methods don't deliver great-looking files.

Before you give up and think that this quest is hopeless, don't worry, we'll get you there. With a little knowledge, common sense, and patience, your files will look great and be ready to publish to the Internet.

Determining Delivery Format

You will face some important decisions early on when you want to determine your delivery format. For example, making video files that will work in an RSS feed is a lot easier than those that work on an iPod. Picking the right format is a give and take scenario, so let's explore some of the options.

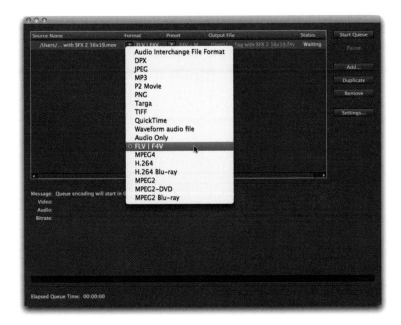

Most compression applications offer a choice of several formats. Adobe Media Encoder is included with Premiere Pro and the Adobe Creative Suite.

File Format

There are a myriad of formats available on the web. The driving factors here are the audience. If you're targeting a corporate environment, then creating files that work with the bundled Windows Media Player application is essential. On the other hand, you may be targeting mobile phone users, in which case MPEG-4 is the clear leader. Don't make the mistake of lumping online video formats together; they often have very unique properties.

MPEG-4

The MPEG-4 format is really a suite of standards with many parts. Each part offers a set of standards for aspects such as audio, video, and file formats. The standard was first introduced in 1998, but it continues to evolve with important new changes. MPEG is an acronym for the ISO/IEC Moving Picture Experts Group, which serves as the governing body for the format.

The two most common parts of MPEG-4 are part 2, which is used in codecs such as DivX and QuickTime 6, and H.264, which is part of QuickTime 7 and QuickTime X as well as Blu-ray Discs. We'll explore the newer H.264 in a moment, but let's first look at the common .mp4 file that is often used for the web.

Many compression tools offer the more plainly labeled MPEG-4 option. This generally means that the older MPEG-4 part 2 Simple Profile specs are being followed. This ensures greater

H.264 Is Future-Proof

With H.264, we seem to have a video format that most portable device and entertainment system manufacturers can agree on. The H.264 format gives excellent quality across multiple bandwidths—from 3G for mobile phones to HD television broadcasts. This is great news as it means there is a lot of support and effort being placed into tools and technology.

With H.264 being mandatory for the Blu-ray specification and the 3GPP (3rd Generation Partnership Project) standards, H.264 is going to be around for a long time. Additionally, major manufacturers like Apple, Sony, Nokia, SanDisk, Palm, Blackberry, and even Microsoft are onboard. If your content has an eye to the future, stick with H.264.

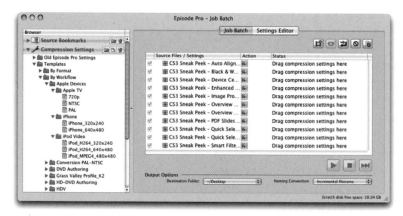

Many encoding tools, including Telestream's Episode Pro, offer presets for different encoding jobs. Note that certain players can handle both types of MPEG-4 video, while many newer devices prefer H.264 video.

compatibility with QuickTime 6. The format is also more likely to play using other web-based players such as RealPlayer and the open-source VLC media player. Some podcasters favor this format if they are targeting a user-base of running older computer operating systems. Although the format does offer broader support, it does not offer the same level of quality of the newer H.264 format.

H.264

The H.264 format is an extension of the MPEG family and is also called MPEG-4 Part 10, or Advanced Video Coding (AVC). This format is broadly used outside of podcasting and web video including uses for broadcast television and Blu-ray Discs. The format was first drafted in 2003 and saw widespread adoption by 2005. H.264 video wrapped in an MPEG-4 container is Apple's preferred format, as it is used for both movie trailers on Apple's website and TV shows and movies available for sale in the iTunes Store.

Support for H.264 extends beyond Apple. In 2005, Sony added complete support to the PlayStation Portable line. In 2006, Microsoft launched the Zune portable media player, which included both MPEG-4 and H.264 support. In 2007, YouTube began encoding all uploaded videos to both its standard player and H.264. This move was to broaden the reach of YouTube videos to the iPhone, iPod touch, and iPad models. Additionally, Adobe Media Player released in 2008 also supports H.264 in addition to Flash video.

The format was brought to life as a way to provide "DVD-quality" at half the data rate (i.e., file size) of the optical discs. Besides smaller file size, the format specs mandated that the format had to be relatively easy to use, not cost prohibitive, and work on devices from many manufacturers. The format has succeeded, and is the ideal choice for most video podcasters.

HTML5

While it's not exclusively a video format, the use of HTML5 is quickly gaining ground. One of the driving factors has been a platform war that has engulfed Apple and Adobe over the widespread use of Flash. With the launch of the Apple iPad in 2010, Apple made several public statements about why they chose to not support the Flash plug-in on the device.

When used correctly, HTML5 allows for embeddable players that can be deployed across multiple browsers and platforms. A number of high-profile websites including YouTube, Vimeo, and DailyMotion have begun offering HTML5 video.

There are a few limitations with HTML5 video currently. A major drawback is that HTML5 lacks a true video standard and instead supports multiple video formats. It also currently lacks the ability to play video in a full-screen window (unless the web browser can be enlarged full-screen). Many content creators are also wary because of deficits toward content protection issues.

AVC: H.264 by Another Name

Don't be surprised to see yet another name for H.264 codecs, which is AVC (Advanced Video Coding). This is meant to be a more "consumer-friendly" name. You'll see this term pop-up frequently in different manufacturer's products.

HTML5 Top Sites

HTML5 is a quickly evolving format; to keep up we recommend these links:
- www.webmproject.org
- www.apple.com/html5
- www.html5video.org
- dev.w3.org/html5/spec
- www.templates.com/blog/10-html5-video-players

Try Out HTML5

Want to give HTML5 a try? YouTube users can visit www.youtube.com/html5 and click the Join the HTML5 Beta link. YouTube is using a mixture of videos in the newer WebM format as well as the H.264 format.

The HTML5 player from YouTube is broadly compatible with many web browsers.

QuickTime

QuickTime is a broad category of technologies created by Apple. Its presence is woven throughout Apple's software and operating system. It's also available as a stand-alone media player and plug-in for the Windows operating system running Windows XP, Vista, or Windows 7.

Many users have QuickTime installed on their computers as it is bundled with the Apple iTunes software. With Apple's dominance in the portable media player and mobile phone markets, this software is likely on the computers for a consumer audience. In fact, iTunes currently has a 70%+ market share for the digital music industry.

The native format to QuickTime is a .mov file. This is a standard authoring format used by popular video editing tools like Final Cut Pro, iMovie, and Premiere Pro. The .mov format is really a container file and can hold video that uses a variety of codecs. Some of these are suited for the web, whereas others are meant for desktop and professional editing.

QuickTime In-Depth

For a detailed overview of QuickTime, visit en.wikipedia.org/wiki/QuickTime.

Flash Video

Many web developers favor Flash video since it supports both interactivity and tight integration with a website's user interface. Flash video options work well for embedded players. These can be added easily to blogs or other websites.

Currently, the Flash plug-in has had limited support on mobile devices. The primary complaints are power consumption and stability. The Flash format is used widely, however, as a streaming format for the web, as it can easily handle different connection speeds and data rates. We'll explore Flash video in greater depth in our next chapter.

The Pros and Cons of YouTube

Now owned by Google, YouTube began in early 2005. It quickly rose to the top of video-sharing websites offering both user-generated and professionally created video content. The service uses both Flash and H.264 video as the underlying architecture and has recently started experimenting with HTML5.

Google makes web video technology essentially transparent to the end user through a relatively easy-to-use web interface. Additionally YouTube has tie-ins with both Apple and Adobe software, which offer direct publishing in their consumer lines of software.

Although YouTube is popular, many web creators avoid it. The site has a "flea market" feel to it with everything being a free-for-all approach. Your content can get grouped with other content that is off topic or a direct competitor. YouTube also does not make it easy for most creators to monetize their content through advertising. As such, YouTube views are often seen as taking away from a video's financial opportunity.

Our take is to use YouTube as a promotional tool. Therefore, place some of your content online with the site. For podcasts that target niche or professional markets, you may want to avoid the website altogether and instead harness the power of embedded Flash players that you promote and make available on your own.

If you do choose to use YouTube, be sure to carefully read the terms of service. We have seen YouTube license the works of content creators for profit, while not sharing those profits with others. Additionally, be careful when using embeddable players. Always uncheck the Show Related Content option, otherwise viewers will be encouraged to leave your video and website to explore other videos on YouTube.

Windows Media

Windows Media Player is the default media player for the Windows operating system. With that said, it does not tie in well with Microsoft's own portable media player, the Zune. As a player, it can play back several formats including 3GP, AAC, AVCHD, MPEG-4, WMV, and WMA. It can also play back many AVI, DivX, MOV, and Xvid files.

Windows Media Video is the native video format for Windows Media Player. We don't recommend spending much effort to release video files in the Windows Media format. The architecture often suffers from compatibility issues between versions of the plug-in. Because the player supports formats like MPEG-4, we usually choose that path for broader compatibility.

Silverlight

Microsoft Silverlight is a proprietary application that works with web browsers. It can be used as a way to provide animation, vector graphics, and video playback capabilities of Windows Presentation Foundation. Silverlight can also play back WMV, WMA, and MP3 media content, but it lacks support for formats like MPEG-4 and H.264.

TiVo and DVR Players

A popular make of digital video recorders is TiVo. These boxes are popular among consumers, as they allow for the recording of television programs, which can then be watched at a later time. To broaden the appeal of the devices, TiVo has implemented support for podcasting and web video on three fronts.

The first way is that a select number of programs are available as TiVoCasts. These are essentially podcasts that are released at a large size and are intended for playback on the set-top boxes. These shows can be visually browsed and recorded for viewing like any other program on TiVo. In order for it to work, you'll need a TiVo Series 2 or later DVR and a home network.

Chances are that your program is not already listed in the TiVoCast directory, which means that a user has to manually subscribe. The second method is a little difficult, as the consumer has to use a remote control to enter the RSS feed. This process is not hard; it just requires that your audience have an exact URL for the media RSS feed. You can publish this address and instructions to your show's website. You can also use shortcut URL services like tinyurl and bit.ly to simplify the process.

The third way that TiVos support web video is through the TiVoToGo software option. This software enables you to connect a TiVo to PCs on a network in order to share audio and video files. This option is acceptable, but it is not as seamless as the two previous options.

Silverlight requires much more knowledge about web programming than do other web video formats. However, like anything Microsoft, its worth keeping an eye on as the company's technology continues to evolve with a mindset of reaching and serving the enterprise-level business market.

Although Windows Media and Silverlight are two very different technologies, they have several things in common. Microsoft makes them both, they both continue to evolve quickly, and they are both easier to create on a PC, but offer some Mac and Linux support.

Display Size

Getting the correct display size is essential if you want your files to work on noncomputer devices. If you intend your web video files to work on portable media players, you can have two standard frame sizes:

MacBreak is produced by Pixel Corps in HD. The show is then distributed at three different sizes to best serve its diverse audience.

	16:9 Content	4:3 Content
Portable media player	640 × 360	640 × 480
Mobile phone	320 × 180	320 × 240

On the other hand, video designed for high-definition playback can go larger. Devices like Apple TV, Microsoft Xbox, and Sony PlayStation can play back HD video. A variety of sizes can be used:

Input	Output
640 × 480	640 × 480
1280 × 720	1280 × 720 or 960 × 540
1920 × 1080	1920 × 1080, 1280 × 720, or 960 × 540

Before you decide on a delivery size, however, you'll need to analyze your target audience and its technological makeup. Keep an eye on how big your files are getting; you'll eventually reach a threshold of the customer's willingness to download. How big can the file get? Will people complain that the image quality doesn't look good, or will they complain that it takes too long to download?

Data Rate

The image quality of a web video is strongly affected by the data rate of the file. Data rate is often described in kilobits per second (kbps) or the larger Megabits per second (Mbps). These numbers are generally specified in the compression software and impact the total size of the file.

Higher data rates generally mean better image quality, but they can also increase the amount of hardware needed to play back the file. The data rate really becomes an issue when portable media players are involved. The larger data rate files won't work on most portable media players, as they don't contain the required processing power to play back higher data rates. Additionally, larger data rates can put a greater demand on power, which drains batteries quicker.

Should You Hyper-Syndicate?

We firmly believe that content creators need to explore the concept of hyper-syndication. The goal is to effectively reach the broadest audience possible. This means it's not a bad idea to try multiple delivery techniques. By releasing your content in multiple formats, you can reach more people.

Although a broad approach seems logical, there are a few risks. Using more than one format adds costs to both the compression and hosting stages. Your video's ranking on podcast or video-sharing sites can also suffer because you have your customer base spread across multiple channels.

Compression Tools

There are many video compression (or encoding) tools on the market. Knowing which one (or ones) to pick is a process of reading reviews as well as trial and error. Unfortunately, older tools like Cleaner XL and Procoder have not kept up with newer formats like H.264. On the other hand, less expensive compression tools for the price-sensitive podcasting audience have emerged.

Essential Features

When selecting a tool for encoding video, we look at several aspects including speed, reliability, and price. These types of factors are somewhat subjective and vary based on the video producer's budget, operating system, and specific needs. Here are a few specific features we look for when evaluating tools:

- **MPEG-4 support.** Support for the more basic MPEG-4 video using the "Simple Profile" is fairly common. With that said, make sure your encoding tool of choice supports this older format.
- **H.264 support.** Make sure that the encoding tool can create podcast files using the modern Part 10 protocols we discussed earlier. Older versions of encoding tools may not offer this option, but the newer versions generally do.
- **Flash video.** The next most common format is Flash video. Finding support for the older .flv format is easier than finding support for the newer .f4v. Ideally, the tool you choose will support both.
- **Apple compatible presets.** You need a good starting point for your media compression settings. Look for a tool that offers

A good compression tool should offer broad support for presets, as well as the ability to filter and resize your video. Stomp from shinywhitebox.com is a powerful and affordable Mac tool.

podcasting or iPod presets. This is the dominant media player on the market (by far). Ignore it at your own peril.

- **Customized presets.** An important feature is the ability to modify presets or create your own. By storing customized presets, you can ensure consistent results that are tailored to fit your podcast's needs.

- **Compression preview.** Through a compression preview, you can simulate what the end file will look like before you invoke a compression pass. This is a useful way to visualize what changes to data rate and codec settings will mean for your audience.

- **Batch processing.** The ability to batch process files is an essential time-saver. It allows you to add multiple files to the encoding tool and then apply presets to the files. This essentially means that the time-intensive tasks of compression can be run as unsupervised jobs overnight or on weekends. This is an effective way to make money or at least save time, as it allows you to focus on other tasks.

Affordable Compression Tools

As web video becomes the dominant standard for video consumption, there are many affordable (or even free) options to create web-ready video files. The biggest difference here is that many of these tools lack batch processing and often offer minimal support for customized presets:

- **QuickTime Pro** (www.apple.com/quicktime/pro). This versatile tool makes it easy to convert video from one format to another. QuickTime Pro is a cross-platform solution and lets Mac and Windows users convert video files to work with

Apple's portable media players. The files QuickTime produces are very compatible, but they don't offer as many options as other tools. QuickTime sells for $29.99 and is a preferred tool for most media pros toolbox.

- **iTunes** (www.apple.com/itunes). Although generally thought of as a podcasting client, you can use iTunes to convert incompatible media to an iPod/iPhone-ready format. Additionally, iTunes is essential for testing your files to see if they are compatible with Apple's portable media players. iTunes is a free, cross-platform solution.

- **iMovie/GarageBand** (www.apple.com/ilife). Apple offers a video editing and audio editing toolset as part of its iLife application suite. This software is bundled with all Mac computers and the upgrade to the latest version is $79. The tools are easy to use and offer robust support for creating web video content and then delivering compressed files. The iLife software is a Mac-only solution.

Adobe Premiere Elements brings flexible editing and encoding tools to the consumer.

- **Adobe Premiere Elements** (www.adobe.com/products/premiereel). This versatile suite is well suited for Windows

users. It offers an easy-to-use editing interface and robust support for podcasting, Flash video, and YouTube. This is an excellent solution priced at $99 that offers flexibility and power without being overly complex.

- **MPEG Streamclip** (www.squared5.com). MPEG Streamclip is a powerful video converter, player, and editor. It works on both Mac and Windows. It can encode to many formats, including podcast-compatible formats; it can also cut, trim, and join movies. The biggest benefit? It's free!

MPEG Streamclip is a free, cross-platform tool for viewing and creating MPEG-4 files.

- **Stomp** (www.shinywhitebox.com/stomp/stomp.html). This Mac-only tool bridges the gap from consumer to professional. It offers an easy-to-use interface but also unlocks filters and customized presets. The tool produces great results and offers excellent visual feedback when changes are made to a clip. Another unique feature is that the tool offers Core Image Filters, which are fast and can perform tasks like color correction.

- **Microsoft Expression Encoder and Expression Encoder Pro** (www.microsoft.com/expression/products/Encoder4_Overview.aspx). This PC-only tool comes in both a free and a pro version. It replaces the Windows Media Encoder, which was retired in mid-2010. It can create both Windows Media Video and Silverlight files. The Pro version can also output H.264 and AAC files as well. The application offers screen capture abilities and can also handle captions and basic editing tasks.

Testing and then sticking with compression presets can ensure compatibility with portable media players.

Full-Featured Compression Tools

If you work with professional-level video editing tools, there are often professional-level encoding tools designed to match. There is nothing wrong with the affordable tools mentioned earlier. These tools just match all five criteria we identified at the start of the chapter.

- **Sorenson Squeeze** (www.sorensonmedia.com). Sorenson offers several variations of its Squeeze product line depending on features that you want. This is a cross-platform solution and is popular because of its ease of use. The product's price varies depending on if you need Flash video support and which platform you choose to use. This is the leading PC product on the market. Sorenson also offers a hardware option for faster compression.

- **Telestream Episode and Episode Pro** (www.telestream.net). The Episode Series offers several options for encoding media to several formats. The tools are Mac only. They offer both customizable presets and a flexible filtering engine for improving video. The products are also very fast and have had frequent updates with improved features. The most common tools used by podcasters are the Episode and Episode Pro packages. These are desktop encoders that use the computer's hardware to perform the encode.

- **Apple Compressor** (www.apple.com/finalcutstudio/compressor). This powerful compression tool is included with Apple's Final Cut Studio bundle. It has full support for batch processing and filtering. It also offers powerful networking features that let you tie multiple computers into a compression cluster, which offers significant increases in speed. The product is only sold as part of the bundled Final Cut Studio suite,

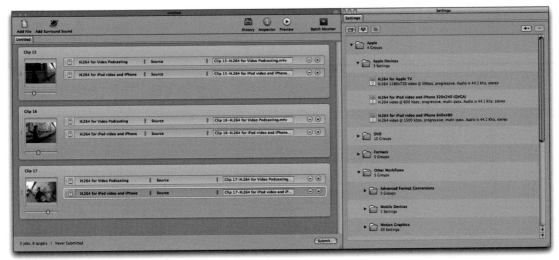

Apple's Compressor is bundled with Final Cut Studio. It offers a full-featured toolset and tight integration with Final Cut Pro.

which means you likely have it if you are using Final Cut Pro or Motion. Otherwise the suite is too comprehensive to buy for just this one application.

- **Adobe Media Encoder** (www.adobe.com). The Adobe Media Encoder is not a standalone product. Rather, it is a core technology in the Adobe Creative Suite products that work with video. You can easily access it through products like Premiere Pro. It supports several formats besides podcasting and offers excellent control.

Encoding Advice

There are four major facets that will shape your compression or encoding approach. We call them the "illities" to make them easier to remember.

- **Portability.** How easy is the file to get from one device to another? Is the compressed file small enough to transfer via the Internet (and at what connection speed)?
- **Compatibility.** Can multiple applications, hardware players, and web browsers view the file?
- **Affordability.** Are the codec or hardware requirements within your budget? Are there any licensing fees involved?
- **Quality.** Does the image or sound quality match your audience's needs?

If you keep these four aspects of video files in mind, the following compression advice will make sense. There are a lot of easy things you can do to make your web videos look better. These things usually happen in the compression software via filters and image processing. The more of these you can fix, the better results you'll get. Every compression tool is different, but you'll usually find these options in the export dialog box or help menus.

Faster H.264 on a Mac

If you want to dramatically speed up the creation of H.264 files, be sure to take a look at Turbo .264 HD from Elgato (www.elgato.com). This accelerator plugs into a USB port and can decrease processing time by 400%. This is really a great way to quickly optimize clips with presets for iPods, Apple TV, and PSPs. Priced at $99, this is an easy way to save time when compressing podcasts.

The Language of Compression Simplified

There are several bits of lingo that will pop up when working with compression software. Here are the most common with their plain English translations:

- **Architecture.** This is like the global family or classification of a file. It includes things such as MPEG, QuickTime, Windows Media, and AIFF. It is the "global" picture.

- **Batch processing.** A benefit of many compression utilities, as it allows you to set up several files to run. This is a key benefit because it allows you to walk away and leave your computer working hard.

- **Bit rate.** How much data per second there is in your file. The higher the number, the larger the file.

- **Channels.** Most common will be the choice between stereo and mono. Stereo files use two channels of audio data and occupy twice the space as mono files.

- **Codec.** Stands for compressor/decompressor. The algorithm of code allows for further shrinking of the files. In some cases, compressors cost additional money to the content creator. Decompressors are usually free to improve the distribution plan and market share.

- **Compress.** The process of shrinking the file using mathematical algorithms. Modern compression techniques are significantly more effective than their historical counterparts.

- **Pixel aspect ratio.** Computer pixels are square in shape, digital video pixels can be rectangular or nonsquare. The video editing software or playback device (such as a television) usually compensates for this. Because you plan to show the video on a computer or iPod, you will need to manually resize the document to the right shape.

- **Resolution.** Also called sample size, it is the number of bits used by the computer to describe the analog data. Audio CDs are usually 16-bit. Bigger is higher quality.

- **Sampling rate.** The number of samples captured per second. Audio CDs are usually 44.1kHz, whereas digital video is usually 48 kHz. Bigger is higher quality.

- **Variable bit rate (VBR) compression.** One of the most effective ways to create smaller files. The computer analyzes the video file before compressing the data. Encoding this way is far slower, but if you can choose this method for superior results.

Start Big, Finish Small

Be sure to work with original source material or low compressed sources. By sticking with DV or better quality, you'll get better compression and smaller file sizes. Recompressing a previously compressed file produces additional artifacts (think making a photocopy of a photocopy).

De-interlace Your Video

The video frame on the left shows interlacing in the fast-moving areas. The frame on the right shows the interlacing removed.

Most NTSC and PAL video files are interlaced; some HD video is interlaced. This means that half of one frame is blended with half of the next. On a television, this produces smoother motion; on a computer or portable media player, it produces junk.

Most compression software offers a de-interlace option via a checkbox or filter. If you are shrinking the video down to the smaller 320 × 240 size, the basic de-interlace filter is fine to use. If you are targeting the 640 × 480 size video, then be sure to use an advance de-interlace option (such as blend or interpolate). These generate better quality but can add significant processing time.

Lower Your Audio Standards

You can often lower the audio quality of your podcasting files. Digital video generally uses a sample rate of 48 kHz, while audio CDs are at 44.1 kHz. The audio is also usually delivered in 16-bit. If your audio is not complex (such as music), you can cut your sample rate. Different tools allow you to change to different rates depending on codec. This can produce unnoticeable audio changes but allow space saving.

Shrink the Window

Although you don't need to make video that is the size of a postage stamp, remember that reducing the window to half-size creates a file that is 25% of the file size of the original. That's a *big* savings in space. These files are four times faster to download or stream. Strongly evaluate the size that you use to deliver your web video.

Going to Flash?

If your podcast is going to end up in a Flash player as well, be sure to convert your audio rate. Video cameras generally record at 48 kHz, which Flash can't handle. Unless you want to hear "chipmunk sounds," be sure to convert to 44.1, 22, or 11 kHz.

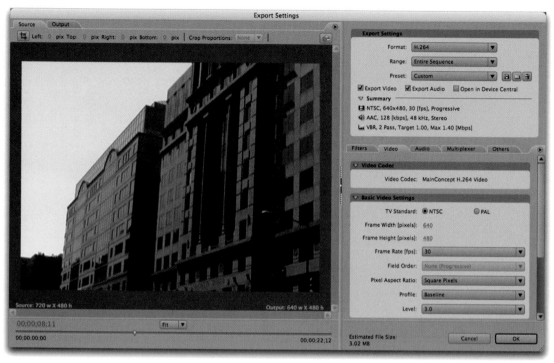

Be sure that your video is being sized to no wider than 640 pixels for use on a portable media player. The correct width is 640 × 480 for 4:3 video and 640 × 360 for 16:9 video. For half-screen video, divide these numbers in half. Like most pro-level compression tools, the Adobe Media Encoder gives you precise control over size and reshaping.

The Rule of 8

Be sure that any dimension you use for a codec is divisible by 8. When a dimension can be divided by 8, it allows the codec to work most efficiently. Otherwise the codec must do additional processing before displaying the material. This results in longer encode times as well as increased challenges for the playback machine.

Reshape the Video

For standard definition, you're likely working with a video file that is sized 720 × 480 or 720 × 576 pixels. You need to resize this to 640 × 480 for it to properly display on the computer monitor or portable media player screen. If the video is widescreen, then use 640 × 360. You must compensate for pixel aspect ratio with your web video. Additionally, you should exceed a width of 640 or a height of 480 if you want the files to work on a portable media player.

If you're working with high-definition sources, you may still need to reshape video. Some high-definition video cameras also use nonsquare pixels. There are generally three target video sizes for HD video: 1920 × 1080, 1280 × 720, or 960 × 540. The larger two sizes are usually reserved for downloadable video (although movie trailers are often viewed in true HD by cinephiles).

Restore the Washed-out Picture

Video signals usually operate between a RGB values of 16 through 235. On the other hand, computers use an RGB value of 0 through 255. You will need to restore the back-and-white point of your image. Many applications have this option built in as a filter.

The biggest concern is to restore (or crush) the blacks. This will help reduce visible noise in the file and result in a cleaner compression. Look for options called Black-White Restore or something similar. Usually the default preset will work. You can always adjust the filter until unwanted noise is removed in the shadowy areas. This is essential if your material contains shadowy or dark areas.

Improve the Saturation

A video file intended for podcast may also need the saturation turned up a bit. This is to compensate for what we call the "Wal-Mart effect." Consumer TVs have their reds overcranked to make skin tones appear richer on their cheap tubes. As such, consumers are used to viewing rich reds and saturated images. Just be careful to not overdue it, or your talent will look like they fell asleep in a tanning bed. Many compression tools lack a saturation effect, so be sure to boost the saturation within your NLE if needed.

Frame Rate Reduction

Fortunately, web video compression is good at saving space. You can still often see a benefit in file size though by reducing frame rate. One method involves shooting the video at 24 fps, which results in less material to encode. Another technique is to try cutting the frame rate in half after you've shot (such as dropping to 15 fps for NTSC or 12 fps for PAL). These tests are worth trying in your experimentation to determine the right settings for your video.

Test Your Settings

Looking for a Great Source on Web Compression

One of the resources I find most useful for current information on web compression is www .proappstips.com. Here you'll find a wonderful PDF called *Simple Encoding Recipes for the Web*. These recipes are just that, step-by-step directions for popular tools like Compressor, Squeeze, and Episode. The information works well for podcasting and covers other delivery methods like YouTube and web pages as well. The PDF sells for $4.95 and its author, Philip Hodgetts, is a respected member of the professional video community. This is a highly recommended resource of ours. It even includes links to web pages so you can compare the results side by side.

Your quest for "perfect' compression will involve trial and error (often a lot of trial and a little too much error). A good place to start will be the default settings your compression tool offers. Duplicate a preset setting, and rename it (such as Flash_Large_2). Then modify a few of the variables we've discussed here. Remember, the biggest impact will be the data rate of your web video. You will often make several settings that are only slightly different, and then test them. When testing, remember to use a short edited clip that contains multiple types of footage and audio to judge the impacts of compression on motion and audio.

Before you compress a lot of video, create a small test file. Try compressing 30 seconds of video with different settings. This test file should ideally include a mixture of footage and graphics that will be in your final shows. The goal is to find compression settings that work well with your material and are also compatible with the technology your audience wants to use.

Testing the Video on Multiple Devices

Always (and we mean *always*) test each web video setting by taking its files and transferring them to an intended player. Put the file on an iPod and an iPhone, put it on a PlayStation Portable, put on a laptop, look at it on a Mac and Windows box, and try a Microsoft Zune. You need to test your settings because something can go wrong with the file.

Trust us, we've been burned. A lot of factors are in play here. You don't want to alienate your audience or anger a client because of a careless mistake or change in delivery protocol. Post bad files, and the backlash can be strong. If it's any incentive, you may be able to write off the purchasing of additional technology on your taxes (be sure to discuss this with your accountant first).

Section 508 Compliance

The goal of Section 508 is to ensure equal access to information. Photo © istockphoto.

Starting in 1998, the U.S. Congress amended the Rehabilitation Act to make it easier for people with disabilities to access information through electronic means. The goal of the changes was to remove barriers to information so that "disabled employees and members of the public have access to information that is comparable to the access available to others."

If you create content for the federal government, Section 508 compliance has become increasingly important. Many state governments also follow suit. In fact, if the project you're working on receives federal or state funding, it may also be subject to Section 508 compliance.

Understanding Section 508 Compliance

For more information on Section 508 compliance, see the following websites:
- www.buyaccessible.gov
- app.buyaccessible.gov/baw
- www.section508.gov
- www.accessibilityforum.org
- www.access-board.gov/sec508/refresh/report

Impairment Types

Section 508 compliance attempts to assist those who face barriers to information. The standard is broad, so it applies to those who make content as well as software and even hardware devices. The groups it attempts to help can face one or more of these impairments:

- **Visual.** Blindness, low vision, or color-blindness.
- **Hearing.** Deafness or hard of hearing.
- **Motor.** Inability to use a mouse or limited fine-motor control.
- **Cognitive.** Learning disabilities or an inability to remember or focus on large amounts of information.

The Impact to Web Video

Section 508 law applies to all federal agencies when they develop, procure, maintain, or use electronic and information technology. Video is one part of that technology. The relevant requirements can be found in section 1194.24 Video and multimedia products (items c, d, and e):

The use of audio descriptions can provide a clearer experience for those with visual impairment.

(c) All training and informational video and multimedia productions which support the agency's mission, regardless of format, that contain speech or other audio information necessary for the comprehension of the content, shall be open or closed captioned.

(d) All training and informational video and multimedia productions which support the agency's mission, regardless of format, that contain visual information necessary for the comprehension of the content, shall be audio described.

(e) Display or presentation of alternate text presentation or audio descriptions shall be user-selectable unless permanent.

If you're creating content independently, there is nothing in section 508 that requires you to comply. However, many voluntarily comply. Making your content more accessible means more potential viewers.

Visual Impairment Strategies

Although many forget the potential audience, those with visual impairments want the same information as others. The most common approach is to add audio description to the video. What is added is similar to that provided by a play-by-play announcer. What's important is to highlight essential information that is needed to comprehend the content. This often includes a description of the people in the video as well as descriptions of their on-camera actions.

For those with partial visual impairment, there are ways to improve the appearance of the video. As you build your graphics, you should check them in grayscale mode for proper contrast. The same holds true for your video footage. While shooting, be sure to look at your video on a grayscale monitor. The better the contrast, the easier it is for viewers to comprehend the information on the screen.

By offering both captioned and noncaptioned versions, this government-produced podcast is in compliance with Section 508 requirements.

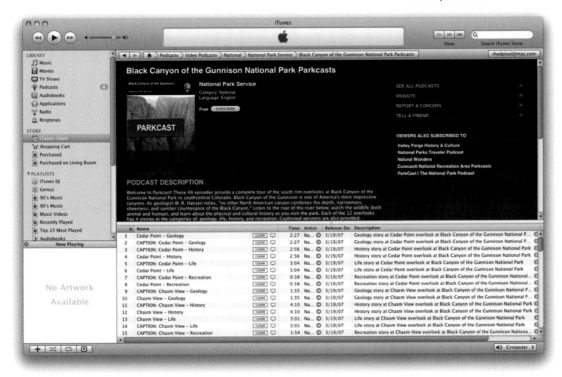

Hearing Impairment Strategies

The types of accommodations that are most prevalent are for those with hearing impairments. The goal here is to provide an accurate transcription of the video program. Additionally, these steps can also improve the search engine optimization for your videos and make them easier to find. How you accomplish this can be done in two ways.

The first approach is to provide open captions, which place the words of the video onscreen (typically synchronized to the speaker's voice). These can be added using technology that is similar to what broadcasters use (which tends to cost between $15 to $40 per minute from most providers). There are specialized software programs such as MacCaption and CaptionMaker from www.cpcweb.com.

Searchable Video in Flash

 Adobe has a whole suite of tools; audio transcription can be accomplished with Adobe Soundbooth. Flash video can also embed synchronized and searchable text. For a tutorial on the entire process, visit http://tinyurl.com/flvsearch.

When creating captions for web video, a viewer must be able to turn captions off and on or they must always be visible. Here graphics are edited above the video track, so these will always be visible.

Captioning for QuickTime

To learn more about support for captions inside of QuickTime-based media, visit www.webaim.org/techniques/captions/quicktime.

The other approach most commonly employed is the use of transcripts. By creating an accurate transcription, those with hearing impairments can read along. Transcripts can be placed on the web page that holds the video. They can also be added as a PDF to a podcasting media RSS feed. Transcription typically costs between $1 and $5 per minute. Costs vary based on turnaround time and the number of speakers. If your video is scripted, then transcription is easy to accomplish.

Advertising
Animation
Banners
Playback
Presentations
Sample Fil...

ActionScript 1.0
ActionScript 2.0
Adobe AIR 2
iPhone OS
Flash Lite 4
ActionScript File

9

UNDERSTANDING FLASH VIDEO

Flash Video is actually an all-encompassing term. The architecture has many different components (including three file extensions and three different compression types). Since the addition of video into version 6 in 2002, Flash has gone on to claim market leader status. In 2009, Flash video accounted for 75% of all online video consumption.

Flash's popularity has been driven by two forces. Developers prefer it as it offers a cross-platform browser-based application. This makes it much easier to author once and deploy to many screens. Web consumers have been attracted to it because of both its ubiquity and its ease of use. In fact, it's estimated that Flash technology is installed on 99% of all computers in mature markets.

Here is the methodology for the survey (www.adobe.com/products/player_census/methodology).

Worldwide Presence of Flash Player by Version, June 2010

	Flash Player 8 and Below	Flash Player 9	Flash Player 10
Mature markets[1]	99.3%	99.2%	97.5%
United States/ Canada	99.1%	99.1%	97.5%
Europe[2]	99.3%	99.0%	97.9%
Japan	99.7%	99.7%	97.1%
Emerging markets[3]	99.0%	98.9%	96.1%

1. Mature markets include the United States, Canada, the United Kingdom, Germany, France, Japan, Australia, and New Zealand.
2. Europe includes the United Kingdom, Germany, and France.
3. The emerging markets include China, South Korea, Russia, India, and Taiwan.

The Push for Mobility

 For an informational resource document about Flash on mobile devices, be sure to see www.adobe.com/devnet/devices/articles/content_mobilization_faq.html.

The History of Flash

For a comprehensive overview of Flash technology, be sure to visit wiki.gis.com/wiki/index .php/Adobe_Flash.

Flash technology has continued to evolve. Its current focus is on substantial expansion into the mobile market. The Flash Player has recently undergone major enhancements to prepare it for broader use on smart phones, tablets, and netbooks. Adobe has added support for a variety of controls including multitouch, gestures, and accelerometer input.

A key to Flash's future success will be its ability to successfully tap into hardware acceleration. This hurdle has been better overcome on the PC platform than on the Mac. Being able to transfer H.264 video decoding over to hardware will significantly improve performance and power consumption. Video delivery is also being improved with HTTP dynamic streaming, which can automatically adjust the quality of video as connection speeds change (such as with mobile devices).

Mobile phones like the Nexus One from Google run the Android operating system. Flash technology was recently enabled on these devices, which will significantly extend its reach. Flash also works on the Palm webOS and Symbian S60 platforms. Image courtesy of Google.

Delivery of Flash Video

Three primary workflows are used to get Flash Video files to your audience. Each method has its benefits and will influence how you choose to encode your Flash video files. Let's explore your options and the best scenarios for implementation.

Adobe Flash Media Server

One of the primary ways that video is delivered is through a stream. The three major benefits of streaming Flash content are that the content is optimized for fast delivery, the delivery servers can adjust to meet fluctuations in demand, and the content can be protected because it is never stored on the end user's computer. An additional benefit for sponsored content is that Flash supports detailed statistics (such as when people left a video that was playing). This type of information can be important to advertisers or funders.

If you want to employ streaming, you'll need to utilize a Flash Media Server. You can host your own Flash Media Server or use a content delivery network provider. The major benefit of a Flash Media Server is that it uses bandwidth detection to deliver the right-sized video to the customer. For example, a mobile phone user would receive significantly lower quality than a T1 modem user.

Apple and Adobe Go to War

There has been an increasingly public battle between Apple and Adobe over Flash technology. The spat has centered on Apple's active maneuvers to block a Flash plug-in from the iPhone. Recently Apple raised the bar and blocked the inclusion of applications for the iPhone that were built using Flash Professional.

Apple published a letter from its CEO Steve Jobs explaining why Apple would not support Flash on its iOS platform. This letter caused quite a reaction in the tech world.

Mixed into this battle is the whole HTML5 movement, which often views Flash as the poster child for proprietary systems. The truth is that the argument is much more complex than either side makes it out to be. Although it's true that other formats are gaining adoption, Flash is still quite valid. The inclusion of H.264 into the Flash ecosystem has ensured a broad compatibility for many years. With 99% penetration, it's going to be some time before consumers turn their back on Flash.

What's more likely is that websites that want to serve the iOS audience (the operating system for iPhone, iPod touch, and iPad) will adopt additional options. An HTML5 player can use the same H.264 encoded assets that are shared by Flash—thus, less work on the part of content creators.

TOOLS	FRAMEWORK	SERVERS	SERVICES	CLIENTS

Flash technology is truly an ecosystem. As a video publisher, you'll likely use Adobe software like Flash Professional or Flash Catalyst to build content. You can also create Flash video files with software made by other companies. Others in more of the information technology space will rely on servers and frameworks to power the delivery of video. The end consumer then uses the Flash Player plug-in or applications built with Adobe AIR for consumption. Image courtesy of Adobe.

Progressive Download

Another option for delivering Flash video is progressive download. This option can provide a similar experience as streaming, in that the video starts playing before the entire file

Need a Flash Media Server Partner?

Adobe keeps two lists of recommended providers for a Flash Media Server. The first list contains service providers who can host Flash video files at www .adobe.com/products/ flashmediaserver/fvss. The second list contains full-service publishing partners at www.adobe .com/products/flashmedia server/fmsp.

Adjusting Vibrancy in Photoshop – HD

By using Flash, this embeddable player from blip.tv can prompt viewers to watch additional episodes from the publisher. What's desirable is that the player can even be customized to link to a user-specified web address to drive traffic.

downloads. If the website accessing the video is a low-volume site and makes limited use of video, progressive download is a valid option.

The file does not truly stream. Rather it will begin to cache once a user clicks the video's play button. After enough video has downloaded to the local computer, the file begins to play. This option is popular because of its simplicity. It's important to note that it cannot scale to meet heavy demands, nor can it protect the files from being permanently saved to a user's computer.

Make sure your computers (and your audience's) stay up to date with the latest Flash Player. Flash compatibility quickly expands to add new features and provide better compatibility with more devices.

Adobe Flash Player Installer

This program will install Adobe® Flash® Player 10.1.
Usage subject to the **Flash Player Software License Agreement**

☐ I have read and agree to the terms of the license agreement.

QUIT INSTALL

Embedded Video

The final option is to embed the Flash video files directly into a Flash document. Once an SWF file is published, the video can be included. This approach can be used for very short clips (such as preloaders for a website).

Although these are the easiest files to author, there are several drawbacks. The published files can quickly become bloated. We also find that audio/video sync can drift. Lastly, any changes to the content require a complete republish and reupload of the SWF file.

Essential Flash Formats

Flash technology has continued to evolve through the years. This is due to several factors. First is the fact that it has changed hands a few times. The technology began with a company called FutureWave Software; it then became a center point for the growth of Macromedia. Eventually, it was a corner piece in the deal by Adobe Systems to purchase Macromedia.

Another driving force for evolution has been the rapidly changing web ecosystem. As rich multimedia content like audio and then video came into play, Flash continued to grow. The expansion of the web into portable devices and home electronics further created a need for a uniform format. As Apple and Microsoft fought out the QuickTime and Windows Media war, Flash quietly stole their customers away.

SWF

The SWF file format is an acronym with two meanings. The first is "Small Web Format." The acronym evolved to mean "Shockwave Flash." It is a repository format for multimedia content and it can also hold vector graphics. The SWF format can play back video files, but it can do much more. With authoring tools, an SWF file can offer interactive controls, connections to web content, and even immersive content like games.

FLV

The FLV format is the original and still most widely used Flash video format. It first appeared in Flash version 6. It has evolved from using the Sorenson Spark codec to a more space-efficient method, the On2 VP6 encoder.

On2 VP6

The On2 VP6 codec is the best choice when you're creating Flash video files that you'd like to import for further authoring. The files are compatible with the Flash Player 8 or later. The codec supports an embedded alpha channel, which means it's easy to layer the video with other elements in a Flash project.

The On2 VP6 codec is a significant improvement over the original Sorenson Spark codec. It offers higher image quality and lower data rates than the original Flash video files. The On2 VP6 codec does take more processing time to encode than Sorenson

Codec	SWF Version (publish version)	Flash Player Version (required for playback)
Sorenson Spark	6	6, 7, 8
Sorenson Spark	7	7, 8, 9, 10
On2 VP6	6, 7, 8	8, 9, 10
H.264	9.2 or later	9.2 or later

Spark. It also places more demands on the viewer's computer. Be sure you consider your target when deciding between On2 and Spark.

Sorenson Spark

The initial implementation of video in Flash was powered by the Sorenson Spark video codec. Sorenson has had a long history with video compression, having created a popular codec for QuickTime media as well as an encoding program.

While the Spark codec was significant for its role in bringing video to Flash, it is now considered obsolete technology. The only reason to still use it is for backward compatibility with significantly older versions of the browser plug-in. If your audience is locked into an older operating system or is severely underpowered, the Spark codec could be a good match.

Open Screen Project

Adobe and its series of partners have an interesting initiative to "provide a consistent runtime environment for open web browsing and standalone applications—taking advantage of Adobe Flash Player and, in the future, Adobe AIR." See www .openscreenproject.org for examples and news on their efforts.

F4V

The F4V format is the newest flavor of Flash Video. The F4V format draws on the open standard of H.264 (also called MPEG-4 Part 10 or AVC) and offers significantly better image quality and a smaller file size.

The drawback is that the files require more time to encode. They also take more processing power by the end user's computer to decompress and view. To successfully deploy an F4V file, the audience must be using a plug-in version of 9.0.r115. or later. This plug-in does work with older operating systems, but it requires the user's computer to be updated.

Another drawback of the format is that it lacks support for alpha channels. This can make it difficult to composite video layers into a multimedia project. The files also do not allow for ActionScript cue points.

These drawbacks are not meant to discourage you from using the F4V format. The use of H.264 video is increasingly growing in popularity. It also increases the chance of broader compatibility as web video continues to evolve. Just make sure your target audience can support the F4V files in their browsers.

Essential Tools for Creating Flash Video

There are many ways to create Flash video files. The path you take will depend largely on the end goals you have in mind. Some of the most popular tools for creating Flash video are made by the company behind the technology, Adobe.

Adobe Media Encoder

The Adobe Media Encoder is a full-featured encoding tool that offers several output formats. Another key benefit is its ability to import Premiere Pro and After Effects projects directly, and then output compressed files. Self-contained video files can also be optimized for use in Flash as an FLV or F4V file. The Adobe Media Encoder is fast to use. Because of its dedicated focus as well as its ability to process multiple files in a batch, video can be much more efficiently processed.

Settings can be customized to create Flash video files at various sizes and quality settings. You'll adjust data rate and playback size to compensate for different connection speeds and devices.

Flash Professional

It is possible to import video files directly into Flash Professional, then have them compress on export. Personally we don't recommend this workflow, as it makes a project cumbersome. You can turn to Flash Professional to develop rich interactive content. On its own, it offers sophisticated tools for animation, video delivery, and interactive design. You can also combine it with other tools from Adobe like Illustrator and Photoshop.

Flash Catalyst

Adobe Flash Catalyst is a new addition to Adobe Creative Suite 5. It is meant to be an easier solution for those looking to create rich video players and interactive content. It doesn't take too much effort to learn and it seamlessly integrates with Adobe

Illustrator or Photoshop for creating menus, buttons, and other user interface elements. Flash Catalyst is an excellent tool for building interactive projects such as portfolios, training modules, and entertainment websites.

Adobe Encore

Adobe Encore is typically thought of as a DVD authoring tool. It in fact has evolved into much more. You can publish your projects as DVD, Blu-ray, and Flash SWF files. It is a fairly intuitive authoring tool that makes it easy to combine video, audio, and photo files into an interactive player. Creating the user interface simply requires a trip to Photoshop.

Other Tools

There are many tools on the market for creating Flash video files. Although you won't find encoders included with tools from Apple, Microsoft, or Sony, there are many others willing to offer encoding tools. Here are a few we've used through the years (but there are many more to choose from):
- **Episode & Episode Pro** (www.telestream.net)
- **Sorenson Squeeze** (www.sorensonmedia.com)
- **DV Kitchen** (www.dvcreators.net/dv-kitchen)

Creating a Custom Player with Flash Professional

Although there are many Flash players on the market, many don't realize that Adobe Flash Professional lets you easily create your own custom player. There are lots of presets that allow for additional customization. By using the Video Import Wizard, Flash Professional will even guide you through the process:
1. Launch Flash Professional.
2. Click the Create New ActionScript 3.0 button.
 A new empty document opens that you can customize.
3. Choose File > Import > Import Video. The Import Video dialog opens.
4. Click the Browse button and navigate to a video file.
 You can precompress the file with the Adobe Media Encoder, or select an uncompressed movie.

When you launch Flash Professional you are presented with several choices. Use the Create from Template or Create New columns to jump start your project. Be sure to also check out the tutorials in the Learn column.

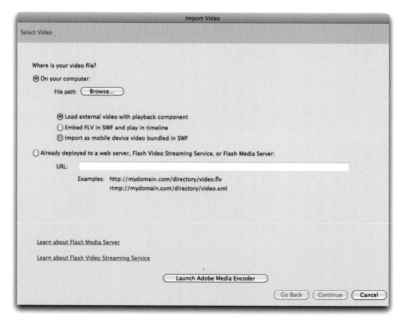

The Import Video window gives you several choices. Be sure to carefully consider where your Flash video files will be hosted.

Import Options

Once you select a file for import, you'll need to determine and specify how you want to use the video file. The Video Import dialog provides three choices for video import. Be sure to carefully consider your options:

- **Load external video with playback component.** This option lets you place the video file on either a web server or Flash Media Server. The project will also use an instance of the FLVPlayback component to provide controls for video playback. This option works well for both the Adobe Flash Media Server or a progressive download.
- **Embed FLV or F4V in SWF and play in timeline.** This option embeds the actual video file into the document. The video file is added to the project's timeline, and the video's frames are represented in the timeline frames. This option should only be used for very short clips, as it makes a very big file that must load entirely before playback begins.
- **Import as mobile device video bundled in SWF.** This option is similar to the previous embedding option. The difference is that it creates a Flash Lite document for use on mobile devices.

We recommend using the Load external video with playback component option. When ready, click Continue to go to the second page of the Video Import Wizard.

Skinning the Player

Once you've added video to a player, you'll want to add actual controls. Flash Professional has several sets to choose from, so you can give the end user control over playback, volume, captions, and more. Flash offers more than 40 skins to quickly add controls. Flash Professional gives you both technical and aesthetic controls.

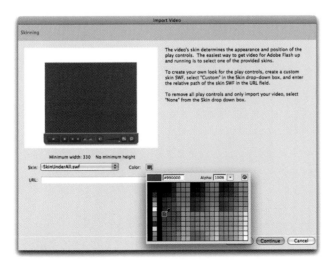

1. From the Skin drop-down menu, choose a skin to place a set of controls beneath the video.
2. Click the color swatch to change the color of the Flash controller.
 The color you choose may be driven by the website you intend to target or the color palette of your show or client.
3. Click Continue to go to the third page of the Video Import Wizard.
 Flash provides a summary of how it will process the video file. Quickly review the details of how the video file will be used.

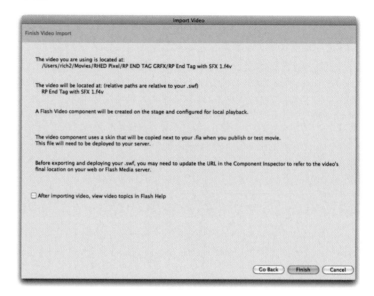

4. Click the Finish button to bundle the video file into the document for use in Flash.
 Flash processes and compresses the video file and adds metadata to the document. The canvas size may need to be adjusted to fit your video.

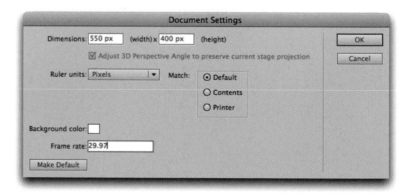

5. Choose Modify > Document.

 Enter a width and height that match your video (you can select the player and see its size in the Properties panel). If you've placed the controls beneath the video, be sure to pad the height of the document by 35 pixels. Also change the frame rate to match the source file.

6. Drag the player window until it's centered in the Flash document.

 You can also set the X and Y position in the Properties panel.

7. Choose File > Publish Preview > Default – (HTML) to preview the video file in a web browser window.

 Your computer's default web browser launches and opens a temporary HTML file. Experiment with the player and make sure it performs as expected. When you're satisfied, close the browser and return to Flash Professional. The document is ready for publishing or further modifications as desired.

Preprocessing for Video-Sharing Sites

Hundreds of websites offer embeddable players based on Flash technology. For many, this is a key way to embed content on their website and share with others. In this case, you are using the hosting services of the video-sharing site as well as their embeddable players.

Although many take a role-the-dice approach, we believe in preprocessing clips before we upload. By taking matters into your own hands, you can get better-looking clips in the final player. You can also get around some of the file size limits that can impede the duration of the video.

Let's take a look at two of the most popular services, YouTube and Facebook. The techniques discussed, however, can be applied to many other sites as well.

YouTube Technical Specs

Although YouTube can ingest many formats of video, it works best when you precompress your files. Uploading a Flash video file is one of YouTube's most preferred input formats. Here are a few technical specs to keep in mind:

Resolution	Export at a square pixel size. HD: 1280 × 720 or 1920 × 1080 SD: 640 × 480 or 640 × 360 (widescreen).
Frame rate	Preserve the frame rate of the original. Progressive frame rates without interlacing are preferable.
Video codec	YouTube strongly prefers H.264 video. As such, stick with the newer F4V presets.
Audio codec	MP3 or AAC preferred. Stick with 44.1-kHz stereo audio, or sync issues can occur.
Duration	Standard accounts are limited to clips under 15 minutes in length. We have seen some clips that run a few seconds over make it through.
File size	The uploaded file must be below 2 GB in size. Although this is not a hard target to hit, precompressing will cut down on upload time and delays in launching the clip. If you use the optional Advanced Uploader, files need to be less than 20 GB in size.

Here are a few more practical tips:

- **Aspect ratio.** Make sure to compensate for nonsquare pixels. Additionally, avoid adding letterboxing or pillarboxing bars. The YouTube player automatically adds these items. Adding your own can create a double-bar effect (called windowboxing) and make the video screen smaller.
- **Frame rate.** Load the videos in the correct frame rate. If you are using a video format with pulldown inserted (which is often the case for 24p tape-based formats), be sure to remove it in your nonlinear editor or compression tool.
- **Resolution.** YouTube supports up to 1080p for regular accounts. The site also has begun experimenting with 3D and higher resolution content from digital cinema. Try to go with the largest size you have access to.
- **Testing.** Make sure you load a test clip up before you post your real clip. This can be an excerpt or a clip you set to private. Once a video is released, there is no way to update it with a new clip. You'll have to remove the old one and release a new one, hence giving up on viewers and rankings.

Facebook Technical Specs

Just like YouTube, Facebook is very accepting of many technical formats. There is even more motivation to preprocess your footage though because Facebook has significantly lower file size limits. Here are a few technical specs to keep in mind:

Here are a few more practical tips:

- **Aspect ratio.** Make sure to compensate for nonsquare pixels. Facebook can handle video between a 16 × 9 and a 9 × 6 aspect ratio. This means that vertical clips *can* be uploaded. This is done to support the upload of video from mobile phones, many of which are held in a portrait orientation when shooting.
- **Frame rate.** Load the videos in the correct frame rate. If you are using a video format with pulldown inserted (which is often the case for 24p tape-based formats), be sure to remove it in your nonlinear editor or compression tool.
- **Resolution.** Facebook supports up to 1080p for regular accounts. The embeddable player is limited to stand-definition resolutions. High-definition video is only viewable on the Facebook site.
- **Testing.** Be sure to upload a short test clip before loading your real clips. Existing videos cannot be updated once they are loaded.
- **Tagging.** To increase the number of potential viewers, tag your video with people who appear in the video or contributed to its making. To tag, you must be "friends" with the person on Facebook.

Resolution	Export at a square pixel size. HD: 1280 × 720 or 1920 × 1080 SD: 640 × 480 or 640 × 360 (widescreen).
Frame rate	Preserve the frame rate of the original. Progressive frame rates without interlacing are preferable.
Video codec	Facebook recommends the older flv format with On2 VP6 encoding.
Audio codec	MP3 or AAC preferred. Stick with 44.1-kHz stereo audio, or sync issues can occur.
Duration	Standard accounts are limited to clips under 20 minutes in length. Loading up HD (or even SD) clips of this duration is not possible without preprocessing the footage and capping the data rate.
File size	The uploaded file must be less than 100 MB in size. You must preprocess the video with compression software before uploading, or your video will time out after a few seconds are uploaded.

PRO*file*: Produce Picker Podcast

All through high school and college, Ray Ortega spent several years working in produce. Little did he know that combining his background with an interest in producing web video would lead to success. The Produce Picker Podcast (www.producepicker.com) is a successful show all about "tips, tricks, and general know-how techniques of identifying, selecting, and preparing fresh fruits and vegetables."

"I heard a writer say, 'you should write about, what you know about.' I took that mindset and applied it to podcasting and the Produce Picker Podcast was born" said Ortega." I had an overwhelming passion to learn how to produce a web show. Combining that passion with the knowledge gleaned through years of work experience, I was able to produce a successful video podcast."

Like many web video creators, Ortega has had to develop strategies to keep his content fresh and think of new ideas. He points out that his show has plenty of room for creative growth before he runs out of ideas.

"Walk into any produce department in any grocery store and you'll see hundreds of items to talk about. Since my video episodes are short in duration I focus on only one produce item at a time. This leaves me with the potential for more shows than I will probably ever actually produce."

Ortega also emphasized his relationship with viewers as being an important part of the creative process. He literally takes requests, figuring that the most vocal members of his audience are a good representation of his viewers.

"I am often asked to do an episode about a particular produce item. Because I'm the one who decides on the content that gets produced, I'm free to change what I will do at any given time. I may be planning to produce an episode about oranges but I have one or more viewers asking for tips on how to choose an avocado," said Ortega. "The audience, in this way, helps me to produce content and when they see that I am listening to their suggestions and requests, they are often more likely to become that much more involved in my success."

Ortega takes his topic seriously and often scripts his demonstrations line for line. This is because he's trying to give highly technical information in a short period of time.

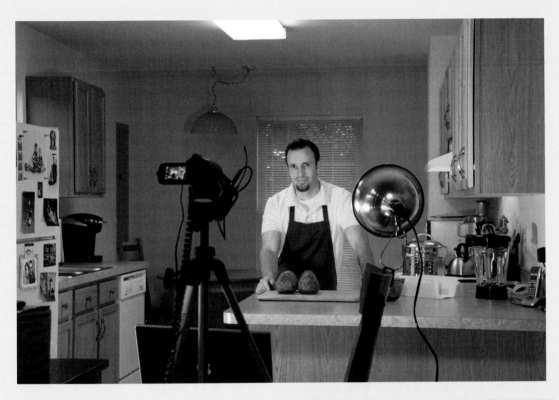

"Fortunately I'm working with a subject I know well so research is usually limited and often times I can just open a text editor and type away," said Ortega. "I want to make sure that it's accurate since the videos tend to be how-to based. However, there is always room for improv and almost certainly how each segment will be shot is decided on set and often is a very fluid process. While this is not what I would recommend to most producers, it does seem to work for my show."

Another lesson Ortega has learned is the need for pacing himself. When launching a show, he recommends that you have a few episodes ready so you can follow up and keep new viewers happy.

"I would definitely get more episodes "in the can" before publishing my first," said Ortega. "I was so excited to get things going with my first shows that I released them as soon as they were shot and edited. This workflow makes it very hard to produce content on a regular schedule."

"Producing quality web video is a lengthy process which is often undertaken by a single individual especially in the beginning. Shooting one episode can take several hours, editing much more than that and remember there is all the time you spend on promotion. Besides that, getting RSS feeds, websites, graphics, etc., all takes considerable time to produce."

Ortega's advice is simple… build up some cushion and make sure your infrastructure is in place before you launch. This includes making sure your website is working and promotional tools like Twitter and Facebook are live.

Ortega generously gives time back to the web video community. He's a board member for the DC Podcaster Alliance. He also runs a twitter feed (@PodcastHelper) and podcast about the art and technology of podcasting. Be sure to check out both his website www.rayortega.com and The Podcasters Studio.

Ortega offers two other bits of sage advice to those just getting started and on a tight budget.

"Find friends and/or family members willing to help you get started and stay on if you continue to produce content. You might be amazed at the talent that surrounds you and is willing to help out for free," said Ortega.

He also stressed the need to take a look around the web video ecosystem for inspiration.

"Watch other web shows. See what the successful shows have done. Get inspired by the creativity that is on the web and pull from all genres," said Ortega. "Develop your own style but don't feel like you can't be inspired by others."

PODCASTING AND RSS ESSENTIALS

There are differing opinions on the importance of podcasting. The meaning of the term *podcasting* is often debated; some take a broader view that includes the use of streaming video and web players, whereas others adhere to a stricter definition of downloadable media using syndication technology. What most people agree on, though, is that the world of digital media is constantly changing.

Podcasting is a symbol of that change. It is possible for a podcaster to reach out and connect with large audiences. These audiences may not rival those consuming mainstream media (although some podcasts regularly outperform cable and network television), but your odds of reaching a large percentage of a niche market is substantial. One thing is certain—the cost of reaching an audience through podcasting is dramatically less than it is through traditional distribution methods.

Just What Is Podcasting?

Many people refer to podcasting as portable on-demand casting. It is thought of as an alternative to broadcasting. Podcasting offers portable content that people can watch when they want, on a variety of players.

A Clear Definition of Podcasting

The majority of people are still confused about what a podcast is. They've heard the word, but if pressed to define podcasting, they'd likely say, "Well, you know, it's like stuff that you can download and watch." Although that's a true statement, it's a bit too vague. It's like asking, "What's a zebra?" and getting the answer, "You know, it's like an animal." To create podcasts, you'll need a solid understanding of the technology.

Podcasting is another name for audio and video blogging (you may also hear the words netcasting or videocasting used by some). The general idea is that you post audio or video content that someone can subscribe to. You are essentially creating a channel, one that you add audio, video, or print content to so it can be automatically downloaded to a subscribers' computer or media player. All of this can occur without the need for email blasts, people logging onto websites, or expensive shipping bills.

Additionally, podcasting is much more affordable than streaming and web video options. Podcasting uses a distributed model, so instead of everyone coming to your website and clicking (then wanting to watch the video at the same time), podcasts download in the background automatically. This means that podcasts are there, waiting to be watched whenever the consumer wants them.

Common Misperceptions about Podcasting

As a podcast producer, you may be called on to act as both an evangelist and a consultant. Not only will you have to give your clients a clear definition of podcasting, but you'll also need to debunk myths and misunderstandings.

Podcasting does not require an Apple iPod. Consumers can use all sorts of technology to consume podcasts including laptops, televisions, or a Microsoft Zune (as seen here).

The biggest misunderstanding is that people ask for a podcast when all they want is a video file that will play on an iPod. That is not a podcast; it is an iPod-compatible file. Releasing a single video file does not make a podcast; at best it's a webcast, a one-time sort of thing. The likely motivation here is that the clients want to do a press release saying they did a podcast or to report to their shareholders that they've launched a podcast.

So what is a podcast? There are a few criteria that must be met if you want your video to be considered a podcast:

1. **Highly targeted content.** The first is that the content should be highly targeted; that is to say, the content is intended for consumption by an interested audience. Podcasting is generally considered to be targeted at niche markets.

2. **Compatible files.** Additionally, the content can be an audio, a video, or even a print file that is distributed via the Internet. The technology relies on relatively open standards like MP3 for audio, MPEG-4 for video, and PDF for print.

3. **Syndicated.** For a web video to be a podcast, it needs multiple occurrences. Those occurrences are serialized, which means there is some sort of plan for when they come out. It can be daily, weekly, monthly, or as needed. Consistency with your release schedule is important for building an audience.

4. **Subscription option.** A key aspect of podcasting technology is its subscription component. Interested parties have the ability to subscribe to your podcast (and unsubscribe) at their own volition. The subscription part is what's really important and differentiates podcasts from other forms of web video.

This is the simplest definition that properly encapsulates all aspects of a podcast. All of these points need to be met if you want to create a podcast.

Not All Web Videos are Podcasts

In order for a web video to be a podcast, it needs multiple occurrences. Those occurrences are serialized, which means there is some sort of plan for when they come out. It can be daily, weekly, monthly, or as needed. Additionally, a podcast needs to offer a subscription component that can be joined or left at the end user's discretion

Is Podcasting Restrictive?

Although there are some strict guidelines of what makes a "true" podcast, don't let this scare you away from the technology. Any video that you create to use in a podcast can also be released by other means. You can take podcasting content and post it to video-sharing sites like YouTube; you can take any of the video files and embed them on a web page; you can even put the video on traditional channels like DVD or broadcast.

Devices like Apple TV and TiVo allow for podcasts to be viewed on television sets.

Who's Watching Podcasts

The podcasting audience is very diverse, but it skews toward younger individuals. Half of all listeners are under 35. The flip side of this statistic is that half of the audience is over 35, which means that you can reach a wide variety of people. Let's take a look at the specific breakdown.

Audience research has shown that 18- to 24-year-olds are more likely to download audio, and 25- to 34-year-olds are the biggest consumers of video. The popularity of video podcasting in older demographics is due in part to the need for faster Internet connections and more expensive hardware (both things that come easier to older, more affluent audiences).

What is important to note is that the podcast audience is pretty well diversified. For example, the same survey by Edison Media Research found that the podcast audience is 49% female and 51% male (essentially an even split). You'll need to make this a part of your business case when discussing podcasts with potential clients and industry peers. There are a lot of misconceptions about what podcasting is and who's watching. Your job is not only to make podcasts but also to help others understand in what situations podcasting works best.

Using a Podcast Aggregator

To make podcasts easier to find and consume, most people choose to use a podcast aggregator. An aggregator can be a standalone software application or a website. Consumers use podcast aggregators to browse podcasts that they are interested in. The podcasts can then be subscribed to for consumption of future episodes.

The Miro podcast player is unique in its broad support for platforms. Besides supporting Windows and Mac, the software runs on several versions of Linux, including Ubuntu and Fedora.

An aggregator automates the process of checking for new content. The user specifies how often the aggregator should check for new content (check every five minutes, check every hour, check once a day, etc.). Once new content is found, the user can also specify what should happen. An aggregator can download everything that's new, download on the newest episode, or simply inform the user that new content is available.

If a user wants to consume video podcasts, a broadband Internet connection is very desirable. Although a podcast can be consumed over a dial-up connection, it's a slow way to pull down large files. There are podcasting software solutions for Windows, Mac, and Linux users:

- **Apple iTunes** (www.apple.com/itunes)
- **Sony Media Go** (www.sonycreativesoftware.com/products/mediago)
- **Microsoft Zune Marketplace** (www.zune.net)
- **Miro Podcast Player** (www.getmiro.com)

Aggregators can also be content management systems. For example, a user can manage podcasts using Apple's iTunes or Microsoft's Zune software. Users can choose which episodes to sync with their portable players, as well as how to handle old content (such as automatically deleting previously watched episodes to save hard drive space).

What's Holding Podcasting Back?

One of the limiting factors of podcasting is the inertia new technology experiences in adoption. The mainstream population needs time to learn how new technology works and what it is good for. For example, TiVo-style DVR devices debuted in 1997, but the product did not go mainstream until 2010 (when it was estimated to be in 50% of all homes). For those of you counting, that's a 13-year journey.

Podcasts work on many portable media players including those made by Sony, Microsoft, and Google.

Portable Media Players Matter

 According to the Diffusion Group, 54% of podcasts are consumed on a portable device rather than a personal computer (www.tdgresearch.com).

Another of podcasting's limiting factors is its name. Many people are stuck on the word *podcast*, believing that they have to have an iPod if they want to consume podcasts. It is important to emphasize the features of podcasting, rather than its name. Many consumers are interested in accessing video that is highly portable and easy to get—content that speaks to their special interests, that can be subscribed to for convenience, and that can be delivered with little or no effort.

Consumer-controlled video is the future, and podcasting is on the forefront of that revolution. Over time, the market and technology will likely evolve. For a podcast (and podcasting as a whole) to succeed, it is essential to emphasize the benefits to the potential audience as well as enable the audience to consume podcasts in easier ways.

How to Explain Podcasting to Your Clients

We often find that many have misperceptions about podcasting, so let's establish an easy to reference analogy that can be used with clients. We equate a podcast to a media tool that behaves like TiVo or a magazine. Both of these media forms allow people to choose topics that they are interested in, both offer subscription models, and both allow time shifting and space shifting.

With podcasts and TiVo, people can watch or listen at their convenience—not just when a program is broadcast. Both podcasts and TiVo let viewers browse and search; viewers can pick what they're interested in and then watch it when it's convenient.

Many people browse and try things without ever subscribing. For example, you might find yourself at an airport with a little time to fill. You might walk up to a magazine stand and if a cover catches your interest you might buy it. After reading the magazine, you will likely make a decision about its value. You'll choose not to read it again, to try it out when you think of it, or to subscribe. The idea with podcasting is similar to a magazine—a show's long-term success is dependent on getting viewers to subscribe.

An Overview of RSS

RSS technology was designed with convenience as the primary goal. The purpose of RSS is to make it easier for members of your audience to find out about new content and have that information delivered to their computer. Because people are interested in many topics, RSS makes it easier to keep up on the latest information (without much effort).

A valid XML feed is easier to read if you load it into a program optimized for coding such as BBEdit, TextMate, or SubEthaEdit.

RSS is an XML-based form of code. It allows the structured publishing of lists of hyperlinks, along with other descriptive information (or metadata). This information lets viewers decide which content they want to view or receive. A simple bit of software, known as the feed reader or feed catcher, checks regularly to see if the RSS feed contains new information. People can set

their computers to fetch this information and display it. A common use is headline tickers or sidebars that people enable on their computers. For example, Windows Vista users can subscribe to RSS feeds and have the information appear above the desktop in a floating box. This makes it easy to see the news a viewer is most interested in.

A Brief History of RSS

The RSS formats evolved from several earlier attempts at syndication. The ideas grew from the concept of restructuring the information found on websites. This work is thought to have been launched by Ramanathan V. Guha and others in Apple Computer's Advanced Technology Group in 1995. This then evolved into the Resource Description Framework (RDF) site summary, the first version of RSS. RDF was an XML standard devoted to describing information resources. This version became known as RSS 0.9 and was intended for use in the my.Netscape.com portal.

The technology continued to evolve, and in July of 1999, Dan Libby of Netscape produced a new version, called RSS 0.91. This version was further simplified and incorporated elements of Dave Winer's Scripting News syndication format. The technology was renamed Rich Site Summary (RSS). The technology had several early adopters because many web publishers wanted to make their content compatible with the dominant Netscape Navigator web browser. Support for RSS waned, though, as new Netscape owner America Online dropped support and all documentation and tools from the Netscape site.

Two different development parties emerged to take up the RSS mantle and continue development (without the approval of Netscape). The RSS-DEV Working Group and Dave Winer competed to create tools and refine the RSS technology, producing different versions of RSS.

The RSS icon first appeared in the Mozilla Firefox web browser. Microsoft then adopted it for use in Internet Explorer and Outlook. The Opera web browser then followed along. This made the orange square with white radio waves the industry standard. Notably, Apple's Safari browser does not follow suit.

In December 2000, Winer released RSS 0.92, which offered the enclosure element. The enclosure element allowed for the addition of audio and video files (and hence served as a spark for podcasting). In September 2002, Winer released a major new version of RSS. Appropriately named RSS 2.0, the format was redubbed "Really Simple Syndication."

The copyright for RSS was assigned to Harvard's Berkman Center for the Internet & Society in July 2003. At the same time, the RSS Advisory Board was launched to maintain and publish the specifications. The group is also charged with addressing questions and developing a community for RSS. The group continues to evolve the specification and address ambiguities in the technology that better enable web developers to deliver content.

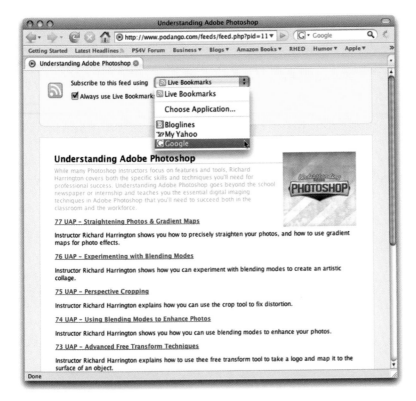

A valid RSS feed contains lots of useful information. Additionally, it can be subscribed to using several different computers and hardware devices.

What Can RSS Do?

The true beauty of RSS lies in its flexibility. A single RSS feed can be read by a multitude of hardware and software technologies. Consumers like RSS because it cuts down on them having to remember to go to their favorite websites. In 2005, Apple introduced video-capable iPods and enabled support for video podcasting in iTunes (mainly as a way to fill the iPod with free content). TiVo has gotten on board by giving users the ability to either read podcasts from a computer in one's house or directly subscribe to podcasts via RSS. TiVo offers channels with preloaded, select podcasts, and you can manually (and painfully) enter an RSS address with the remote control. Other consumer devices, like Apple TV, Microsoft Zune and X-box, and Sony PSP and PlayStation 3, have also gotten on board. Cell phone manufacturers are starting to add the ability to subscribe to podcasts on their mobile handhelds. Even many television manufacturers are building Internet-ready TVs with integrated RSS readers.

RSS and Podcasting

The evolution of podcasting is closely tied to RSS. Once an RSS feed is enabled, computers can fetch the content. You'll recall that an aggregator program, which pulls all of the feeds into a single interface, generally performs this task. The extension of the RSS 2.0 branch allowed enclosures. This format has been widely adopted and is the current standard for podcasting (due largely in part to Apple adopting the format for its iTunes software).

Your RSS feed can support several media types. For video, the choice is either MPEG-4 or the newer H.264 variety of files. You can also enclose audio files (as MP3 files or Apple-specific M4A files). For print materials, show notes, transcriptions, and more, the feature-rich PDF format can be used.

The XML file associated with your page allows for really simple syndication (hence the name, RSS) and it allows these text entries to be easily syndicated—or in other words, packaged, distributed, and consumed. The end user can collect the page's content without actually having to revisit the web page. As soon as something new is added to the page, the podcast aggregator application or web browser indicates that new content is ready.

The Essential Steps to Publish a Podcast

1. **Select or register your web address or domain name.** While you don't have to choose a URL for your podcast, it is a good idea to have a domain name associated with your show. Ultimately your audience will want to interact; giving them a website to visit is essential to building an audience and a brand. You can use an existing website to host a blog and your podcast feed, or you can register a new domain name. Popular registration services include www.Register.com and www.GoDaddy.com.

2. **Select a podcast-hosting option.** You need to find a storage solution that matches your hosting needs. This will be a combination of total storage and bandwidth allowances as well as technical support and customer service.

3. **Build a blog.** Adding a blog to a podcast is essential if you want to build an audience. Your viewers can interact in forums, download resources related to your shows, and find additional opportunities to learn. A blog will also give you a chance to monetize your viewership by offering products for sale. We'll address blogging solutions in our next chapter.

4. **Create an RSS feed.** This is how your audience can subscribe to the content. A valid RSS feed is required for your podcast to be listed in directories. We'll explore RSS feed creation in our next chapter.

Developing an RSS Feed

The goal with podcasting is not only to have an RSS feed that is technically compliant but to have one that is well written and that actually motivates casual browsers to come and view your content. As such, the feed must contain elements that help others find the show through web searches and enables the content to stand out when people browse podcast directories.

A podcast feed contains both creative writing and code. Although you can choose to generate the code portion by hand or by using RSS feed software, you are on your own for the marketing copy. An RSS feed has several components that help define what a podcast is about. Let's take a look at the major elements that involve creative writing:

- **Podcast title.** Your show needs an effective title that connects with your audience. Although there are lots of differing opinions about what makes a title good, we believe in simplicity and brevity. Keeping a name simple means avoiding unnecessary humor or wit that outsiders might misunderstand. Brevity means working the key topic early in the title, especially because many podcast search engines truncate titles when browsing.
- **Author.** You may think that this is an easy one, but it's not. You need to decide who should receive author credit for the show. Is this the name of your talent? Is it the sponsor? The production company? This is a tricky decision to make, and it should come down to which name carries the most weight. We generally favor the name of the primary host and the production company. This way, casual searchers can find a show based on the "celebrity," and the production company also gains name recognition. Be prepared for the sponsor also wanting author

Feed Tutorial with Sample Code

 Looking for an in-depth tutorial on all the tags available in a feed as well as sample code to modify? Then be sure to check out "How to Create RSS/XML Feed for Podcasts" at www.podcast411.com/howto_1.html.

credit; we usually recommend working the sponsor's name into the show's description instead.

- **Category.** You need to determine which categories your show appears in. You can specify up to three categories for your show for the text search view. For the image-based browse system and for placement in the Top Podcasts lists, only the first category is used. If you pick a subcategory, you'll automatically appear in the parent category. For example, a "Fashion & Beauty" listing in the iTunes Store would appear in the "Arts" category as well. Do not pick three categories just to have three. Make sure your podcast genuinely belongs in the categories you assign it. Miscategorized shows are often rejected from the iTunes Store as well as other directories.

- **Description.** Your show's description is very important. It is the *TV Guide*-style listing that people will read when they are browsing for new shows to try out. This is the one thing that influences prospective customers the most once they've landed on your podcast's page or entry in iTunes. They need to believe that your show is worth downloading and that it covers

The descriptive information about your podcast is the primary way a new subscriber finds and selects your podcast.

the subjects they're interested in. You are limited to 4,000 characters (including spaces) for a description, but we recommend you keep it shorter than that. In our experience, a one- or two-paragraph description should be more than adequate. We strongly recommend you take a look at show descriptions for the top-rated shows in the category you intend to choose. Look for how different podcasters try to appeal to their customer base. Depending on the style of your show and its subject matter, your style of writing may vary.

- **Keywords.** You can enter up to 12 keywords that help people to search for your podcast. These keywords are meant to supplement your show's description. iTunes will remove your podcast if it includes lists of irrelevant words in the itunes:summary, description, or itunes:keywords tags. Be sure you separate each keyword with a comma.
- **Episode title.** The episode title is generally the name of the file you publish. We recommend using your show title as an acronym, followed by the episode number and a short title (e.g., PSV_76_Channels.m4v). This will indicate to new visitors that your show is serialized and makes it easier for them to spot unviewed content.
- **Episode description.** The episode description generally appears below or next to a show's title. You can assign a description using up to 255 characters. Be sure to "get to the point" quickly and describe the content of the episode. This is also referred to as the subtitle.
- **Content description.** This is a standard RSS 2.0 element that allows you to enter in show notes, messages, or other HTML-based content that you would like to have associated with your podcast. This is similar to the episode description element previously mentioned except that it is the section of your RSS feed that will be accessed by search engine robots and could help new listeners find your podcast. Show notes (essentially a transcription or outline of the show) should go in this section. This is important because as of this date no reliable audio or video search engines exist.

Your show's graphic should help establish the show's subject matter and tone.

Creating a Feed That's iTunes Friendly

Because the majority of users find podcasts using the iTunes client, it's a good idea to focus on achieving an iTunes-optimized feed. Apple offers the following advice about writing your feed:

- You need to pay very close attention to the title, author, description, and keywords tags at the <channel> level of your podcast feed. This is the information that is indexed for searches. This is also the copy that becomes your "packaging" in the store.
- Make your title specific. Apple says, "A podcast entitled 'Our Community Bulletin' is too vague and will attract no subscribers, no matter how compelling the content."
- The <itunes:summary> tag allows you to describe the show in great detail. Apple suggests telling your audience about the "subject matter, media format, episode schedule, and other relevant info so that they know what they'll be getting when they subscribe." A good idea is to create a list of search terms you think a user would enter, then build these into your podcast description.
- Minimize your use of keywords. iTunes favors the summary tag over keywords. iTunes recommends instead that you use keywords for things like misspellings of names or titles. To prevent the abuse of keywords, iTunes ignores all but the first 12 keywords you've entered.
- Make sure you assign a valid iTunes category (you can browse iTunes for a list of categories). This makes it more likely the show will appear in its appropriate category and makes it easier for casual browsers to find your program.

- **Show graphic.** Your podcast needs a graphic to go with it. This artwork should be square shaped, and it will appear on the screen of the portable media player as well as in the podcast aggregator software. This is also the artwork used in the podcast directories. Having eye-catching artwork that helps brand your show is essential. This is often the first thing a person browsing sees, so be sure to get it right.

Anatomy of a Feed

Although we've identified many of the parts you'll need to write or make decisions on, let's take a look at a feed from a technical angle. The iTunes Store requires that a feed use RSS 2.0. You can also add some specialized tags that are highly useful in helping people find your podcast. These iTunes tags often repeat information already found in the feed, but they ensure compliance with iTunes specifications.

```
<?xml version="1.0" encoding="utf-8"?>
<rss xmlns:itunes="http://www.itunes.com/dtds/podcast-
1.0.dtd" version="2.0">
```

The RSS feed begins by identifying that it is using XML with UTF-8 encoding for your feed. Other encodings are not guaranteed to work in iTunes. The feed is also identified as using RSS version 2.0, which is needed for most podcasting aggregators.

Channel Information

After the RSS feed is identified, you need to populate it with information about the channel. This information remains constant and should apply to all shows within the series:

```
<channel>
        <lastBuildDate>Mon, 12 Nov 2007 10:33:48 -0500</
lastBuildDate>
        <title>Secrets of Style with Kim Foley</title>
        <itunes:author>Kim Foley ,Äì RHED Pixel</
itunes:author>
        <link>http://www.kimfoleystyle.com</link>
        <language>en</language>
        <copyright>©2011 RHED Pixel</copyright>
```

The feed then contains information about the channel; this includes a build date, which identifies when the feed was last modified, as well as the title and author of the show. You'll want to identify what language the show is published in (it is a global market after all) and specify who holds the show's copyright:

```
    <itunes:summary>Want to be memorable, approachable and
exude confidence? If you are 40, 50, 60 or beyond you will
love this inspirational, detailed journey showing you all
the tricks and trade secrets of how to look fabulous. Kim
Foley, a television stylist for over 25 years, shares all
the secrets that make your favorite Hollywood stars look
great! She shares the secrets of illusion dressing and
spills the beans on the techniques of television stylists.
Watch the podcast series for makeup techniques, hairstyle
how to's and clothing advice to really flatter your
figure.</itunes:summary>
```

This is the show's description. Remember, you are allowed up to 4,000 characters to convince a potential viewer to watch.

```
<itunes:owner>
    <itunes:name>Kim Foley</itunes:name>
    <itunes:email>kfoley@nodmomain.net</itunes:email>
</itunes:owner>
```

This information is not visible in the directories, but is there so people can contact the podcast creator:

```
<itunes:image href5"http://podcastingforacause.com/kim.
jpg" />
```

This is a URL for the show's logo. The image must be a JPEG or PNG file. Size the image to 900 × 900 pixels for maximum compatibility with iTunes.

```
<itunes:category text5"Arts">
  <itunes:category text5"Fashion & Beauty"/>
  <itunes:keywords>Fashion, Beauty, Hair, Makeup, Make-
up, Fitness, Kim Foley,Kim Foly, Red Pixel, RHED Pixel</
itunes:keywords>
  <itunes:explicit>clean</itunes:explicit>
```

You should next identify the show's category or categories. Remember to use keywords to address misspellings or additional search criteria that aren't covered by the show's description. Lastly, you should categorize the show using one of three labels: <itunes:explict> yes, no, or clean. If you choose "yes," an "explicit" parental advisory graphic will appear next to your podcast artwork. If you choose "no" you will see no indicator. If you specify "clean," then a "clean" graphic will appear.

Item Information

After the channel information comes the information for each episode (or item). This information provides a description of each episode. An accurate description is important because it motivates viewers to keep watching your shows.

```
<item>
    <title>Kim Foley - Makeup in Minutes</title>
    <itunes:author>Kim Foley,Äì RHED Pixel</
itunes:author>
    <itunes:subtitle>A two-minute makeup.
</itunes:subtitle>
    <itunes:summary> Television stylist Kim
Foley shows you a two-minute makeup that will give you a
polished look when you're running out of time.
</itunes:summary>
```

This information contains the description for each episode. Be detailed, but remember you have a 255-character limit for each item.

```
<enclosure type5"video/mp4" url5" http://media.podhoster.com/
photoshop/Kim_Episode_4.mp4" length5"17977053" />
```

The <enclosure> tag must have three attributes:
- **Type.** What kind of file the enclosure is. iTunes supports the extensions m4a, mp3, mov, mp4, m4v, and pdf. Other aggregators may support additional file types.
- **URL.** Identifies where the file lives on a server.
- **Length.** The length attribute is the file size in bytes.

```
<guid>http://media.podhoster.com/photoshop/Kim_Episode_4
.mp4</guid>
     <pubDate>Mon, 12 Nov 2007 10:26:05 -0500</pubDate>
     <itunes:explicit>clean</itunes:explicit>
     <itunes:duration>00:01:31</itunes:duration>
     <itunes:keywords>Fashion, Beauty, Hair, Makeup, Kim Foley
</itunes:keywords>
```

Every item in your feed must have a unique identifier that never changes. This *g*lobal *u*ser *id*entification (or guid) is used to determine which episodes are new. Most people choose to use the episode URL for the guid value. You can also add information about the file, including its publication date, duration, and additional keywords:

```
     </item>
```

At the end of an item you must close the item off with the end tag`<Author text type A> </item><Author text type A>`. You can then start over and insert additional items to the feed.

Programming the Feed

There are several ways to create a podcast feed. Which method you choose will depend on your skill level with RSS and your personal preference. Some people enjoy hand-coding their feed, whereas others want to do everything with a web browser. There is no right way—it depends on each situation—but here's an overview of your options and some suggestions about when to use each method.

Hand Coding RSS

Many podcasters choose to hand code their RSS feed. If you have a background in web design or programming, then this is a perfectly valid approach. You'll find a sample feed on the iTunes tech spec page: www.apple.com/itunes/podcasts/specs .html.

The benefits of this approach are that it will deepen your understanding of what is really happening with your files and that it will give you precise control. The drawbacks are that you may have to learn a new programming language and that it can be time consuming.

We may sound wimpy, but we're not big fans of hand coding. We recommend using a tool to generate your RSS feed. Then learn to read and analyze your feed as errors arise.

Blog-based Solutions

Using a blog software tool is an easy way to publish a podcast. Blog software is both affordable and easy to use. Remember that a podcast is essentially a blog with audio or video. This is probably the easiest way to create your RSS feed (especially if you want a website to go along with your show).

To generate the feed, you can add an entry (or post) to your blog. The post on your blog can contain show notes (essentially an outline of the show) as well as any weblinks or resources. This has the added benefit that many users choose to subscribe to blogs with email notification. In this way you can notify viewers who prefer to browse podcasts via a web browser. The steps for creating a podcast from a blog feed vary slightly depending on the software tool used but are very well documented in the support forums or online documentation for each tool.

iWeb is a useful application for creating blogs and podcast feeds. It is an easy-to-use application that is good for newer users and those looking for a simple solution.

There are dozens of tools for creating blogs. Some are free, such as the web-based Blogger. Others are full-featured and require you to install components on your web server. A good comparison of popular blogging tools can be found at www.ojr .org/ojr/images/blog_software_comparison.cfm.

If you are looking for the easiest technical approach, try a hosted blog solution. These can be active within minutes and don't require you to set up hosting for the blog (you still need hosting for your podcast media). The solutions can have monthly charges, so be sure to explore your options fully. Here are the three most popular hosted blogs:

* **TypePad** (www.typepad.com)
* **Blogger** (www.blogger.com)
* **LiveJournal** (www.livejournal.com)

If you host your own blog, you can gain greater control. There are several tools that can work with new or existing web hosts. Here are some of the most popular software tools:

* **Movable Type** (www.movabletype.org)
* **WordPress** (www.wordpress.org)
* **RapidWeaver** (www.realmacsoftware.com)
* **iWeb** (www.apple.com/ilife/iweb)
* **Contribute** (www.adobe.com/products/contribute)

Web-based Solutions

Many podcasters choose to use web-based solutions to generate their RSS feeds. Most podcast-hosting companies include browser-based tools that make it easy to upload your files and generate your RSS feed at the same time. We evaluated several podcast hosting companies in our last chapter, and all but one provided ways to create feeds using a web browser.

The major benefits of these web-based tools are ease of use and compatibility. Because the tools are designed for nonprogrammers, they prompt you to enter all of the required information. This approach practically guarantees a compatible feed; it can also open up many other options. Several hosting companies optimize the feeds and make it easier by adding one-click subscriptions and email subscription lists.

The principle drawback of using browser-based approaches is a lack of speed. Entering information manually can create a lot of repetition. If you have to load several episodes at once, the browser option generally limits you to a single upload at a time (which can result in a lot of waiting time).

If you're new to podcasting, and are not prepared to invest the extra time in a blog, then browser-based solutions are generally the best fit.

One-Click Zune Podcast Link Builder

Want a one-click button that lets your readers subscribe to your podcast in the Zune Marketplace? Then visit www .zunepodcastsubscription .com.

WYSIWYG Solutions

As podcasting's popularity has grown, a new crop of software tools has emerged. WYSIWYG is an acronym that stands for "what you see is what you get," and that's exactly what these tools do. Several software developers have released RSS podcasting tools. The two most notable are Podcast Maker for the Mac (www.lemonzdream .com/podcastmaker) and the Podcast RSS Buddy for PC and Mac (www.tolley.info/rssbuddy).

Both of these tools offer an easy-to-use interface. They also let you simulate how the podcast will look in iTunes. Both programs generate a standard feed as well as an optimized version with the iTunes tags. Both tools are easy to use. Podcast Maker offers the extra benefit of having an FTP program built in, which speeds up the publishing process.

These solutions are best for podcasters who need to publish several episodes in a short time period. These give you the ability to control the feed creation process with the safety net of a preview feature. The drawback is that both of these tools have small development teams, so if you encounter problems or errors, you can't expect the level of support that a major developer would offer. With that said, we have found both of these products to be reliable and easy to use.

Delivering Podcasts with Apple Compatibility

For most podcasters, compatibility with an iPod and iPhone is an essential requirement. Although using an iPod or an iPhone is not the only way your audience will consume your podcast, it is still a very popular method. Therefore, you'll want your files to work on Apple's portable media players.

The Apple iPod and the iPhone support video up to 640 × 480. If you are targeting Apple TV for HD playback, you can use a video file up to 1280 × 720. An Apple iPad screen can display 1024 × 768 pixels, but most publish 640 × 480 for it. You can ensure compatibility with iOS devices using the following guidelines:

- H.264 video, up to 1.5 Mbps, 640 × 480, 30 frames per sec., Low-Complexity version of the Baseline Profile with AAC-LC audio up to 160 kbps, 48 kHz, stereo audio in .m4v, .mp4, and .mov file formats

Need to Move an RSS Feed?

It is not uncommon to need to move a feed from time to time as your podcast evolves. This could be due to server upgrades or a change in your podcast's website. This is why the <itunes:new-feed-url> tag exists.

This tag allows you to change the URL where the podcast feed is located without having to cancel and resubmit your feed. You can add this item at <channel> level and it lets you redirect both iTunes and subscribers:

<itunes:new-feed-url>http://podcastingforacause.com/example.rss</itunes:new-feed-url>

After adding the tag to your old feed, leave it in place for at least 48 hours (the recommended time is two weeks). You can then retire the old feed because iTunes will have updated its listings. For more information see www.apple.com/itunes/store/podcaststechspecs.html#changing.

For other redirects, you'll use an HTTP 301 response. For details, see www.somacon.com/p145.php.

- H.264 video, up to 768 kbps, 320 × 240, 30 frames per sec., Baseline Profile up to level 1.3 with AAC-LC audio up to 160 kbps, 48 kHz, stereo audio in .m4v, .mp4, and .mov file formats
- MPEG-4 video, up to 2.5 Mbps, 640 × 480, 30 frames per sec., simple profile with AAC-LC audio up to 160 kbps, 48 KHz, stereo audio in .m4v, .mp4, and .mov file formats

If you are podcasting high-definition video, you are likely targeting computers and television sets. In this case it is a good idea to use the Apple TV guidelines. The Apple TV unit is designed as an easy way for consumers to play media from their personal computers on their televisions or home entertainment systems. You can ensure compatibility with Apple TV using the following guidelines:

- H.264 video, up to 5 mbps, 1280 × 720, 24 fps, Progressive Main Profile. Apple TV supports AAC-LC audio up to 320 Kbps.

Apple TV Video Specifications

Input	Output
640 × 480, 30 fps	640 × 480, 30 fps, 3 mbps*
1280 × 720 24 fps	1280 × 720, 24p 5 mbps*
1280 × 720, 30 fps	960 × 540, 30 fps 4 mbps*
1920 × 1080, 24 fps	1280 × 720, 24 fps 5 mbps*
1920 × 1080, 30 fps	960 × 540, 30 fps 4 mbps*
1080i up to 60 fps	960 × 540, 30 fps 4 mbps*

*Represents an average bit rate.

If you want to create a single file that works on all iOS devices, then deliver a 640 × 480 (or 640 × 360) file and keep the data rate below 1.5 Mbps.

Publishing an RSS Feed

Once you've successfully built your podcast feed, you'll need to register it with several podcast search engines. This is how new audience members can find you and subscribe to the show. The process is straightforward but must be executed with care and precision. If you make mistakes, your show can be delayed or blocked.

Testing the Feed

There are lots of things that can break a feed: a misplaced character, a malformed date, the list goes on. Fortunately, testing a feed is easy. Once you have your feed and media available online, you'll want to test it. The easiest way is to visit

www.feedvalidator.org, where you can enter the address for your feed. If there are errors in your feed, they will be clearly identified. The website also offers suggestions and links to more information on how to fix common problems. This website is invaluable and should be a part of your testing process.

Once you think a feed is working, you should test it with the iTunes client. Before you submit the feed to directories for listing, follow this easy process:

1. Launch the iTunes application.
2. In the Advanced menu, choose Subscribe to Podcast.
3. Enter your feed URL in the text box.
4. Click the OK button.

If things are set up correctly, the podcast will be added to your Podcast playlist, which shows all the episodes you are subscribed to. If you see an orange circle next to the new podcast description, it means that iTunes is successfully downloading the most recent episode. When the orange circle disappears, the episode has been downloaded. Double-click to play the selected episode. If the episode plays successfully, your RSS feed and media are iTunes compliant and should be submitted to podcasting directories.

Feed Validator helps identify errors with your RSS feed and suggests repairs you can make to improve compatibility.

The Difference Between the iTunes Client and the iTunes Store

You'll often see the word *iTunes* used to mean several things. The first means is a software application that allows Mac and PC users to manage music, movies, podcasts, and TV shows. The program can help organize a large media library and allows you to transfer content to devices like iPods, iPhones, iPads, and Apple TV.

The other meaning is an online site called the iTunes Store. This allows users to browse for purchase content as well as free podcasts. When you submit a podcast to the iTunes Store, you are asking it to display your RSS feed in the appropriate category and to make it searchable. If your feed is accepted, the iTunes Store updates the podcast directory with new or updated information about your podcast.

Once a user subscribes to your podcast, they no longer need to access it through the iTunes Store. Instead, it will be added to the Podcasts tab in the user's library. The feed is checked directly from your sever and the media is downloaded from your server.

Optimizing the Feed

Once your feed is valid, you can optimize it for greater compatibility and exposure. A popular service is FeedBurner (www. feedburner.com), which is now owned by Google. FeedBurner offers several free services, and since Google's purchase, the pro features are now free as well.

FeedBurner optimizes a standard RSS feed and adds several important features. FeedBurner publicizes your feed and offers tools that make it easier for people to subscribe. The feed is also optimized so it is ready for other web services such as digg, Yahoo, del.icio.us, Google, and AOL. Most important, it provides detailed traffic information so you can analyze your feed and who is consuming it.

If you are creating your feed by hand or with a blogging or WYSIWYG tool, FeedBurner can make the feed podcast-ready. The feed is also optimized for web browsers, can be subscribed to via email, and has multiple social media options enabled.

Submitting the RSS Feed

Before you submit your feed to directories, it needs to be working properly. If your feed is not working and validated, as we discussed earlier, your show could be blocked from directory sites. When a podcast is ready, you need to submit it for inclusion.

Submitting the Feed to iTunes

The first place you submit should be the iTunes Store (this is where your biggest audience will come from). If, when you are testing the feed, you can subscribe to your podcast using the Advanced menu, then your show is ready to submit.

To register a podcast on iTunes, you'll need to have a valid iTunes account (which requires a valid credit card, but you won't

Email Subscriptions

 Although it may seem counter-intuitive, many viewers want to be notified via email when a new podcast episode comes out. Be sure to take advantage of the email list options offered by FeedBurner and several podcast hosting companies.

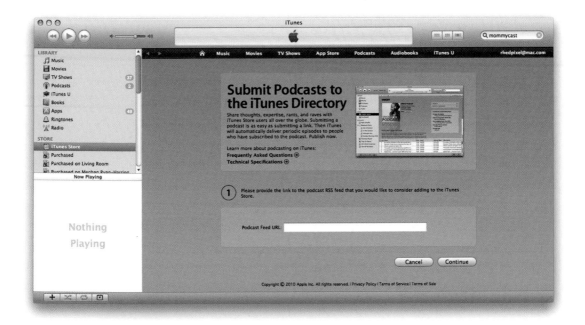

be charged unless you make purchases). Apple requires users to log in, which increases the likelihood the user's contact information will be valid;

1. Launch the iTunes application.
2. Click the iTunes Store icon in your sources list in the left column.
3. In the top navigation banner, in the iTunes Store box, click the Podcasts link to go to the Podcasts page.
4. In the Podcast Quick Links box in the upper right corner, click the Submit a Podcast link.
5. Follow the instructions on the Submit a Podcast page. You will need to have your podcast feed URL ready.
6. If you are not logged in, iTunes will prompt you to do so before accepting your submission.
7. If your RSS feed is valid and has all of the recommended iTunes tags, you will see a summary page after you submit your feed URL. If some of the required items are missing, iTunes will prompt you to fill them in.

Submit to More Directories

Although the iTunes Store has about 70% of the market for podcast subscriptions, it's not the only game in town. There are several more podcast directories on the market. Some are for special interests like religion or family-friendly content. You can find a useful directory at www.masternewmedia.org/podcast_directory.

Advice on Succeeding in the iTunes Store from Apple

 Looking for some helpful tips on how to succeed in the iTunes Store? Apple offers a useful video called "The Podcast Recipe: Producing a Successful Show." They promote this as an opportunity to "find out what it takes to perform a great-sounding podcast, produce a professional show, and promote a podcast to reach as many people as possible." The online seminar is free (www.seminars.apple.com/seminarsonline/podcast/apple/index.html).

We recommend submitting to the following podcast directories:

- **Podcast Alley** (www.podcastalley.com)
- **Zune Marketplace** (www.zune.net)
- **Podcast Directory** (www.podcastdirectory.com)
- **Odeo.com** (www.odeo.com)
- **Podcast Pickle** (www.podcastpickle.com)
- **MeFeedia** (www.mefeedia.com)

The Submission Queue

Once you submit a podcast to the iTunes Store, it needs to be reviewed. Depending on the number of shows submitted, this could take awhile. iTunes actually has its shows reviewed by live humans. The same holds true for other directories like the Zune Marketplace.

If you want to ensure your podcast makes it out of the approval queue, check the following issues:

- Are there any technical problems with the feed? This includes a lack of episodes or the inability to download or play episodes from the host server.
- Do you require a login or password? If you require a login or password to access your feed, it will be blocked from the iTunes Store.
- Does your podcast include a large amount of sexual content or a title that uses explicit language? If so, your show will be rejected. You *can* use explicit language in a show, but it must be labeled as explicit.
- Have you misused copyrighted material? If you misrepresent Apple copyrights, including "iPod" or "iTunes," your show will be blocked. This includes using an image of an iPod in your show artwork.
- Could your content be considered offensive? Material that is deemed offensive, such as racist content or child pornography, is not allowed in the iTunes Store.

Addressing these issues is a good idea before you submit to any other podcast directory as well. Keep in mind that all listings will take some time to appear. For example, it can take an average of five days for a listing to appear in the browseable categories of the iTunes Store. Your show's logo can take even longer to appear because images must be cached, then propagated across multiple servers.

How to Jump the Queue

If you are on a deadline and need your feed to be live by a certain date, start early. When pressed for time, we build our feed early. Even if the first episodes aren't ready, we cut together a promotional trailer that explains the concept of the show and offers a taste of what's to come. Most directories will block "test" feeds, so make yours real and populate it with a trailer. Your feed will be ready to go when you need it.

PRO*file*: Photoshop User TV

Photoshop User TV (www.photoshopusertv.com) is a very popular podcast produced by the National Association of Photoshop Professionals (NAPP). The show offers a collection of tips, tricks, tutorials and news about Adobe Photoshop. Photoshop User TV runs weekly during the 13-week season with a 4-week break between seasons. The show has a huge following… keeping it consistently in the Top 5 for its category.

The show is hosted by three well-known authors and trainers, known as The Photoshop Guys. Each week, Scott Kelby, Dave Cross, and Matt Kloskowski get together to show timesaving techniques, inspirational photography, and technical news. The show is well-known for its mix or technical subject matter and good humor.

"Just because you get in front of a camera doesn't mean you have to be serious," said Kloskowski. "If you are serious then by all means, don't try to change that. If you're not serious then have fun. People can get the information in podcasts anywhere. They'll watch your podcast because of personality. They can relate to it."

While this approach doesn't appeal to all viewers, Kloskowski emphasized that is impossible to create a show for everyone.

"The sure way to failure is trying to please everyone out there. Pick an audience and stick with them," said Kloskowski. "Cover the things that you're interested in. You'll enjoy it more and your audience will relate to you more if you do. For better or worse, put yourself, your opinions, your recommendations and your personality into it and that's what people will come back for."

This approach has worked well for the show. Photoshop User TV frequently tops a million viewers for their episodes. This sort of traction has attracted major sponsors to the show, which help cover the cost of producing and delivering the weekly episode. Subscribers are encouraged to subscribe to the show, so it will download automatically. Casual browsers, though, can't access the back catalog.

"Every week, we post a new episode of PhotoshopUser TV that you can watch, download and keep forever and ever," said Kelby. Members of the National Association of Photoshop Professionals (NAPP) have access to the entire archive of PhotoshopUser TV episodes as part of their membership.

The show attracts new members to the organization, which also publishes books, online training, magazines, and conferences. The use of a podcast is a way to attract new people to the NAPP training products.

"We love to teach people how to use Photoshop and podcasting was a way to get that training out to a lot of people that wouldn't have otherwise seen it. If they like it, then hey… good for them. They got some free tutorials and maybe they'll

come back and try our other products," said Kloskowski. If they didn't like it then no harm done. It didn't cost them a thing. It really comes down to exposure though."

That exposure plan has worked out well. According to Scott Kelby, "The show has reached nearly three million downloads in a month. We never dreamed it would take on the life it has but we're thrilled to be along for the ride." The show is also very popular on a global scale, and also tops the charts in the International iTunes directories as well.

"It's amazing. We get emails, feedback, and questions from people around the world. It takes up a lot of time but it's fun too," said Kloskowski. "I guess the main impact is time. It takes plenty of time to keep up with it but the rewards (both business and personal) that we make from it are priceless."

Gear List

- 3 Panasonic AG-HCM150 cameras
- 6 Sennheiser G3 wireless lav microphones
- Mackie Onyx Mixing board
- Westcott Spiderlight 3200k halogen lights
- Lowell Pro-lights and Omni lights
- Elation DMX LED Wash lights
- DMX Lighting Controller and Dimmers
- Kessler Crane system
- Manfrotto tripods with 503 heads

HOSTING WEB VIDEO

You've developed great content, executed a (near) flawless production, edited a masterpiece, and compressed it to a small file that works on an iPod, laptop, and Droid phone. Now what? Well, your web video is ready to share with the world, so get it out there.

You'll need to place your media files on a file server that can be accessed from the Internet. You'll need to find a location that can handle the demands of large files and lots of requests. After all, web videos are relatively large compared to typical files that are accessed with web browsers. A typical web hosting solution just won't cut it.

Having your files hosted on a robust server with an RSS feed can enable publishing to powerful directories like the Apple iTunes Store.

Website Requirements

As a web video creator, we highly recommend that you have a dedicated website for your creations. This site may see much lower traffic than your video receives via service like YouTube or iTunes, but it's truly your traffic.

By giving your most interested viewers a clear destination to visit, you increase the chance for a meaningful exchange with the audience. We recommend setting up a blog to house entries for each video as well as other text-based content you want to share.

RHED Pixel maintains the graphics blog RasterVector .com as a resource site for other professionals. The site is built with RapidWeaver, a blogging platform. The site also sells additional products and services.

Having a site is also important as it lets you better monetize your videos. Sponsors will want a place for banner advertising. Viewers will want to read show notes and take action. You'll also find a real need for people who want to connect and evangelize your content.

Creating a clear destination for interested parties to converge, especially if it's a destination under your complete control, is a good thing.

Budgeting for Hosting

We generally equate serving video on the Internet to hiring a caterer to serve a party. If you buy too much, it's just wasteful and you'll have leftovers that won't keep (after all, you pay for bandwidth whether you use it or not). On the other hand, if you're too conservative and don't get enough, everyone stands around complaining and no one goes away satisfied.

Finding a Good Domain Name

You'll likely want to find a custom URL that matches the name or content of your web video. This will give you a website property that you can develop to support your videos. The dot-com names are the most popular, but you can choose others such as dot-tv, dot-net, or dot-org depending on the content of your show. The domain registration services have search engines for finding available names. Here are a few practical pieces of advice when creating your custom URL:

- Try to find a URL that is short and easy to remember.
- Try to match your podcast, production company, or video series name and URL if possible. This will create synergy and make it easier for your viewers to remember it.
- If you want your website to appear higher in search engine results, work the topic into the URL. For example, the URL www.PhotoshopforVideo.com ranks high when people search for information about Photoshop and video editing as well as for Photoshop training videos.
- Be sure to rent your domain for multiple years or set it to automatically renew. You don't want to build up a popular show and domain, and then lose it because you forget to register it again.

Free Hosting

There are several services that offer free video hosting. These plans generally offer a smaller amount of storage and may have bandwidth caps. These plans generally require you to use web-based tools for generating your RSS file (or offer no RSS feed at all). The biggest drawback is that most of these free plans will insert ads into your video (and they do not share revenue). With the large amount of affordable hosting plans, we generally recommend staying away from "free" plans—after all, you get what you pay for.

Affordable Hosting

The costs for video hosting vary greatly and will require the producer to evaluate each purchase based on several factors (which we'll explore in a moment). There are several moderately priced ($10 to $50 a month) plans that offer unlimited bandwidth and storage from 200 MB to a few gigabytes. Most of these give you precise control over an RSS feed and allow a high level of customization. There are several "small" differences between plans, such as FTP access and detailed statistics. For producers with high volume needs, several hosting companies offer larger plans.

Offsite, Dedicated Hosting

Many web-hosting companies offer dedicated servers that you can use for your videos. If you are willing to pay for the entire machine, they'll provide the service and Internet connection. For example, GoDaddy offers 2000 GB of storage and 3000 GB of transfer per month for about $270. Depending on how big your show gets, be sure to consider using a dedicated host. You should also weigh the costs of renting a server versus installing and maintaining your own (and the required network connection). We often find that external solutions are best unless the client has a long history of running its own servers at very high bandwidths.

© iStockphoto.

Self-Hosting

If your company runs its own server, you can certainly consider hosting your web video files yourself. We just highly recommend having a discussion with the IT department early on. Some of our clients choose to add dedicated servers for podcasts and web video, but most have been content with an enterprise-level hosting plan from an outside provider. In this case, they put the RSS feed and embeddable players on their site but keep the large media files offsite to improve stability and performance.

The Costs of Using a Website-Hosting Service

There are several providers of affordable website-hosting plans. These are not podcast or web video hosting plans. Although the website plans may offer high bandwidth options, you may be in violation of the plan's agreement if you place large media files online.

When each media file is 20 to 80 MB, it is so easy to go over your bandwidth limit. We had a web-hosting plan with 20 TB of data transfer. We thought, we'll never use that. We were wrong. We logged in a week and a half later and we had already incurred $100 in overage charges because iTunes had decided to put our podcast on the front page that week and everybody found it.

Even if you can afford the bandwidth, many web-hosting plans specifically identify large media files in their terms-of-service agreements. We have had entire websites suspended because of large files and high usage. Be sure to look closely at web-hosting agreements if you decide to go this route.

The short lesson here is be sure to choose a video hosting plan with an unlimited bandwidth option.

Hosting Requirements

Podcasters and web video producers have some unique requirements when it comes time to finding the right home for their video files. It's important that your hosting company support the workflow you desire. Do you plan to upload files with an FTP program? Do you want to host your RSS feed on your own website? Do you want the hosting company to generate your RSS feed for you? Do you need customizable video players? What sort of social media functions do you need? There are several questions to ask when looking for the right host.

Bandwidth

Web video files can get relatively big. Combine that with even a relatively moderately sized audience and you need a lot of bandwidth. The term *bandwidth* is used to describe the amount of data that can be transferred as part of the chosen hosting plan. An easy way to think of this is as the monthly data transfer rate.

As your library grows, unlimited bandwidth plans become critical. Be sure to track your bandwidth usage over time. Its important to keep an eye on it, or you may get expensive overage charges or have your site shutdown.

Unlimited Bandwidth

There are dedicated podcast-hosting servers that are different than web-hosting services. These generally have very low prices. On the other hand, streaming video services can vary greatly in price because of their higher performance.

You want a plan that has a no-bandwidth charge, so if your viewership goes through the roof, you're not paying through the nose for it. The last thing you want is a web video that costs you a bunch of money to make and then a bunch more money just to deliver (especially if you're not making direct money off the content).

Therefore, it's critical that you attempt to estimate and then measure your audience. What you are trying to do is estimate how much storage and bandwidth you need. Try to determine how many people are going to pull down each episode; initially this may be a guess, but an attempt at accuracy is better than none at all. Additionally, how many episodes do you want to have up at a time? You have to weigh the total usage (or bandwidth) you need as well as how much total storage you want.

Exceeding your bandwidth limits generally has two outcomes. The first is that your files can be "capped," which means that your videos (and possibly website) will no longer download. This is an undesirable outcome, as your site will appear to essentially stop working. The other likely scenario is overage charges. Just like what happens when you go over your allotted minutes on a cell phone plan, overage charges can add up quickly.

Storage

Depending on the type of hosting plan you choose, your amount of total storage will vary. Just how much storage do you need? Well it really depends on how many episodes you want to have online at once. Do you want to keep all of your episodes available in an archive? Will you just keep the current episode up? The answer probably falls somewhere in between.

How Much Is Enough?

Determining how much storage and bandwidth you'll need can be a bit tricky when you try to think in abstracts. So let's take a sample scenario. When we release a five-minute standard definition video, it's about 20 MB. If we release four of these in a month, we need 80 MB of storage. If our audience of 500 downloads each episode in a month, we'd need about 40 GB of bandwidth. Notice how quickly videos consume bandwidth? As such, the unlimited bandwidth plans are the only way to go as soon as your audience grows.

Take a look at the average size of your video files. Then multiply that size by the number of episodes you'd like to keep online at once. For example, if your average episode size is 40 MB and you want to keep 20 episodes up at once, you'll need about 800 MB. To allow for flexibility, you should choose a 1-GB hosting plan in this scenario.

RSS Tools

Several podcast-hosting plans offer a suite of RSS tools. Many of the sites are designed to offer web-based feed generation tools. You can create the RSS feed by simply filling information into a web form. These RSS tools are a useful way to track downloads as well as syndicate the videos to other websites.

Social Media Integration

Many video hosting companies now offer direct ties into social media websites. These can allow your audience to do things like send a tweet to Twitter or post a video to their Facebook page. Having these features and more (such as embeddable players) can dramatically increase the reach of your video. If these features are not available, they can be often stitched into your blog or website. Native support, however, is the best option.

YouTube follows the practice of many other sites and allows users one-click posting to popular social media sites like Facebook, Twitter, and orkut.

Upload via File Transfer Protocol

The use of file transfer protocol (FTP) is a convenient way to transfer multiple files to a server. The convenience is that you can transfer multiple files simultaneously (which lets you set up a large transfer, then walk away from the working computer). Additionally, an interrupted file transfer can often be resumed. Virtually all computer platforms support FTP protocol, but not all server-hosting companies enable FTP access as part of their video-hosting plans.

If you plan on having several videos to upload at once, then look for a host that offers FTP access. This can be a big time-saver, as it allows you direct access to your files on the server (as opposed to using a slower web interface). FTP access is less common in hosting plans, because it requires hosting companies to open up their servers directly. Although security protocols are easy to implement, many service providers don't offer this option. Be sure to check if FTP access is an option for the hosting companies you are considering.

Upload via the Browser

The alternative to FTP access is using a web browser to load the files. This style of hosting services generally requires you to enter the details for the video via a web browser, then click a button to select a file on your local hard drive in order to transfer the file.

Although this style of hosting is simple, it doesn't offer the flexibility of FTP access. We recommend browser-based solutions for clients with low-volume needs (that is to say, only a few videos to load each week). It is possible to find a host that offers both browser and FTP solutions, which gives you the flexibility to choose a solution based on your personal comfort level and needs.

Loading video through a web browser is typically not as fast as other methods like FTP.

Use of Private Domain

Many hosting solutions are self-contained, which is to say your media files and RSS feed must stay on the hosting company's servers. Although this is desirable for media files (after all, you want the bandwidth and support of the hosting company), it is less so for RSS files. Many producers (and clients) want the RSS file to live on their own website. Ask yourself what's more desirable, www.yourdomain.com/podcast.xml or yourdomain .podcasthostingcompany.com.

In general, the best option is to keep the RSS feed on your own website. This way, browsing customers can choose to explore the rest of your site after they've looked at your RSS feed. If having your own private domain is not an option, look for a host that lets you put together a customized landing page on your own website. The more customized you can make this page, the better.

Customizable Players

There are two big drawbacks of the YouTube player. The first is the "related videos" option that is turned on by default. After viewers watch a video, they are presented with other videos that YouTube thinks are similar. The other problem is a giant YouTube logo in the corner, making it clear that YouTube's branding is more important than yours. Click either of these elements, and the viewer is whisked away from your website back to YouTube. Not good for traffic you fought to get in the first place.

Affordable Customizable Players

A great option for those looking for customizable players is Vimeo.com. With the Vimeo+ level account, you get increased storage and a completely customizable player. This is one of the most affordable options.

The same holds true for blip.tv, which is a very flexible player. You can even decide which video technology to use in your embeddable player and customize branding and web links.

A custom player was built for the Understanding Adobe Photoshop show with a link right to the book's page on Amazon (affiliate link included).

This is why a customizable player is so important. You'll want to be able to tweak which controls are visible to the end user. Are the sharing functions enabled so they can promote your video? The size of the window and even the color should coordinate with your website. Is there a fallback technology if the user doesn't have the correct plug-in loaded? Fortunately, video-hosting companies have really caught on and most are making this an easy option.

Statistics

For your video traffic to grow, it's important that you both target and track niche markets. If you want advertisers, then statistics are essential. If you need to prove the "effectiveness" or "reach" of your video, you'll also need numbers. In fact, we're big proponents of measurement, so you can learn from both your successes and failures. Without measurement, your videos are operating in a vacuum.

You can get accurate statistics about downloads. Through services like Podtrac and Feedburner, you can get statistics on a per-country basis. You can quickly learn where your video is being consumed and on what computer platform. Most streaming service sites also offer detailed statistics (though many charge extra).

Disputed Statistics

Many tracking services "discount" their numbers to try and filter out "false hits." You might experience under-reporting if your episodes are going into places like colleges and universities, because these environments can be using distributed IP addresses. Try to focus less on the hard numbers and more on the trends for your show. Look at change over time and see what is happening to your videos.

A spike in viewership should be analyzed. This often leads to practical techniques or strategies for increasing viewership.

You'll want to keep an eye on when and how a show is consumed. You should also track the popularity of different video topics. In this way, you can learn from your strengths and your weaknesses and evaluate how individual episodes are doing.

Advertising Model

Many video-hosting services defer their costs through the use of ads. The less you pay for video hosting, the more likely there will be ads in your videos or on the web page. There are other services that attempt to sell ads for you and then keep a percentage of those sales.

Regardless of the host's policy toward ads, you will need to determine your show's own rules. Some videos need to run advertising-free because the client or sponsor wants the show to appear unbiased. Other shows are simply looking to cover their costs. Be sure to investigate your options when considering the financial prospects of your video.

Members using the free version of Vimeo see ads on their pages when browsing. Those using the paid service (Vimeo+) do not see ads.

Terms of Service

Be careful and always monitor the terms of service with your video hosting solution. Many of the "free" sites reserve the rights to license your video for profit (their profit, not yours). Most sites also require you to leave some of their branding or links intact. This can create issues for those distributing video on behalf of their clients or company. Hosting companies also take steps to protect themselves in regards to videos marked private, stating that although they intend to keep them private, they can't be held accountable for unauthorized views. Be sure you read what you are agreeing to, and if you spot any red flags, you may need to consult a lawyer.

Selected Hosting Vendors

There are several video-hosting companies in the market. Each offers a unique mix of services, technical options, and pricing. The right host means balancing the factors we've discussed in this chapter with the needs of your show or client. The accompanying table lists a few popular solutions well suited to video hosting and podcasting. Be sure to look at their individual websites, as pricing and technical details change with time.

© Fotolia

Hosting Service	Cost / Month	Bandwidth	Storage
Apple MobileMe (www.apple.com/mobileme)	$8.25	200 GB	20 GB
AvMyPodcast (www.avmypodcast.com)	$4.95–$24.95	Unlimited	250 MB–2 GB
blip.tv (www.blip.tv)	Free–$8	Unlimited	Unlimited
CacheFly (www.cachefly.com)	$99–$409	256 GB–2048 GB	1 GB –4 GB
GoDaddy Quick Podcast (www.godaddy.com)	$4.24–$19.99	100 GB –500 GB	1 GB–10 GB
Hipcast (www.hipcast.com)	$4.95–$49.95	5 GB–Unlimited	5 MB–5 GB
Libsyn (www.libsyn.com)	$5–$30	Unlimited	100 MB–800 MB
Libsyn Pro (www.libsynpro.com)	Negotiated	Unlimited	Negotiated
Podbean (www.podbean.com)	Free–$39.95	Unlimited	100 MB–4 GB
podblaze (www.podblaze.com)	$14–$97	2 GB–20 GB	200 MB–1 GB
Podhoster.com (www.podhoster.com)	$4.95–$49.95	Unlimited	250 MB–4 GB
Podkive (www.genetichosting.com)	$10–$375	Unlimited	100 MB–120 GB
PodStrike!™ Podcast Manager (www.podstrike.com)	Free–$19.95	Unlimited	50 MB–10 GB
Vimeo (www.vimeo.com)	Free–$9.95	Unlimited	Up to 20 GB month
YouTube (www.YouTube.com)	Free	Unlimited	Unlimited

RSS Tools	Statistics	FTP Upload	Browser Upload	Advertising
Yes, with iLife	No	Yes	Yes	No
Yes	No	No	Yes	Yes
Yes	Yes	Yes	Yes	Yes
No	Yes	Yes	Yes	Yes
Yes	Yes	No	Yes	Yes
Yes	No	No	Yes	Yes
Yes	Yes	Yes	Yes	Yes
Yes	Yes	Yes	Yes	Yes
Yes	No	No	Yes	Yes
Yes	Yes	No	Yes	Yes
RSS	No	Yes	Yes	Yes
Yes	Yes	Yes	Yes	Yes
Yes	Yes	Yes	Yes	Yes
No	Yes	No	Yes	Yes
No	Yes	No	Yes	Yes

PROMOTING YOUR VIDEO

As the world of web video continues to explode, getting noticed gets harder and harder. In the early days, things were much easier as the competition was poorly funded (and often produced marginal projects). These days you're likely to find yourself up against people with more money, higher production values, and perhaps the backing of major studios or media corporations.

How can you possibly compete?

It's simple (and it's how we continue to succeed). Produce good content that you are truly passionate about. Then be sure to make a lot of noise and promote that content. Don't waste your time trying to reach the masses; rather, target the groups that need you. There are many ways to raise awareness. The ideas contained in this chapter are drawn from our personal experiences as well as those of several respected experts.

Essential Groundwork

Raising a buzz might be second nature and you've got promotional headshots and biographies of all key players in your project. You've already contacted the media, been tweeting about your project, and have published your video to 30 directories.

Wait. You haven't?

It's okay. We realize that promotion is not a normal activity for most folks. Even if you live and breathe public relations and advertising, guess what? You probably have far less budget than you're used to. In this chapter we've got some practical advice to share no matter what your experience level or budget. You will frequently hear from guests in this chapter, because promotion requires many different approaches in order to succeed.

Special Thanks and Good Inspiration

This chapter contains insight from four people we respect when it comes to targeting and reaching audiences. Special thanks to the following:

- Jason Van Orden, author of *Promoting Your Podcast*
- Paul Vogelzang, executive producer of MommyCast
- Ray Ortega, podcasting expert and community leader
- Hayden Black of Evil Global Corp., who makes some of the funniest videos on the web

Goodnight Burbank is a highly successful web video series. It offers a complete media kit that introduces the show and features press coverage it has received. Visit www.goodnightburbank.com to learn more about the show.

A Reality Check

"The biggest challenge to promoting a show is time. It probably takes more time to promote a show than it does to write and shoot it," said Ray Ortega. "Other challenges that go along with time are energy and drive."

Ray Ortega (www.rayortega.com) knows from a great deal of personal experience. Producing web video is his day job as he works for a nonprofit trade association creating video content to educate members and the general public. He also produces a show about produce ("The Produce Picker Podcast") and a podcast and Twitter feed about the art of podcasting ("The Podcasters Studio").

"Because promotion takes so much of your time, it naturally requires that you have the energy to put in that time. Drive is as much of a factor as time and energy because if you do not have a genuine interest in your show's topic, then it will be hard for you to go out and spend time at the places where you need to be in order to get the word out about your show," said Ortega. "Having a real interest in your topic will make it much easier for you to spend time on the web talking to others about your topic and thus creating interest in your show."

Start with a Compelling Title

Your title is most likely the first exposure someone will have to your web video. There truly is something to the saying "You only have one chance to make a good first impression." Your video series or episode title has only a few seconds to attract your target audience, grab their attention, and make them want to watch.

A good title instantly tells people what your show is about. Avoid "clever" puns that people have to think about. We find that being short and to the point works best. Many websites and podcast aggregators have character limits as to how many letters can be displayed.

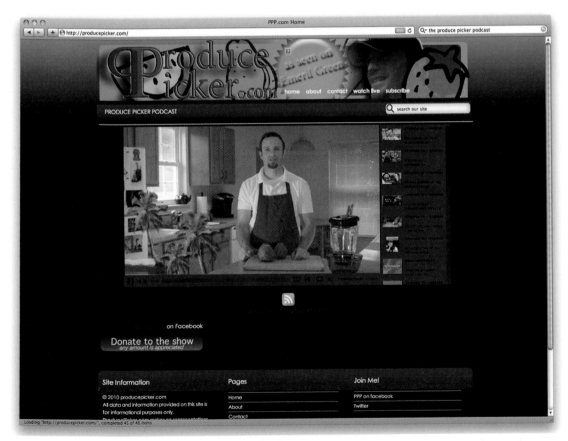

Ray Ortega's "Producer Picker Podcast" has a clear name with nice alliteration. This improves the chance of potential users remembering the show's title.

Capture Content Early

To promote, you need something to show. But how can you promote something that doesn't exist? That's easy. Show the creation process. Get your fans onboard early though social media. Here are a few practical ideas.

- Capture photos on set and release them through Facebook or Flickr.
- Regularly tweet about your show as it develops.
- Start a Facebook group and invite friends and colleagues. Post preview clips and photos.
- Launch a blog and post entries about your show as it unfolds.
- Cut a trailer right away and post to as many places as possible. You can even submit this trailer to places like iTunes and the Zune Marketplace to get your RSS feed validated and approved. Publish a press release and target those who are most interested in your content.

The Photo Trekker web video series (www.thephototrekker.com) uses its Facebook page to keep in touch with fans and share details about its upcoming shows:

Working with Public Relations Firms

Many web video creators with larger budgets utilize PR firms to raise awareness. With traditional media, PR firms are often a mainstay because of their extensive connections. In the world of web video though, things are so new that many PR firms aren't sure how to help.

"One of the greatest challenges in promoting a web video is cutting through the noise created by everyone else promoting a show," said Hayden Black. "One of the solutions is hiring a professional PR firm, but then you have to find money to do that as well as making sure you've actually got a good PR firm."

It's important when working with an outside group that you are clear about your expectations and your subject matter. No one knows your show better than you, and you probably have a pretty good idea about your target audience. Therefore, you must work as partners if you want to succeed.

"With one [web video] series we were producing, we were instructed by [the client's] PR firm not to talk to the press about the launch of the show until the day the show aired," said Black.

The staff at the PR firm thought keeping things a secret would help build up buzz. They prevented Black and his team from releasing a promotional trailer. They also instructed the big-name stars not to talk to the press.

"I'm still not sure why [they wanted to stop] us from creating a buzz for a new show that was airing over the course of one week," said Black. "We did what we could with the time we had and actually got a great audience, but it would have been a *much* bigger audience had we began promoting it even a week sooner."

There are a few lessons learned here. First, be sure that the PR firm you work with has real experience with web video projects. Second, be sure to push for open communication with your target audience. Web video relies on transparency and "genuine" content. Third, make sure all parties involved in the project discuss their priorities and approach. Don't make assumptions that everyone shares the same approach.

Alignment with Media Partners

New media cannot ignore traditional media. Similarly, traditional media is struggling to adapt to and adopt new media techniques. How can the two help each other? The simple answer is to build a bridge. By aligning your show with traditional media outlets, you can increase your reach:

- Write a magazine column or blog post for a large website.
- Serve as a forum moderator for an online message board.
- Pitch journalists on your topic or expertise.

It's important to realize that many people still turn to traditional media. You can't ignore the reach of television, magazines, and the general web. Web video producers who partner can get a lot further than those who attempt to do everything on their own.

The proper use of tags can make your video easier to find when searching.

Keyword/Tag Development

Videos are often searched for by topic rather than name. The use of keywords and tags influences how results are generated. When you upload a video to a sharing site, you usually have a tag field. The same holds true when generating an RSS feed; you can often insert keywords into your show's description.

Typically, sites limit you to 20 tags. Just because you have this many doesn't mean you should use them all. If a video has too many tags, it can lose relevance in a search and appear lower in the results. Only tag a video with the most essential tags that accurately describe its content. Keep in mid that tags take a while to work their way through a search system. So it may take a few hours (or even days) before a search bears results.

Search Engine Optimization

There are many things you can do to make your web video more search-engine friendly. The goal is to make your video's site appear as relevant and authoritative as possible. The good news is that search engines like sites that are frequently updated (which your blog should be).

Unfortunately, the major search engines do not watch and index your video content. This makes the text content extremely important. Be sure to include textual show notes for each episode—detailed descriptions and content outlines that let readers and the search engines know what each episode is about. For even better ranking, consider posting transcripts of your show to provide additional text content that search engines can index.

The more other websites link to your content, the more authority you have on the Internet. More authority leads to a higher search ranking, which in turn leads to more traffic and more inbound links. The simple truth is that most people don't make it beyond the first few hits on a web search.

The best way to encourage links to your site is to regularly publish quality content. Find directories that allow you to submit your web address. Develop relationships with bloggers and

Publish a Blog

You should use a blog platform to publish a podcast and host web videos. It provides a great home base for your video series where viewers can find archived shows and comment on each episode. Blogs are very search-engine friendly.

podcasters who publish related content and might want to link back to you. Include links to your site when you participate in blog commenting and forum posting. You'll want to build several paths to your website (just be sure you return the favor to those who help you).

Hyper-Syndication Strategies

A guiding tenet of our publishing beliefs is that of hyper-syndication. Another way of saying this is "create once, publish many." In this section, you'll learn practical techniques to publish your podcast or web video to as many screens as possible. This lets you take advantage of the many different viewing options on the market and grow your audience.

Hyper-Syndication Tools

Getting your content on a ton of sites takes a lot of effort. After all, imagine the time involved with uploading to 30 different websites and re-entering the same information each time. To make things easier, paid services have emerged. Let's take a look at two of the most robust, TubeMogul and blip.tv.

TubeMogul

The OneLoad service from TubeMogul (www.TubeMogul.com) offers both a robust free version (which allows for 100 videos per month) and a scaled paid service with advanced features for large publishers (priced at $50 per month and up). The principal benefit here is that it offers a single point for deploying videos to the top video and social networking sites.

You first set up accounts at any of the 30 sites supported by TubeMogul. You then upload a video to TubeMogul's site and it is sent on to the other sites. This means you need to spend a little time setting things up, but once you've published more than two videos, this method is substantially faster. The site also offers detailed analytics (for supported sites) that can show real-time viewership, geographic tracking, stream quality, and more.

blip.tv

One of our favorite services has to be blip.tv. This robust site lets you publish your video to many outlets (including nontraditional ones like TiVo and Internet-connected TVs). In fact the company claims that its network "reaches more than 80% of Americans on the Internet and a growing number of television households."

TiVo is one of the many distribution channels that blip.tv can unlock.

We really like how flexible blip.tv is, in that you can choose your distribution format. You have options to use Flash, MPEG-4, QuickTime, and more. Its player is also highly customizable and can be fully branded to your site or brand.

The service has both a free version and a paid version at $8 per month. The paid version offers priority encoding so your files are available in multiple formats. This is a great feature as it lets others resyndicate your content using a player of their choice. The control panel for the site is robust and gives you complete control over targeting specific networks and social media sites.

Video Hosting Sites

There are a myriad of websites to choose from for hosting content. Some sites are general interest and serve as large portals or search engines (think YouTube), whereas others are meant to be for specific genres or audiences (Howcast, for example, only features tutorial videos).

Here are a few sites to keep in mind for your network:

- **5min** (www.5min.com)—Tutorial videos shorter than five minutes in duration.
- **Bing** (www.bing.com)—Microsoft's new search engine has a video directory.
- **Brightcove** (www.brightcove.com)—A paid service that lets you target many outlets including mobile phones.
- **Cardomain** (www.cardomain.com)—A site for automobile enthusiasts.
- **Dailymotion** (www.dailymotion.com)—A broad interest site that also has distribution to many mobile devices.
- **Graspr** (www.graspr.com)—A site that features educational videos only.
- **GrindTV** (www.grindtv.com)—A site for extreme sports videos.
- **Howcast** (www.howcast.com)—The site specializes in educational videos and offers applications for both the Android and Apple iOS platforms.
- **iFood.TV** (www.ifood.tv)—A site all about food.
- **mDialog** (www.mdialog.com)—A paid service that offers a flexible SDK for integrating video into iOS applications and dynamic ad insertion.
- **Metacafe** (www.metacafe)—Another large portal site for general interest.
- **Sclipo** (www.sclipo.com)—A paid site that offers e-learning systems.
- **Sportpost** (www.sportpost.com)—A site for sports content.
- **Streetfire** (www.streetfire.com)—A site for automobile enthusiasts.
- **StupidVideos** (www.stupidvideos.com)—A site for humorous videos.
- **Viddler** (www.Viddler.com)—A free service for video distribution.
- **videojug** (www.videojug.com)—The site only offers "factual" content rather than entertainment.
- **Yahoo! Video** (video.yahoo.com)—A general interest search directory by the search engine company.
- **Zoopy** (www.zoopy.com)—A site that offers video, audio, and photo sharing on one site.

iTunes Searching: How Will You Be Discovered?

There are three ways a potential subscriber can find you in the iTunes Store. Understanding the three methods is important if you want to improve your chances of being found.

1. **Search.** The iTunes Store contains a search field. Results are returned based on popularity and relevance. Popularity relates to the number of new subscribers you've had in a given period (which is an uncontrollable factor). Relevance is due largely to your show's description and keywords (which you have complete control over). Be sure to write an accurate description that addresses your show's topic. You can also use keywords to address misspellings or additional search criteria.

2. **Featured content.** The iTunes Store routinely features content. There are several factors that contribute to a show being featured. First and foremost, the quality of content is considered. Second, your show must have attractive artwork (which does not include Apple items like logos or iPods). The staff at the iTunes Store also favor shows with consistent content that is released regularly (e.g., weekly or daily). It should also go without saying that your feed needs to be valid, so periodically check it at www.feedvalidator.org.

3. **Top lists.** On each page of the iTunes Store there is a "Top List." These lists showcase the top shows in each category. These lists are based on new subscriptions. We often recommend launching a show with four episodes (simply predate the first three to offset their "release"). This way a new show offers visitors multiple options. This initial surge can help you make a splash. Once you are on a Top List, it is essential you maintain your release schedule and quality. Staying on a Top List is very helpful, as it makes it much easier for visitors to discover your show.

Ping-O-Matic can automate the process of notifying websites about your new podcast.

Notifying Directories Automatically for RSS Feeds

Each time you post a new episode of your show to an RSS feed, you want several directories to immediately crawl, index, and list the new content. The easiest way to make sure this happens is to send an instant notification, called a "ping." If you use a blog to publish your show, the blog software can be configured to do this for you automatically, each time you post a new episode.

Another option is to visit www.pingomatic.com each time you post new content. Submit your feed, and Pingomatic will automatically notify the most important directories. If you don't manually ping the directories, it can take a few days for new content to appear.

Social Media Tools

These days you'll hear a lot of the miracles of social media. Our take is that this is simply a new name for a practice that's existed since the start of the Internet. We remember being in college and belonging to online bulletin boards and groups about some of our favorite hobbies and interests. We shared photos and video; we interacted with others (and this was the early 1990s).

Of course, social media is now all the rage. Multiple generations from grandkids to grandparents share videos, pictures, and text updates regularly. If you make a concentrated effort to engage folks this way, you can see real results.

"We reach out to our fans and speak to them so they can feel more connected. That's something that you simply can't do with TV. TV has more of an 'us versus them' vibe, with 'them' being the audience. There's an aloofness there," said Black. "But with the Net you can Twitter or email the casts and crew so

Hayden Black uses his Facebook page to stay in touch with fans. Witty updates keep his audience engaged and often generate comments.

there's more of a duty to connect with people who are reaching out to you to tell you they're a fan. Once you do that, fans are far more willing to help out because they feel engaged and part of the process."

But be careful of social media overload. Although repetition is okay, it needs to be done creatively. Don't just blast the same message to Twitter, Facebook, your email list, and press releases. You'll need to get creative and stagger your messages.

"When you're on a grassroots budget [social media] is about 100% of the way you can promote. But you have to tread a fine line and not piss people off by targeting them over and over on different platforms," said Black. "Nothing turns me off of wanting to watch something when the producer has contacted me five different ways."

Enabling Share Technologies

If you enjoyed this article, please bookmark/share it:

 Digg del.icio.us Reddit StumbleUpon

The viral nature of social networks has created a marketing nirvana. People can instantly share content with their entire social circle. By making it easy for your audience to share your content on popular social networks, you will increase the reach of your show. Popular social networks include Digg.com, Del .icio.us, Facebook.com, and StumbleUpon.com. These sites provide bookmark widgets that you can include on your site so visitors can share your content with one click. It is a good idea to add these to your show's blog.

Twitter Essentials

Twitter is a short messaging service that lets interested people follow the activities of others—no, not in a stalking sort of way; only the information that one group decides to share with others. What makes this so effective is that you can post quick updates about your web video.

Many mobile phone applications support Twitter. This means you can quickly post photos, video, or text updates right from the set or location shoot. As comments come in, you can interact with others in a meaningful (albeit short) exchange. Twitter takes a little getting used to (we recommend lurking for a few weeks to get the hang of it). Watch how others you admire or respect use the tool to get ideas.

Metadata Is Essential

Your show needs good metadata so people can find your podcast. This includes all of the information that describes your podcast to the potential subscriber, as well as to podcast directories.

Besides your show's title, author, and description, you can use up to 12 keywords to determine relevance. A high percentage of potential subscribers look for podcasts using searchable directories. If you don't have useful, robust metadata, your podcast will not turn up.

Justin Seeley is an active web video producer who keeps his audience up to date through Twitter (http://twitter.com/JustinSeeley).

What we've found is that it's the best way to connect with our most interested fans. These fans are also the most likely to post or share information about our videos and products.

Ray Ortega also uses Twitter as an inspirational tool to discover topics for new shows he produces. He also builds a loyal following of viewers.

"Twitter allows me to monitor search terms related to my show, such as 'fruit,' 'vegetable,' 'ripe,' et cetera," said Ortega. "When I notice people talking about or asking questions, I can respond quickly and with very little effort I have gained a potential new viewer and almost certainly made a connection with someone who shares my passion."

Schedule Tweets

 One service we use is SocialOomph.com. This lets you schedule tweets to come out over time. It lets you set up a message and have it trickle out or even repeat. The site offers both free and paid services.

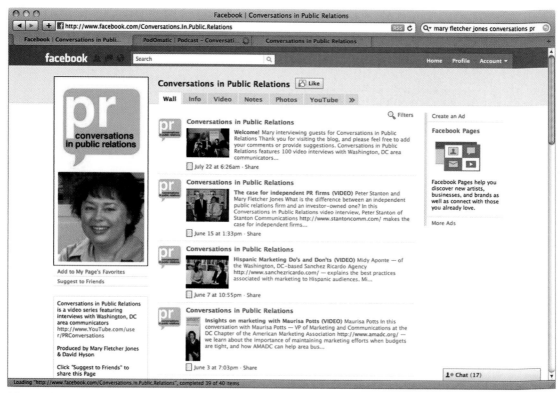

"Conversations in Public Relations" is a web video series focusing on luminaries in PR. The show uses its Facebook page to publish its video.

Facebook Essentials

Facebook has grown incredibly since its launch (with many calling it Internet crack). With currently more than 500 million active users, Facebook truly is the Internet's gathering place, with more than 30 billion content posts per month. Plus, other websites tie into Facebook to allow for sharing of content back and forth (more than 1 million current connections).

What does this mean to you? Well, you better set up a Facebook page for your web video series, production company, or host. This page should ideally be a Facebook page (and not a personal profile). You can set up a page by visiting www.facebook.com/pages/create.php. These pages are much more flexible and allow you to share and interact more easily with fans of your show.

While you are on Facebook, be sure to look for groups that match your show's topic. Becoming an active member of several groups lets you gain exposure to potential viewers and will serve as a source of inspiration for new content. For more on creating and joining groups, see Facebook's online help (www.facebook.com/help).

Live Engagement

Some video creators stream their shows' creation live. This works particularly well for shows that do not rely on much editing (such as talk shows). This method lets the most interested fans tune in from the start and even shape the content of the video.

"Sometimes when the show is recorded, I also live stream the process so that others can join in and get a behind-the-scenes view of what it takes to produce an episode," said Ortega. "This also allows me to gain feedback instantly. I can ask the audience their opinion on what I'm about to film and make changes to the production in real time. Including your audience in the process of production gives them a feeling of ownership, and they are certain to become the core group of people who will rally others around your content."

Additional Promotional Strategies

While we're talking about promotion, there are several other methods that bear mention. The techniques covered in this chapter won't work in every case. Be sure to explore and experiment to determine the best "media mix." Here are a few other techniques that have worked for us and our colleagues.

Cross-Promote with Other Internet Shows

An effective way to find potential listeners is to target the audiences of shows that are similar to your own. Most podcasters and video creators don't believe in the "pie theory," which says there's an infinite number of listeners that can only be divided so many ways.

"I often tell people not to reinvent the wheel when it comes to promotion. Go to where your audience already is. You don't have to spend all of your time searching the web and forums to reach one person at a time. Find out where people are gathering around content in your niche," said Ortega.

We have found that many are willing to share their audiences through cross-promotion strategies. We regularly interact with other video producers and even contribute to their shows.

"In the beginning most people will view this as competition. You should view this as opportunity, an opportunity to instantly expose hundreds or thousands of people to your show," said Ortega. "In most cases you have an individual take on the same topic and there is certainly room for people with like content to share an audience."

Podcasters enjoy using content from outside sources to make their shows more interesting. Find shows that relate to your topic, then contribute content that adds value to those shows and that

UStream

If you'd like to stream your video program live for free, check out www.ustream.tv. This site is easy to use and offers easy tools for creating a stream on a laptop or desktop computer.

A Great Book on Podcast Promotion

Promoting your podcast is essential to its long-term success. Although we've explored several ideas in this chapter, we highly recommend *Promoting Your Podcast* by Jason Van Orden. You can find out more on the book at www.promotingyourpodcast.com.

promotes your show at the same time. Here are some suggestions from Jason Van Orden:

- Offer to be a guest on other podcaster's shows, and then return the favor by inviting them on your show.
- Produce guest segments or serve as a field producer for another podcast.
- Add questions or comment to other show's blogs. Be sure your show is mentioned in your signature line.
- Consider exchanging show promotional announcements with other podcasters.

Advertise and Promote

This may sound obvious, but you need to promote your show. This includes running ads in traditional venues like magazines or websites. One technique we employ is creating a business card for each of our podcast series. In this way, when we talk up the show with people we meet, they can easily remember the show name and blog when they get to their computer. You don't need to spend a fortune on advertising—many podcasters trade ads with one another, placing ads in their shows for certain products or events, then asking for links or ads in exchange.

Aggregate Your Content

If you produce multiple podcasts that could appeal to the same audience, then be sure you aggregate and cross-promote. For example, you can list other shows on your blog page. We often add blog posts about other shows to promote crossover content that should appeal to the audience.

You can also create an artist page on iTunes. This is a single page that lists all your shows in one place. Simply click on the Report a Concern button, and select Remove a Podcast. In the

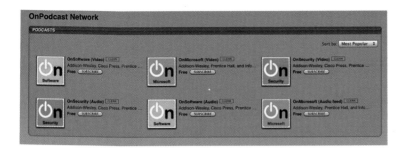

Pulling multiple series together on iTunes is a good way to expose fans to other shows you produce.

dialog box, explain that you would like an artist page, give the exact name of the artist (don't include "Inc.," "LLC," etc.), and list the exact feed URLs or links to your podcasts. Note that a podcast can only appear on one artist page.

When using services like YouTube, you can keep videos grouped together under one account. Since accounts are free, we recommend that you set up a page for your production company or even just your show. This will put all of the videos onto a single page and make it much easier for people to discover your content.

Word-of-Mouth Marketing

The use of word-of-mouth marketing relies on communication between two people. The term has grown to include social media but still refers to an influencer talking (or posting) about a

Feedback from viewers is very important. Encourage fans and colleagues to post reviews as they often influence potential viewers and drive up a video's ranking.

Word of Mouth Marketing

 Word-of-mouth marketing is so popular that there's an actual professional group, Word of Mouth Marketing Association (www .womma.org/main). Its website offers several free resources worth exploring.

product or service to the person's peers. This type of communication is often seen as being credible, because the recommendation comes from a known source and not a commercial source.

"Word of mouth is probably your best marketing strategy. Getting the viewers you already have involved in the process of promoting your show is an easy way to grow your audience," said Ortega. "I ask people to become a friend of the show on Facebook, Twitter, or any number of social networking sites. This allows me to know who is watching and to connect with them beyond the simple act of them watching my content."

Once fans connect, it's much easier to build a web of influence. As you release news or content, they will be automatically notified. They can also talk about you to others in their network and easily share content. The key, though, is to not just "talk at" your audience but rather to "talk with."

"When you listen to your audience and have real interactions with them, you build a relationship with your content and brand that is oftentimes much stronger than their experience with traditional media," said Ortega. "These people in turn write about you on their blogs, send out tweets about each episode you produce, or pass the word through their own social network, exposing many others with like interests to your content."

Getting Press Coverage

Getting traditional media coverage is not as hard as you think. We've found a few practical approaches that increase the likelihood of good press. Here are three of our favorite techniques:

- **Be sure to have photos easily accessible.** The press loves pictures, so not having photos is often a deal-breaker. Post stills to your website that show both the finished product and behind the scenes.
- **Don't be shy**, but at the same time don't annoy. Journalists often are spread thin these days with budget cuts. By following up and being responsive, you'll be seen as a good source.
- **Lastly, be sure to pitch your content in relationship to a bigger angle.** For example, perhaps your show is about saving energy and a better environment. Pitch journalists on Earth Day or when green energy initiatives are up for a vote. Tie yourself to your content and pitch when relevant.

Once you've built a relationship with a member of the press, be sure to maintain it. Remember that most journalists have a job to do, and that is to find and report on stories that are of interest to their readers. If you are easy to access and genuinely open, they'll likely revisit you.

Hayden Black has firsthand experience in keeping a healthy relationship with press.

"I have been very lucky in that 99.9% of the press I've gotten has been generated by the press itself," said Black. "I've built on the relationships I've made with journalists after articles have been written."

Many journalists (as well as fans) follow Black on Twitter or Facebook. Because comedy is his business, his feeds don't disappoint.

"I use Twitter too [@HaydenBlack and @GoodniteBurbank], but as an outlet primarily for jokes. Every so often I throw in a bit of marketing so people don't get burned out with it."

Build a Relationship with Your Audience

Although attracting new subscribers is important, long-term success comes from maintaining the subscribers you already have. To do this, you must build a meaningful relationship with your audience. Here are a few ways to connect and build on that connection.

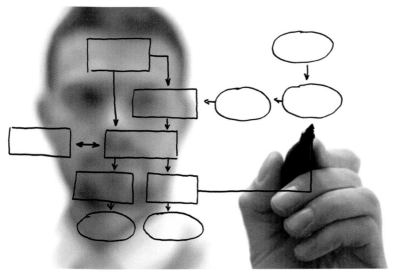

© iStockphoto.

Stay Focused

What is your show all about? Perhaps you should write it down "for the record." Many web video creators struggle to come up with new show topics. As such, their shows drift away from the intended topic (and subsequently lose both their focus and their viewers). One recommended technique is mind-mapping, which involves visually organizing information. You can essentially start with a few core topics and keep breaking them down into related ideas to come up with new show topics. You can find out more on mind-mapping at www.en.wikipedia.org/wiki/Mind_map.

Remember Who Watches

Do you know who watches your videos? Be sure you have a target audience in mind when you develop show ideas. One thing we find useful is to look at our podcast page in iTunes. Here we can see a section called "Listeners Also Subscribed To." You can follow the links listed there and discover what other shows your listeners are consuming. You'll also see similar features on most video-sharing sites when other recommended content is presented. This can help you develop an overview of what your audience is interested in.

Interact with Your Audience

You want to provide your audience a way to speak back to you. This can mean an email address or voicemail line. Another way is to allow commenting on your blog or allow forums. When your audience members speak up, answer them. Include their comments in the show. Thank them for participating. Respond to what they say.

You should also include surveys on your website or blog. We frequently use the survey tools from MajikWidget (www.majikwidget .com). Others employ the more detailed Survey Monkey (www. surveymonkey.com). Whatever technology you use, people like having a chance to voice their opinion.

Another option is to be sure to visit places where people visit who'd be interested in your content. This means hanging out in forums or social networking groups. Remember though, it's not enough to just find the people who would be most interested in your content and posting a link. Ray Ortega insists that you need to actually engage with people in a genuine fashion such as answering their questions or commenting on their content.

"It's important to be cautious about simply going to another site and posting a link to your show. This is quickly written off as spam and rightly so. If you are there for the purpose of only promoting your show, you are going to lose. You are more likely to do more damage to your show's name/brand than you are to promote it," said Ortega. "If you get pegged as a spammer, then your brand is tainted. If on the other hand you enjoy the conversations with people who share your own (and your show's) interest, then you are likely to do yourself a huge favor by reaching the people you are shooting your show for in the first place."

At Evil Global Corp., Hayden Black has gone as far as actually integrating fans into the show. He knows that people who like his style of comedy should like his new video series as well. He goes out of his way to interact with fans through social media.

"We were one of the first web shows to use Twitter within a scripted show. In *The Occulterers*, we created a mock 'live feed' from the castle that the bungling ghost hunters were spending each night in and then invited fans to tweet what they saw to the ghost hunters," said Black. "We got inundated with people telling us what they saw or what they heard, and we used their Twitter names in the show to report what was being seen."

The use of surveys on a blog or website is a great way to involve your audience.

Watch Other Shows in Your Space

Do you know what your video's competition is? It's important to periodically check out what other shows are doing. You can learn a lot by analyzing shows and videos that are ranked both above and below yours. You'll want to look at them for ideas on content and approach.

In some ways you can counter-program. For example, if your competition is fairly dry, you can integrate light humor. If other shows are very long, try taking the abbreviated approach. What you should do is analyze the market, looking for both ways to make your show stand out and best practices.

Build Your Brand and Host Recognition

We have found that establishing credibility and building a brand have been helpful in the long run. Podcast hosts should look to improve their "terrestrial" credibility by speaking at conferences as well as offering interviews to traditional media.

The "Produce Picker Podcast" saw significant growth once it loosened up its format and let humor into the show.

We also find that showing the host on camera works well. Be sure to give some face time to your host, rather than just focusing on the subject of an interview or source of a technical demonstration.

"In the beginning the show was pretty raw, just a video of my hands showing people how to select and prepare fresh fruits and vegetables. The next step was getting myself in front of the camera, and once I did that I realized the show could use a touch of humor," said Ortega.

Ortega pointed out that many web video producers feel trapped by "traditions" or "rules" of broadcast television. Web video is a much more open medium, however.

"[Originally] the show was basically a green grocer format, something you'd see on any local newscast or public access channel. But I quickly realized that this was not traditional TV and in fact it was the web, where you can do virtually anything you want," said Ortega. "I decided it was time to add some fun into the show. Thus began a tradition that usually involves me getting pelted with whatever fruit or vegetable happens to be featured on a given episode. So in that way, having food thrown, dropped, or just generally making a mess was an unusual approach to the kind of content I'm producing. People have definitely commented on the humor element to the show, and it sticks out as something they like seeing."

Make It Easy to Subscribe

It is important that you make subscriptions easy. This means you need to recognize that your audience may have different desires regarding technology than you. Make sure that you offer both RSS subscriptions and one-click subscribe buttons for several popular formats. Usually your host company can help with this; if not, you should harness the power of FeedBurner (www.feedburner.com).

You'll also want to take advantage of any tools offered by video-sharing sites. These include share buttons to popular social media sites and channel subscriptions.

One overlooked technology is email. A surprising number of folks still want to be emailed when new episodes come out. We usually turn to FeedBurner for this, but other sites also offer the option for users to be emailed.

MONETIZING YOUR VIDEO

With Paul Vogelzang, Executive Producer of MommyCast

Making web video costs money and takes time (and time is directly related to money). As such, you'll need to discover ways to monetize your content. For some, this is easy. Web video can save organizations money when it comes to travel, training seminars, or shipping to customers.

For others, it's not merely enough to spend less money; they need an actual influx of capital. Perhaps the goal is to make enough for the video to fund itself. Maybe it's to generate an extra source of income. Either way, you won't get there overnight.

What we offer here are some starting points. These are proven ways you can monetize your web video content. You'll need to experiment to find which approaches will work for your content.

We've learned to be direct with our efforts to monetize web video. In this case, we used a short four-second preroll ad that is also used as a longer postroll. We also put a direct link to a for-sale training product below the video. Social media options also led to comments and tweets about the training.

More on Making Money from Podcasting and Web Video

There are a few sources we respect for ideas on making money from web video:
- **Online Media Success Podcast** (www .onlinemediasuccess.com)
- **Podcasting for Profit** (www.leesabarnesbooktour .com)
- **Internet Business Mastery** (www .internetbusinessmastery .com)
- **The Business of Podcasting and New Media** (www.paulcolligan.com)
- **Podcast Academy: The Business Podcasting Book: Launching, Marketing, and Measuring Your Podcast** by Michael Geoghegan, Greg Cangialosi, Ryan Irelan, and Tim Bourquin

Potential Revenue Sources

There are many different ways to make a living; the same holds true when it comes to making money from web videos. Essentially you can make money by support of your audience making purchases or from those who want to reach the audience we've built. Many video producers try to employ a mixture of techniques as they find a combination that works for their topic and audience.

Remember, there are two ways to make money, directly or indirectly:

- **Direct.** This is the closest model to traditional entertainment and news. In this case, you are trying to turn your viewership into money. This can be for advertisements you sell, paid downloads by your audience, or sponsorships you accept.
- **Indirect.** This approach can be quite successful in that it lets you leverage your experience as a marketable skill. In other words, you take your experience in producing content for the web and make it a hirable skill. This also works by trying to convert viewers into clients for other services that you sell.

Affiliate Revenue

One of the easiest financial models to participate in is affiliate programs. In this case, you can choose to promote or mention particular products (such as technology, books, film, or music). In theory, your audience may want to purchase these items after

seeing you use them (or hearing your opinions). Some take a direct approach and link right to products and services, while others have a support or site button.

The number one online retailer who has a great deal of products to sell is Amazon.com. If your video has a blog or website, you can provide a list of the featured products. For example, if your podcast talks about a piece of software or a book, and you link to Amazon to buy it, you can get paid. Simply sign up for an Amazon Associates account (affiliate-program.amazon.com). Amazon pays you up to 15% commission on everything you sell as a click-through on your website. Additionally, if someone who clicks through does any other shopping there, you get a percentage of that purchase as well. This is an easy way to bring in revenue that can offset or even cover costs associated with a podcast.

In a move similar to the Amazon Associate model, Apple offers the iTunes Affiliate program. This program lets you create links to a podcast or for-sale item to take visitors to the iTunes Store. You then earn a 5% commission on sales of songs, movies, TV shows, apps, and audiobooks purchased by customers who linked to the iTunes Store from your website. Anything they purchase during the next 24 hours will be credited to your affiliate account. The iTunes Affiliate program is only available in selected countries (www.apple.com/itunes/affiliates).

Advertising

If you have a large viewership, then you can explore ad sponsorship services. There are several in this space, such as YouTube, Podtrac, blip.tv, and Limelight Networks. The rates earned will vary based on your show's subject matter and audience size. Most of these services will sell ads for you and then keep a percentage of the sales.

Many video-sharing sites offer opt-in advertising programs so you can monetize your content.

You can insert AdSense ads into a blog. Other services like YouTube also offer advertising revenue sharing for top performers.

You can sell your own ads, which is more work but you keep more money. If you want to seek a sponsor, you'll need to put together a media kit that showcases the strength of your podcast and accurately describes its audience (both in size and in demographics). We'll explore this method more in a moment.

None of the podcast directories have an issue with shows that contain ads. On the other hand, many video-sharing sites want to insert their own ads into your program. As a general rule, free hosting means no ads, while paid hosting means it's up to you. We do recommend keeping ads short and to the point. The most effective ads are those that match products or services closely to a video's target audience.

Many video producers choose to place ads on their websites. For some, this takes the form of banner ads from show sponsors. Others take the easier approach of allowing Google AdSense ads into their blogs. These are generally text-only links and can be placed in the sidebar area of a website. An easy way to add these to your blog is by using FeedBurner (www.feedburner.com).

Related Products and Services

For many video creators, there is a reason they publish. Although there is, of course, the desire to create and share, you'll usually find some easy-to-spot motives just below the surface. For example, RHED Pixel has produced several podcasts and web videos through the years. Some of the benefits we've seen (besides ad dollars) include the following:

- Increased opportunities to bid on video production jobs
- Consulting and speaking opportunities
- Increased sales of our books and for-sale training products
- Increased loyalty from existing customers
- Substantial media coverage

All of these factors should be great motivation if you have something to sell. Whether it's products or services, web video can truly raise your profile. It's also an excellent way to engage existing and potential customers in meaningful dialogue.

By creating a landing page for all of our podcasts and web video programs, we can raise awareness for other services and projects.

Working with Sponsors and Advertisers

Making video for the web takes time and money. Ultimately, someone needs to pay those costs. Some create web videos as promotional materials to raise awareness for their causes or efforts. Others take a more direct approach and try to involve sponsors or advertisers in their web videos.

Lining up sponsors or advertisers for your web video can be challenging. Think of it this way: if getting sponsors were easy, every person who wanted to get his or her show on television would be successful. This method is not for everyone, but it can work quite well for certain video producers.

Monetization

Some video creators see monetization as a bad word. They fear giving over control of their show and simply becoming a mouthpiece. These concerns are valid, as many podcasters and video creators we know have felt pressure to give favorable reviews.

When done correctly, however, monetization can allow you to receive the important funding that you need to cover costs. The important step is to establish editorial independence from sponsors and clearly spell out what sponsors or advertisers will receive for their money.

"Partnering with sponsors is vital to the success of our show, and expenses such as hosting, bandwidth, editing, equipment, and marketing are not inexpensive," said Paul Vogelzang (executive producer of MommyCast).

"Our method of sponsor inclusion is to offer 'host information and recommendation,' as well as logo placement on our sites. We never promise favorable reviews, but honest opinions from our hosts, thereby ensuring the passion that our audience demands."

Sponsorship versus Advertising Models

Understanding the difference between advertising and sponsorship is important. Under the advertising model, commercials are inserted into the web video. This can take the form of pre- or postroll advertisements (much like you'd see in a television broadcast). Many web video players also support the use of embedded or overlaid advertising. These ads can provide hyperlinks that encourage a viewer to click a text or graphic link to visit another website (hence leaving your show in the middle).

Sponsorship, on the other hand, takes the form of financial support given toward a program that is identified and perhaps

MommyCast successfully uses the sponsorship model for its video content and integrates display ads on its website.

integrated into the show. This form tends to be a little subtler to the viewer, as it often takes an integrated approach. It can impact the choice of guests, it can take the form of relevant information covered, or it can even affect a video's topic.

On the other hand, sponsorship can also take a fairly hands-off approach. In this case, the "Public Broadcasting" model is often followed, where sponsors are recognized and thanked but have little input on the show or its content. This is the model that is employed by several top podcasters.

"Sponsorship, as opposed to advertising, will let us pay us, and all other expenses, keeping the show moving forward but allowing for the independence we insist on to remain relevant to our audience," said Vogelzang.

This editorial separation is important, as it preserves a genuineness that is essential for web video.

Your Case for Sponsors

Lining up a sponsor takes far more than just a great idea. Most shows never get sponsors (at least in the traditional advertiser sense). Even successful shows need to be able to explain their impact in a way that traditional advertisers or sponsors can understand. We've experienced firsthand the frustration of trying to explain the value of web video to sponsors. Many are simply more comfortable going with magazine advertisements or the pay-per-click banner ads that they're used to buying.

"Sponsors today are becoming more and more interested in proving the value of advertising. We spend a lot of time with sponsors who want to know the total number of viewers," said Vogelzang. "They also want to know what level of engagement is there. Is there sharing that goes on… is there any way that you can quantify your listenership."

He added, "We've been able to provide value to companies so that they have proof that they are connecting with people... but not going over the line and becoming an infomercial."

Vogelzang has suggested that you offer the following items to potential sponsors:

- **Show description.** Offer a clear description of what your video or series covers. Describe the type of content you produce and who you are trying to reach. This description needs to be unique and clear. For example, here is the description MommyCast uses:

 We are MommyCast! We are moms immersed in the fullness of life. We are experienced, confident, and interesting... and made so by our families, and the chance to reach out to busy moms everywhere. Millions of women and moms are entering a new age of boundless communications possibilities, and one show is their voice. MommyCast!

- **Viewer statistics.** You're going to need to provide accurate numbers about your total number of downloads and streaming views. As we discussed in the previous chapter, some of the hyper-syndication services can help aggregate your numbers across multiple video-sharing sites. Many hosting companies can also provide detailed and verified viewing statistics. Keeping track of these numbers can be challenging, so we recommend trying to use some of the aggregator services that will gather statistics.

- **Website statistics.** Many sponsors only understand website views. As such, you'll want to track the stickiness of your website. We highly recommend using a blog engine to power your website. The use of RSS feeds can increase the total readership for entries and embedded videos. You can also use social media outlets to help with syndication and sharing of content.

- **Audience surveys.** Because web video and podcasting is so new, we often recommend selling the quality of the audience rather than the quantity. If you sell high-end bags for digital cameras, what's more effective? Advertising in a mass-market magazine that has 500,000 subscribers or sponsoring a video about lighting for digital photography that reaches 5,000 professional photographers? In order to make the distinction, you need to know who's watching.

 To attract and satisfy top advertisers like Microsoft, Proctor & Gamble, and State Farm Insurance, MommyCast surveys its audience three to four times per year. For example, those who manage the site can tell you that 54% of the audience has a four-year degree and 29% an advanced degree. MommyCast has also found that the average show is forwarded 34 times to friends and family.

"We send out surveys to our audience. We ask them questions about their lifestyle, about their age, about their income level. We spend a fair bit of time surveying," said Vogelzang, "about four times per year. Our audience is interested in participating because they know that what we create costs money to make and they want to help us."

- **Media kit.** The media kit should clearly package the preceding information for potential sponsors and advertisers. The goal is to make it easy for those who need the information to browse it. This material should include relevant information about the show (but often excludes rates). Be sure to also summarize key information about your audience and videos. This material should be laid out in a publishing application and posted as a PDF to your website.

Identifying and Approaching Sponsors

Approaching sponsors can be a challenge as web video advertising or sponsorship is often handled by very different groups within an organization. One of the easiest groups to target is made up of those that are already advertising. Look at top-rated content that is similar to your genre or web series. Who is advertising in that space already?

Once you've identified who is already in the web video market, an equal (if not better) opportunity exists in finding those who are not. Look to see if the competitors of the firms you identified initially are participating. Oftentimes the market leaders with the biggest budgets aren't advertising in web video, whereas smaller, more agile companies are.

© Fotolia.

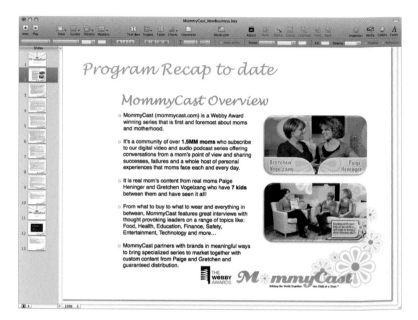

Paul Vogelzang builds customized presentations to make his case to potential sponsors. He mixes facts about the show with specific details targeted to the client.

Sponsors are going to want to know that you are visible in your market. This is where the media kit and research we discussed earlier really matter. Rankings on charts like iTunes matter. So do YouTube views. Pull up visible accomplishments that less savvy users can understand. Quality can work too. Focus on unique accomplishments, top guests who've appeared, or other things like awards or industry recognition.

Be sure to also bundle up your content so it's easy to see. We've often found ourselves sending preloaded iPods or DVDs to potential sponsors. Although web video may seem perfectly easy to you, we've encountered more than one person holding the purse strings who couldn't figure out how to watch (or hear) video. We've even encountered major sponsors and media firms who've had video-sharing sites blocked to cut down on workers' "wasting time."

Once you get your foot in the door, be prepared to make a proposal with your offer. Potential sponsors will want to know about your video series as well as how you plan to incorporate them. You'll also want to demonstrate that you have some metrics for your video series performance and address how you'll measure performance in the future.

Involving Sponsors

There are many ways to involve sponsors that are far more effective than tacking an advertisement on the front or back of your video. We don't recommend that you use all of these methods at once. Rather, mix things up and use the techniques you feel most comfortable with.

- **Invite sponsors as guests.** Your sponsors often know your subject matter quite well. Consider inviting a knowledgeable expert recommended by your sponsors. Be sure to set some ground rules for the interview or segment. Stress the relationship with your audience and the genuine connection you are trying to create. Podcast and web video audiences tend to be pretty savvy. Make sure you respect the audience, but don't miss out on top experts as well.

- **Point to a resource.** Many sponsors will have useful information on their websites. Perhaps it's a web tutorial or a free download. It might be a recent report or even a technical white paper. Try to point out genuine content and even reference it on your site or in a video.

- **Review a product.** Your viewers often like to hear the latest news about products related to your program or topic. Be sure to offer genuine commentary about the products you review. Our personal philosophy is to only recommend products that we'd recommend to a friend or colleague (think 3.5 out of 5 stars or better). If we are asked to review a product that we don't like, we send our comments to the manufacturer with suggestions for improvements. We don't tend to publish those opinions, however.

- **Use a product in a video.** In the world of film and television, there is definitely a trend to product placement. In this case, sponsors like to see their products in use by a video's host. Be careful to balance the use of product placements and make sure that you believe in the products you recommend.

- **Have a giveaway or a contest.** People like free stuff. They also like games and contests. Consider having contests around user-generated content, or perhaps a giveaway of free software or products. There are legal requirements for contests, so be sure to work with the sponsor to be compliant with the law. A useful site to learn more about what issues to consider is www.squidoo.com/contest-rules.

- **Thank the sponsor in the program.** If the host of the video names and thanks a sponsor in the video, it often has a positive effect for the sponsor. Chances are the sponsorship you receive is essential to bringing the content to the viewer. Letting the audience know this can create a halo effect and lead viewers to check out the sponsor's website or products.

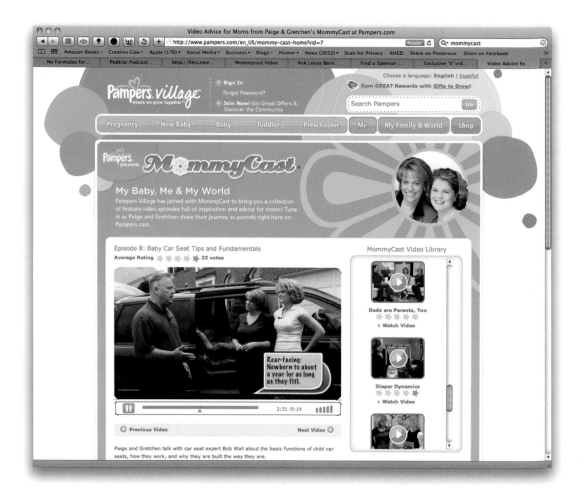

- **Give sponsors videos for their websites.** This is truly a win-win relationship builder. By giving videos to your sponsors, they can get more visitors to their site and increase visitation times. For you, the video creator, you get new potential viewers and increased exposure.

Banner and Click-Through Advertising

One of the most prevalent forms of advertising on the Internet is the banner ad that asks viewers to click through to visit another site. The problem with this approach is that it fails to measure the true strengths of web video: personality and relationships. A banner on a website is much less important than a meaningfully integrated product or the halo effect of sponsoring great content that an audience loves.

Although sponsors are starting to recognize that web video is an effective, highly targeted medium, the ad agencies that represent the sponsors are only comfortable with what they know. Unfortunately, this is display advertising. This is what has been sold in magazines and newspapers for years.

"One of the things we've learned through the sale of banner ads is that every single sponsor demands them," said Vogelzang. "Most of our viewers subscribe to MommyCast and they get the show via iTunes or another directly, and it's pushed to them onto portable devices or their computers. The banner ads really aren't that meaningful... but they are to our sponsors."

How do you resolve this dilemma? Make sure that the links you are using for click-through measurement are embedded in multiple places. You can also encourage your viewers to frequent sponsors and mention their support of your program. Ultimately, though, you need to take the high road and attempt to educate your sponsors.

"We sell banner ads because we have to, but it's not the real value. What the sponsor really gets is an integration of their product with our content," said Vogelzang. "For example, our hosts talking genuinely about Microsoft's parental controls and how they want those controls for their children... that's what's important to our audience. The banner ads are just a value to the advertiser [and not the viewer]."

Ultimately, if you take the sponsorship path, you'll need to keep both parties happy. Be sure to not overwhelm your viewers and also try to mix up the advertisements so your audience doesn't tune out because of repetition.

Selling Your Content

Logic says if something is good, it's worth buying (of course, that theory gets tested all the time). Many video creators are testing that theory and attempting to bring their content directly to their audiences. There are many potential methods here, considering the value of your content.

Many creators have decided that *unlimited* and *free* are dangerous words. Instead of keeping their entire library of podcasts or web video freely available, they've taken steps to limit access. The goal is not to drive folks away, just to drive up demand.

Digital Downloads

One method that video creators seek to employ is that of digital downloads. With venues like Apple's iTunes and Amazon.com, it is getting increasingly easier to deliver for-sale digital files.

Kim Foley uses her podcast and web video series to drive people to her website. Once there, she offers full-length DVD training and e-books.

Other creators use private RSS services to limit access for subscribers (check out www.showtaxi.com and www.klicktab.com).

The challenge with downloadable files is digital rights management (DRM). It is difficult to prevent customers from sharing your files with others who have not paid. The challenge with DRM is the constant balance to make it restrictive enough without punishing those who've made legitimate purchases.

Traditional Media

Many traditional magazines, television shows, and websites license content. You may find some interest in licensing your content to other channels. These arrangements can be for cash up front, but usually they are done under a profit-sharing arrangement. Networks and syndicators are often looking for additional content, which can then have ads sold against it.

Back Episodes

Many podcasters and web video producers look to make money from their catalog of materials. Some do this by bundling back episodes together and selling them on DVD at full quality.

Others make back episodes available for sale or through subscription only. The theory here is to keep around 20% of your back episode content available for free and move the rest behind a wall that people pay to get access to.

Exclusive or Expanded Content

Another option is to produce shorter videos and then offer more in-depth materials for sale. Many see web video as a brand builder, something that can be used to pull in new people and sell related products or services. Consider using this approach to take your most loyal fans and make them paying customers. This approach is like a VIP line. The most interested viewers will want your best content—and will likely pay for it.

We've produced advanced training in a longer form for release as an application. We've also included an e-book, quizzes, and hands-on files to increase the value of the content.

Applications

Another solution is the expanding market of applications for mobile devices. Leading the way is the Apple iOS platform. The practice here is bundling applications into functioning apps.

We have firsthand experience in this practice. The challenge to date has been the "race to the bottom" pricing approach that has pushed applications into selling for very low rates (or even free).

Fortunately, three recent trends are making this market potentially viable:

- **iBooks/eBooks.** Devices like the Apple iPad and Amazon Kindle are beginning to support rich media electronic books. This means that video can now be safely embedded into a publication. Apple Pages (part of the iWork suite) makes authoring an iBook file easy.
- **iPad applications.** The market seems to have learned from earlier mistakes with the iPhone. Video-rich iPad apps have emerged and are sticking to higher prices and offering top video quality.
- **App-building services.** Creating applications has continued to get easier. Thanks to services like AppMakr and appOmator, nonprogrammers can create their own iPhone-compatible applications. New efforts from Adobe that tie into the inDesign publishing platform are also emerging onto the market.

The Road Ahead

The world of web video and podcasting will continue to evolve at a rapid pace. To keep this book relevant, please keep in touch with us. Visit these sites to keep up with the latest news and information:

- **Book's Downloads**
 (www.hypersyndicate.com)
- **RHED Pixel**
 (www.RHEDPixel.com)
- **Rich's Blog**
 (www.RichardHarringtonBlog.com)
- **Facebook: RHED Pixel**
 (www.Facebook.com/rhedpixel)
- **Facebook: Richard Harrington**
 (www.Facebook.com/RichHarringtonStuff)
- **Twitter**
 (www.twitter.com/rhedpixel)
- **YouTube**
 (*www.youtube.com/rhedpixeltv*)

INDEX

Page numbers followed by *b* indicate boxes, *f* indicate figures and *t* indicate tables.